ROWLANDSON

WATERCOLOURS AND DRAWINGS

FRONTISPIECE: Detail from *George III and Queen Charlotte Driving through Deptford* (Plate 24)

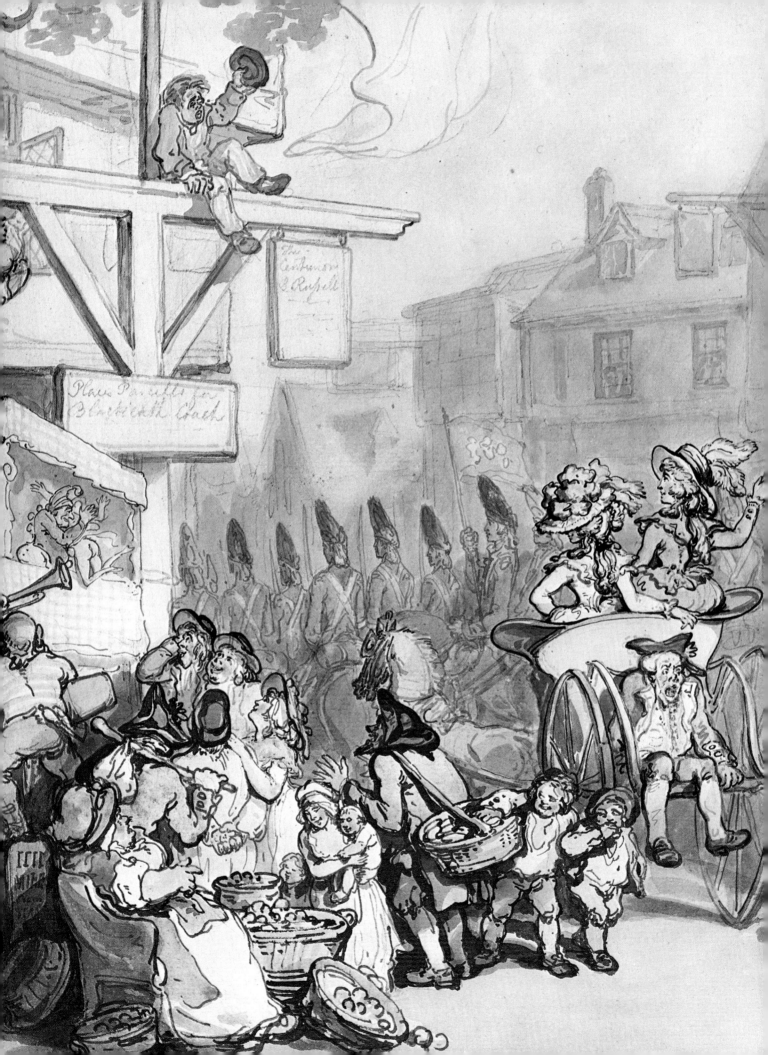

JOHN HAYES

ROWLANDSON

WATERCOLOURS AND DRAWINGS

PHAIDON

For Heather

PHAIDON PRESS LIMITED, 5 Cromwell Place, London SW7

Published in the United States of America by Phaidon Publishers, Inc.
& distributed by Praeger Publishers, Inc., 111 Fourth Avenue, New York, N.Y. 10003

First published 1972 © 1972 by Phaidon Press Limited All rights reserved

ISBN 0 7148 1555 1 Library of Congress Catalog Card Number: 79–190599

Printed in The Netherlands by Drukkerij de Lange/van Leer NV, Deventer

CONTENTS

PREFACE

Rowlandson was one of the very greatest of English draughtsmen, arguably the greatest of all as a master of pen line, and it is the purpose of this book to illustrate the quality and diversity of his work as well as to discuss the evolution and character of his drawing style. The coarse and bawdy side of his production, so often supposed to be the whole of Rowlandson, should not be ignored, since it reflects one side of his personality, and no doubt the taste of his public; but I have underplayed it deliberately in order to concentrate on equally significant but perhaps less generally familiar aspects of his art.

I cannot claim that this is a book incorporating much original research, though I have always taken the opportunity, over the course of the last fifteen years or so, to see whatever Rowlandsons I could in print rooms, libraries and private collections, and a fair proportion of the drawings illustrated have not been reproduced before. Relatively few new facts are adduced, and I am aware that certain important matters, such as the probable debt of Rowlandson to French eighteenth-century watercolour, the sources of his imagery and subject-matter generally, and the question of whether he did or did not employ studio assistance, still require detailed exploration. The problem of meaning in Rowlandson has recently been examined by Ronald Paulson, and the results of his investigation, also to be published this year, will form a study usefully complementary to the emphasis of my own essay.

Among fellow scholars I am especially indebted to Robert Wark, with whom I retraced Rowlandson's 'Tour in a Post Chaise' in 1961, not only for many enlightening conversations about Rowlandson, but for his careful scrutiny of the typescript. John Sunderland has been extremely helpful with regard to material in the Witt Library, and many members of the art trade, in particular Agnew's, Appleby's, Colnaghi's, the Fine Art Society, Sabin Galleries, Frank T. Sabin and Spink's, have gone out of their way to assist, often lending me valuable photographs or procuring fresh ones.

The Phaidon Press and I are deeply grateful to Her Majesty The Queen for gracious permission to reproduce drawings in the royal collection, and to all those owners and curators who have so kindly permitted us to reproduce works in their possession or charge; we owe a particular debt of gratitude to those owners who have generously provided photographs themselves or who have allowed their homes to be invaded for the purpose of photography.

At the Phaidon Press itself, I am indebted to Keith Roberts for his patience and friendly encouragement throughout; to Jane Rendel, who collected the illustrations; and to Simon Haviland, who has watched the book through the press with a combination of enthusiasm, efficiency and sensitive attention to detail.

April 1972 J.H.

Mr & Mrs Fran. Rimbault

Account with T. Rowlandson

1822 Settled up to 29 April £ s
 20 . 6
by 2 Acceptances of £13 each

New Account £ s

May 1. To Brussels market
 bought in at Sale ——— 1 —
 2. Noblemen building
 and cutting down timber
 10/6 each 1 1 —
 Venus and Silenus ——— 10 6
 small Sketch ——— 2 6
June 9 Barnett Market place — 1 1 —
 Dutchman sleeping wife kissing 5 —
 Politicians smoking 3
Sept 3. View in the Isle of Wight ——— 10 6
 To Tower Stairs Boats &c 1 5 —
 14 To going to a Fair ——— 1 5 —
 To 3 Venus ——— 1 1
 1 Do ——— 10 —
 small Drawing ——— 5
Dec. 14. Drawing Venus ——— 1 11 6

 9 1 6

Reputation

Of the innumerable artists active in Britain in the latter part of the eighteenth century and the first quarter of the nineteenth—and there were many more competent practitioners in all the arts than historians would have us believe—Rowlandson must surely have been one of the most popular and the most widely known. He was enormously prolific and his appeal was general. Not for him the intellectualizing precepts of Reynolds, the high seriousness of Constable, or the mysticism of Blake: his genius was unmistakably for the comedy of everyday life, and by and large he sensibly kept firmly within this range of common experience.

He was never rich, and claimed that he had 'little sway . . . with the long pursed gentry',[1] but nonetheless he attracted aristocratic, and even royal, patrons as well as devotees who became personal friends. The Prince of Wales seems to have bought the *English* and *French Reviews* (Plates 49 and 50) prior to the Academy of 1786 since apparently they were spoken of as already 'carefully framed for the Royal collection', and he certainly acquired other drawings from Colnaghi's in later years;[2] Lord Grosvenor possessed Rowlandson's drawing of Lunardi's balloon, and five of his female portraits, all of which were sold in 1802;[3] the Dukes of Gordon and Hamilton owned groups of drawings, now in the Mellon collection and at Brodick respectively;[4] Byron is said to have commissioned four drawings illustrating the sports of England for the decoration of a screen;[5] and Sir James Lake, the friend and patron of J. T. Smith, purchased the series known as *Mathew Bramble's Trip to Bath*.[6] Turning to Rowlandson's own circle, Henry Angelo built up an extensive collection, which later, for financial reasons, he disposed of to their mutual friend Jack Bannister;[7] and Matthew Michell owned over five hundred and fifty examples, including the finest of his Dutch and Flemish topographical views.[8] Among the principal buyers at the Michell sale in 1819 were Jackson, possibly the portrait painter of that name who made a lively sketch of Rowlandson (Figure 10), and Francis Rimbault, the musician, part of whose account with the artist for 1822 happens to survive (Figure 1). Rowlandson seems to have been able to charge three guineas even for a fairly slight drawing in the mid-1780s,[9] but his prices in 1822, when his reputation must have been declining somewhat, ranged chiefly from half a guinea to twenty-five shillings. Few of Michell's fine drawings fetched more than three pounds in 1819, the important exceptions being the magnificent *Stadthouse of Amsterdam* and *Place de Mer at Antwerp* (Plate 91), which realized six and a half guineas and nine pounds respectively; and the prices at the Rowlandson sale in 1828 ranged generally from a few shillings to a pound or two.[10] But in Rowlandson's heyday the fashionable print-selling firms of Rudolph Ackermann and S. W. Fores had huge stocks of his drawings continually available, and Ackermann was largely responsible for the output of fine illustrated books such as *The Microcosm of London, The Three Tours of Doctor Syntax* and *The*

English Dance of Death, which sustained Rowlandson's fame beyond the confines of the capital long after the laughter caused by his necessarily ephemeral political prints had died away. Doctor Syntax, indeed, passed into folk-lore. Figurines were produced at the Derby porcelain factory, and Syntax souvenirs were sold in the shops.[11] He was undoubtedly Rowlandson's greatest hit.

Yet no one ventured to collect material for a biography. Perhaps, as Osbert Sitwell observed, he was one of those artists too busy to have much time for an eventful life.[12] Perhaps again, as Paul Oppé has it, so long as the facts of Rowlandson's life were readily ascertainable they were either too well-known or too little worth knowing.[13] Nor—though the two letters which are all that survive from his correspondence display lively enough touches—does he seem to have been a wit with the sparkle and originality of Gainsborough or of his friend Bannister, whose *bon mots* might be collected and avidly retailed. Even the gossip-writers, such as Angelo and Pyne, who knew him so well, record precious little, what they do say being doubly valuable from the scarcity of other information.

Forty years after his death he was unknown. A Birmingham collector, William Bates, wrote in 1869 that 'even among artists and professed "picture-men", few in London, none out, have ever heard of his name; and it is only by introducing him as the inventor of "Dr. Syntax" that you gain him a *locus standi* in the court of art criticism. I have seen artists stand astounded before the talent of his works, and marvel at their own utter ignorance of one whose genius and powers were so consummately great.'[14] Of course, the point here is that it was not only the man but his works, that whole gargantuan output of prints and watercolours, so popular in their day, that had faded with such astonishing rapidity from the collective memory. This is a fact that requires explanation, though the explanation will perhaps seem obvious.

For a large part of the answer can be found quite simply, by turning the pages of one of the earliest volumes of *Punch*, a periodical which first appeared in 1841, little more than a decade after Rowlandson's death. Both the situations and the humour are poles apart from Rowlandson's. Restraint, decorum and gentility are the keynotes; and these changes reflect a profound shift in taste and morality, associated with the effects of the Reform Act of 1832, the growing industrialization of Britain, the Evangelical conscience and other factors all of which are symbolized for us by the single word 'Victorian'. The ribaldry, gusto, high and doubtful living of the apparently carefree later Georgians was alien to the Victorian ethic; the pen that sought to describe human life in all its animal normality was repugnant to the Victorian sense of propriety. As late as 1891 F. G. Stephens wrote that it was 'much against Rowlandson's popularity with the British Matron and Mrs. Grundy that a very large number of his productions exhibit features which were questionable in his day, and are quite out of the question now.'[15] But Rowlandson even at his least bawdy, in the hunting scenes, the country idylls or plain topographical views, also found little favour.

Not till the seventies were there signs of any reversal of this trend, though interest had been aroused by the appearance of the *English* and *French Reviews* at the International Exhibition of 1862, to which they had been lent by Queen Victoria. By the seventies, however, several collectors were actively in pursuit of Rowlandson: Thomas Capron, Colonel Gould Weston, William Bates and, above all, Joseph

Grego, whose book on the artist's prints, an important but somewhat indigestible compendium, was published in 1880.

Nothing else of any significance was published on Rowlandson until Paul Oppé's book of 1923. But by then impressive collections of his work had been formed by Desmond Coke, Louis Deglatigny, Henry Harris, Dyson Perrins, Sidney L. Phipson and others; and Rowlandson grew steadily in popularity thereafter. In parenthesis, it is interesting to observe that, probably owing partly to the seemingly inexhaustible supply of his drawings, many Rowlandson collectors are devotees solely of Rowlandson; though this is by no means true of the leading Rowlandson collector of recent years, Gilbert Davis, nor of Duke, Oppé, Reitlinger, J. Leslie Wright or Sir Bruce Ingram. The first full-length biography was attempted by Bernard Falk in 1949, and a number of serious studies, more limited in their scope but more scholarly in their approach, have begun to appear, notably by Robert Wark, curator of the Henry E. Huntington Art Gallery, San Marino, California, whose holdings of Rowlandson are now almost unrivalled. After nearly two hundred years, Rowlandson's reputation stands as high as it ever did in his lifetime, both as draughtsman and social commentator, so that it is perhaps a good moment to stand back and try to put together, in a short essay, all the information that is available to us now about the man and his drawings. It is very much to be hoped that this attempt will stimulate fresh research into aspects of Rowlandson as yet inadequately charted.

Life

Thomas Rowlandson was the son of William Rowlandson, a wool and silk merchant with adventurous ideas about the development of his business who had moved from Old Artillery Lane, Spitalfields to a rather smarter address in Old Jewry only a little while before his son's birth.[16] Hardly anything is known about William except that his speculative temperament soon brought financial disaster, for in January 1759 he was declared a bankrupt; his fortunes seem never to have recovered, as he still owed money to his sister-in-law in 1783. Of Rowlandson's mother nothing at all is known, not even her Christian name.

There is still some dispute as to the precise year in which Rowlandson was born. Until the examination of the Students' Register of the Royal Academy Schools[17] the date of July 1756 given in the obituary in *The Gentleman's Magazine* had been accepted as correct. Now the date of 14 July 1757 provided by this new evidence has been questioned on the grounds that the relevant part of the Students' Register (the years 1769–73 inclusive) was filled in *en bloc* at a later period.[18] Presumably it was compiled from first-hand evidence, and to suspect it of error (while justified in the strictest sense) might seem to carry scepticism to a point where almost any historical evidence would be inadmissible. But in fact this scepticism is fully justified, a vital piece of evidence hitherto overlooked being provided by Harlow's portrait of Rowlandson (Figure 9), which seems to have been presented to the artist and is inscribed in the latter's hand: 'Tho.ˢ Rowlandson Aged 58. 1814.' This rules out a birthdate of 1757 and corroborates *The Gentleman's Magazine* obituarist.

Rowlandson had no brothers, but he had a younger sister, Elizabeth, who later married the sporting artist Samuel Howitt. When their father fell on hard times, the youngsters were cared for and educated by their uncle, James, a prosperous Spital-

fields silk weaver, and his wife, Jane, who had no children of their own. James Rowlandson died in 1764, and his wife then decided to sell the business and moved to Soho, where she rented apartments at 4 Church (now Romilly) Street, Thomas being sent to school at Dr Barwis's highly respected establishment in Soho Square.

The usual stories associated with artists are current of Rowlandson having covered the margins of his school-books with drawings at a tender age, but the first actual evidence of his artistic inclinations is his admission to the Royal Academy Schools on 6 November 1772, at the age of sixteen. Among his fellow students was John Bannister, later one of the greatest actors of his age, who joined the Schools in March 1777 and was to become his intimate and lifelong friend. Both were of a high-spirited and prankish disposition, and Henry Angelo, another of Rowlandson's oldest friends, tells us that Wilson, who was Librarian at the Academy from 1776 to 1781, kept a watchful eye on them: Rowlandson 'once gave great offence, by carrying a pea-shooter into the life academy, and, whilst old Moser was adjusting the female model, and had just directed her contour, Rowlandson let fly a pea, which making her start, she threw herself entirely out of position, and interrupted the gravity of the study for the whole evening. For this offence, Master Rowlandson went near to getting himself expelled.'[19] Whether the story is true or not, or could possibly refer to Rowlandson at the age of twenty or more, it clearly reflects an essential truth, for the boyish side of Rowlandson's character can be deduced from other evidence.

Rowlandson made a sketch of some of his contemporaries, including Beechey and the younger Grignion, at work in an Academy drawing class in 1776 (Figure 16), and this is his earliest surviving dated drawing. His first exhibit at the Academy had been made the previous year, 1775; this was a drawing of a biblical subject described in the catalogue as *Dalilah payeth Sampson a visit while in prison at Gaza*, the only subject of a conventional historical nature he is recorded as having attempted and most unfortunately no longer extant. In 1775 he was still living with his aunt in Church Street, Soho. But by the time of his next Academy exhibit, a drawing of an unspeci-fied subject submitted in 1777, he had moved to 103 Wardour Street and was pre-sumably living on his own: the old housekeeper who looked after him there appears in several of his drawings for *A Tour in a Post Chaise* (Figure 2). It was also in 1777, the last but one of his years as a student, that he received the silver medal of the Academy: his merits were not only recognized, but generally recognized, as he was awarded the medal by 23 votes to 1.

Sometime during his student years he went to Paris, a natural and common enough practice among English artists and students of any period, but particularly important for a young man in the mid to late eighteenth century, as there was then a considerable interchange of artistic ideas between the two capitals. The obituary in *The Gentleman's Magazine* states that he went there in about 1772–3, after being admitted to the Academy Schools, and stayed there nearly two years: 'In his six-teenth year he was sent to Paris, and was entered a student in one of the drawing academies there, where he made rapid advances in the study of the human figure. . . . On his return to London, he resumed his studies at the Royal Academy.' Grego embroidered on this statement by suggesting that Rowlandson's aunt lived in Paris and invited him over.[20] Rowlandson's aunt was indeed of French extraction, though both the 1827 obituarist and therefore Grego give her maiden name as Chattelier (which was in fact her younger sister's married name) instead of the correct Chevalier

—but, as we have seen, she did not live in Paris. It is likely, of course, that she had relatives or friends in Paris who could have looked after her nephew, but that is a different matter. Angelo, who was in Paris from 1773 to 1775, gives us more precise information, stating that 'during my residence there, Rowlandson came over, in company with an Englishman of the name of Higginson, whom he got acquainted with at Dover. . . . Their arrival at Paris was immediately after the death of Louis the Fifteenth, at the moment of the putting on of public mourning. . . . I had many of the drawings made by my friend *Rolly*, at this time.'[21] In another place, he refers to his acquaintance with Rowlandson as having begun in Paris, when the latter was 'studying in the French school'.[22] Angelo's evidence sets Rowlandson's coming to Paris as July 1774.

Now, since the requisites for remaining on the books at the Academy Schools were not exacting—the production of three drawings or models a year, to be precise—there is no reason to reject out of hand the statement that Rowlandson went to study in Paris for a prolonged period while he was still enrolled as a student at the Royal Academy. The date of his going to France varies slightly as between the obituarist and Angelo, but Angelo's is not only more circumstantial but more plausible in that it falls eighteen months after Rowlandson's entering the Academy Schools rather than at the beginning of his studies there. Rowlandson had been brought up in French quarters of London by an aunt who came of a French family, he spoke fluent French (probably from an early age), and his style as it eventually developed in the 1780s had a French facility and technical ease, and French sophistication, elegance and delicacy; so that at first sight there seems to be a strong case for accepting the view that he studied in Paris. On the other hand, there is no documentary evidence of his having entered a French drawing school, as the obituarist claims,[23] while with regard to the matter of style the character of his drawing in 1776 was totally English (could it have reverted so easily after two years in a French drawing academy?), and he was in Paris at least twice during the 1780s. Considerably more evidence is needed

2. Rowlandson:
Rowlandson at Dinner.
From *A Tour in a
Post Chaise*, 1784.
Pen and watercolour
over pencil, $5 \times 7\frac{13}{16}$ in.
(127 × 198 mm.).
San Marino,
California, Henry E.
Huntington Library
and Art Gallery

than is available to us now finally to settle whether Rowlandson actually studied in Paris or whether he was only there for a comparatively short stay in the summer of 1774 to become conversant with French style (adequate justification for Angelo's phrase 'studying in the French school').

Rowlandson was on the Continent again in the early 1780s, and seems to have visited Italy as well as France. A drawing unquestionably from Rowlandson's later period nevertheless bears the genuine inscription in vermilion: 'Sketch'd at Rome 1782' (Figure 3), and must presumably have been based on a sketch of that date, probably largely of the figures, since the architecture is Roman only in general character. Whatever the explanation, however, it is difficult to discredit the evidence, hitherto overlooked, that Rowlandson was in Rome in 1782. A somewhat similar drawing of a Venetian scene, again fanciful in its topography, survives also, though this is neither inscribed nor dated; this subject may or may not have been derived from sketches or memories of his own. [24] It is possible that Rowlandson travelled outwards in 1781, since there is some evidence for supposing that he visited the Paris Salon of 1781;[25] his famous drawing of the Place des Victoires in Paris (Plate 13) dates from 1783 (there is another version of 1784), so he may have returned from Italy via Paris, too, but he was clearly in England by the spring, since he exhibited four drawings, including the *Place des Victoires*, at the Society of Artists in April.

Angelo has an attractive story, which sounds convincing enough, of a summer visit organized at this period, prior to the French Revolution, by J. R. Smith: 'a party having been made between him, Rowlandson, Westmacott (father of the present eminent artist), and Chasemore (who, in a delirium, shot himself at Bath), to go to Paris, a large party were previously invited—Peter Pindar (Doctor Wolcott), Morland, Rowlandson, myself, &c.—to finish what Burgundy was left in his house, as

3. Rowlandson: *View in Rome.* About 1800–10. Signed and inscribed. Pen and watercolour over pencil, $8\frac{1}{8} \times 11\frac{1}{8}$ in. (206 × 283 mm.). Oxford, Ashmolean Museum

Please your Honours Remember your Post Boy

a *prendre congé*. This was in the month of July. . . .'[26] Possibly the year was 1785, since there is a watercolour of people on board ship, some of them certainly portraits, which he did that year and described as 'Sketch'd on board the Europa'.[27] On the other hand, it could have been 1786, as we know that Rowlandson was in Paris again then from his inscription on a drawing in the Mellon collection: 'Figures Sketch'd from a Window at Paris 1786'; or even the following year, since he signed a view of Samer, near Boulogne, as 'Drawn on the Spot in 1787' (Plate 42).

There is no need to be conjectural, however, about a trip which Rowlandson made in the company of his friend Henry Wigstead during the autumn of 1784, since the principal stages of this journey can be established from the evidence of drawings.[28] A post-chaise was hired for twelve days, and the tour embraced Salisbury, Southampton, Lymington, Cowes and Portsmouth, with Rowlandson sketching all the way. The two men made subsequent trips of a similar nature, one to Brighton in 1789 and another to Wales in 1797; on both these occasions Wigstead provided a commentary to accompany Rowlandson's drawings, and the two were published together. Such may have been the intention on the earlier tour, and the location of Wigstead's journal of the trip would be a happy discovery. Wigstead was himself a caricaturist, but evidently an amateur; he was comfortably off, and a person of some standing (he was appointed J.P. for Kensington two years before his death in 1800).[29] For much of his life he lived quite near Rowlandson in Soho, and was probably a family friend, since he was one of the executors of his aunt's will. He had a reputation for hospitality and generosity,[30] and he certainly emerges from Rowlandson's drawings of 1784 as a genial and good-natured person, perhaps about ten years older than the artist (Figure 4). Rowlandson himself appears as a handsome and healthy young man with a roving eye as well as pen.

From 1778 to 1781 Rowlandson's exhibits at the Academy had been chiefly small watercolour portraits, in which he may have specialized at this time. But in 1784 he

contributed two of his most famous genre subjects, *Vauxhall Gardens* (Plate 16) and *The Serpentine River*; and, taking into account the splendid drawings for *A Tour in a Post Chaise*, this must surely be counted the *annus mirabilis* of his career as a draughtsman. It was also the year when Rowlandson came to the fore as a political caricaturist, working chiefly for Humphrey and Fores, and taking full advantage of the events of the notorious Westminster Election.

In or just before 1787 Rowlandson moved to 50 Poland Street, and we know that at this address he was being looked after by his aunt's servant, Mary Chateauvert.[31] It was while he was living there that he was attacked in the street one night by a footpad, no uncommon occurrence in the London of that time. The following day he tried to identify his assailant with the aid of a thief-taker, but failed in his quest. He did, however, identify one ruffian, who was duly hanged—much to Rowlandson's satisfaction: 'for, though I got knocked down, and lost my watch and money, and did not find the thief, I have been the means of hanging *one* man. Come, that's doing something.'[32] There was nothing squeamish or soft about Rowlandson, as other anecdotes amply confirm.

In April 1789 his aunt died and left him a substantial legacy: not only two hundred pounds in cash and another twelve hundred pounds in securities, but also the entire contents of her apartments (with the exception of her clothes).[33] According to *The Gentleman's Magazine* obituarist, who exaggerated the legacy to seven thousand pounds, Rowlandson 'then indulged his predilection for a joyous life . . . was known in London at many of the fashionable gaming houses, alternatively won and lost without emotion . . . frequently played throughout a night and the next day'. Nevertheless, 'he was scrupulously upright in all his pecuniary transactions, and ever avoided getting into debt.' No doubt his father's bankruptcy stood before him as a frightening example, and he knew he could redeem himself through hard work. 'I have played the fool; but', holding up his pencils, 'here is my resource.'

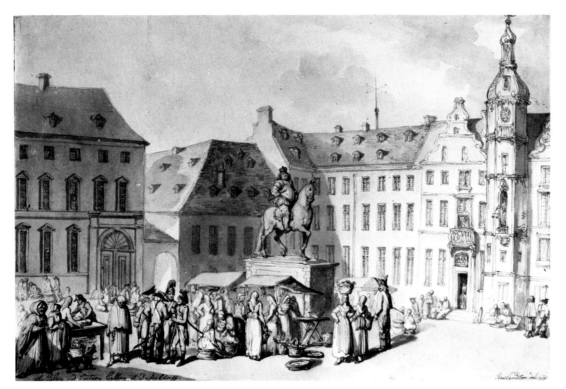

5. Rowlandson: *The Market Place and Town Hall at Düsseldorf.* Signed and dated 1791, and inscribed. Rowlandson must have muddled his drawings of Düsseldorf when he worked them up, because he has put the wrong inscription on this watercolour. Possibly he was misled by the equestrian statue of the Elector Johann Wilhelm. Pen and watercolour over pencil, 10¾ × 16½ in. (273 × 419 mm.). Düsseldorf, Stadtgeschichtliches Museum

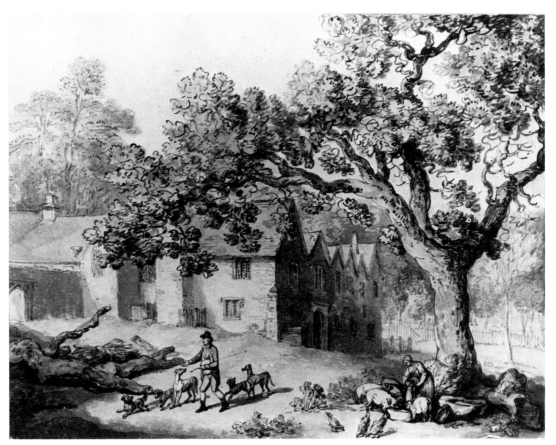

6. Rowlandson:
Hengar House, Matthew Michell's Country Home near Bodmin, Cornwall. About 1795. Pen and watercolour over pencil. Formerly London, Frank T. Sabin

There may be some substance in the story that Rowlandson dissipated his fortune at this time: witness his drawing of the celebrated Crockford which he inscribed, somewhat caustically, *Crockford the Shark Keeper of Hell Gaming House Piccadilly*.[34] He was clearly addicted to gambling, and he described himself as being poor in a letter of 1804 (though admittedly this was fifteen years later).[35] He also moved house several times during this period, always to modest if not positively shabby premises. In 1792 he went to 52 Strand; and from 1793–5 he occupied the basement of 2 Robert Street, Adelphi. For a time, probably in the late 1790s, he had rooms adjoining Morland, who can hardly have been a sobering influence, on the second floor above Mrs Lay's print-shop near Carlton House. His last move was in 1800, to the attic of 1 James Street, Adelphi, where he lived for the rest of his life.[36]

What has not been taken into account, however, in interpreting these changes of address is the fact that Rowlandson made several, possibly protracted, visits to the Continent in the decade following his aunt's death and before he settled in James Street. A drawing of Cologne is dated 1789, and one of Bois le Duc, near Paris, 1790. Drawings of a Dutch packet and a German post house, of The Hague, Düsseldorf (Figure 5) and Juliers in Westphalia are dated 1791. A drawing of Amsterdam is dated 1792, and the subject inscribed as having been sketched that year (Plate 89). A drawing of a head waiter in an Amsterdam restaurant is dated 1793. His important drawing of the Place de Mer, Antwerp is dated 1794 (Plate 91). And a drawing of posting in Germany is dated 1799. Possibly not all these dates are to be trusted, but the internal evidence favours trips at any rate in 1791 and 1792. Further, we are told by Angelo that his views of the Place de Mer, Antwerp and of the Stadhuis, Amsterdam, the former dated 1794, were executed when he was on a tour in Holland with Matthew Michell, the banker.[37]

Michell, a portly *bon viveur* with an apparently insatiable appetite for Rowland-son's drawings, was one of the artist's closest friends from the 1790s until 1819, when he died, and gradually took the place in Rowlandson's affections that Wigstead had held prior to his death in 1800: indeed, in his good-humoured attitude towards life and in other ways he must have resembled Wigstead quite closely. Michell divided his time between his residence in the Strand, a house a few miles north of London—at Enfield—and his country estate, Hengar in Cornwall (Figure 6); not only was he rich but enormously hospitable, 'a good-natured and liberal man', as J. T. Smith called him,[38] and Rowlandson was a frequent and welcome visitor at all three houses. Angelo recalls convivial evenings in Beaufort Buildings with Rowland-son 'having nearly accomplished his twelfth glass of punch, and replenishing his pipe with choice *Oronooko*;'[39] the Cornish etchings of 1812, and countless drawings of the Cornish countryside which are among Rowlandson's most lyrical works, were the fruits of holidays with Michell at Hengar House, near Bodmin; and Pyne gives us a delightful and very circumstantial glimpse of Michell chatting with Caleb White-foord, the fashionable wine merchant, wit and man-about-town, after climbing up to see Rowlandson in his attic and enticing his friend to return to Grove House, Enfield, with him: 'Roly has promised to come down—I would have taken the rogue with me, only that he is about some new scheme for his old friend Ackermann there, and he says he must complete it within an hour. You know Roly's expedition, and so he will come down by the stage.'[40]

This flash of Rowlandson as he lived and worked is enormously revealing; and

7. John Bannister (1760–1836): *Portrait of Thomas Rowlandson*. Dated 4 June 1795. Coloured print. London, British Museum

8. John Raphael Smith (1752–1812): *Portrait of Thomas Rowlandson*. About 1795. Pencil, black chalk and grey wash, $11 \times 8\frac{1}{8}$ in. (279 × 206 mm.). London, British Museum

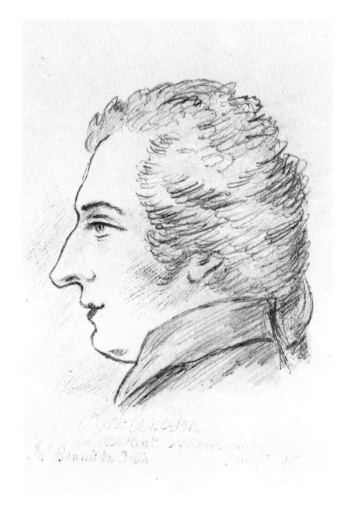

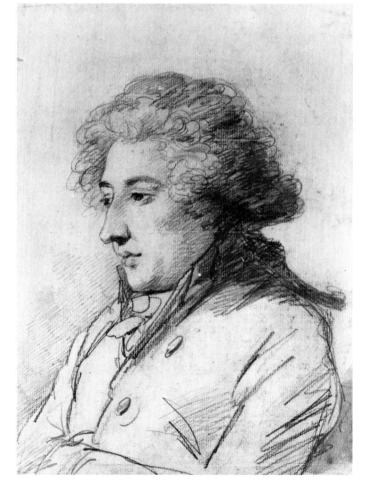

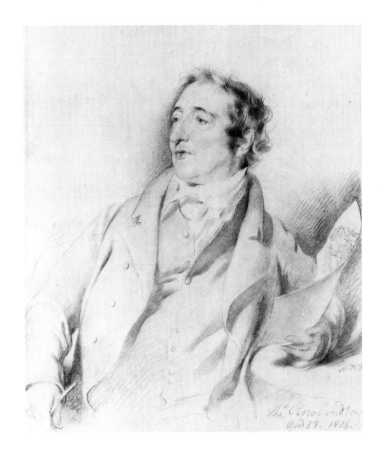

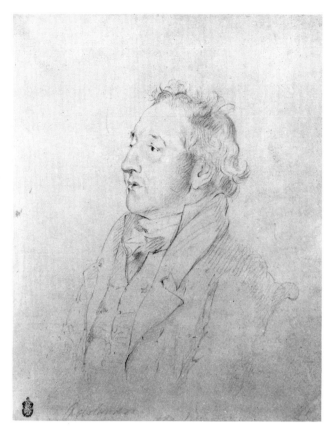

9. George Henry Harlow (1787–1819): *Portrait of Thomas Rowlandson*. Signed. Dated 1814 and inscribed (by Rowlandson). Pencil and chalk, 9¼ × 7¾ in. (235 × 197 mm.). London, National Portrait Gallery

10. John Jackson (1778–1831): *Portrait of Thomas Rowlandson*. About 1815. Pencil, 9½ × 7½ in. (241 × 191 mm.). London, National Portrait Gallery

there are a number of other scraps of evidence of different kinds, some of which happen to date from the mid-1790s, which help to round out our somewhat limited knowledge of Rowlandson's character and daily life.

First we must take the portraits that were made of him. There is a profile by Jack Bannister dated 4 June 1795, when Rowlandson was nearly 39 (Figure 7); a sketch by J. R. Smith which dates from very much the same time (Figure 8); the rather romanticized half-length by Harlow dating from 1814, where Rowlandson has noted his age as being 58 (Figure 9); a pencil study by John Jackson which is a more credible likeness of Rowlandson at about the same age (Figure 10); and J. T. Smith's drawing of him working in the print room of the British Museum, inscribed 15 June 1824, when the artist was just on 68 (Figure 11). All show a strong well-built man, alert and enquiring. In the Jackson portrait there are signs of age in the thinning hair (a feature rather glossed over by Harlow), while Smith shows him balding on top, bespectacled and perhaps a little stiff in the joints. But to judge by this latter portrait he must have retained most of his robust constitution until the onset of his last illness in 1825.

His character and outlook on life reflected his normal good health. He was well-balanced, though inclined to the normal excesses of the period, hard drinking, gambling and promiscuity; good-mannered, sociable, on the whole mild-tempered and lacking in indignation, ready enough to accept life as it was, not taking anything too seriously; somewhat contemptuous of the weak, and insensitive to human suffering and infirmities, at any rate when he was not personally involved. This last trait is illustrated by Angelo's description of a visit to Portsmouth in 1794 to see the return of the British fleet with its prizes after Lord Howe's defeat of the French in the Channel on the glorious First of June. In one of the sick-bays a Frenchman, mortally

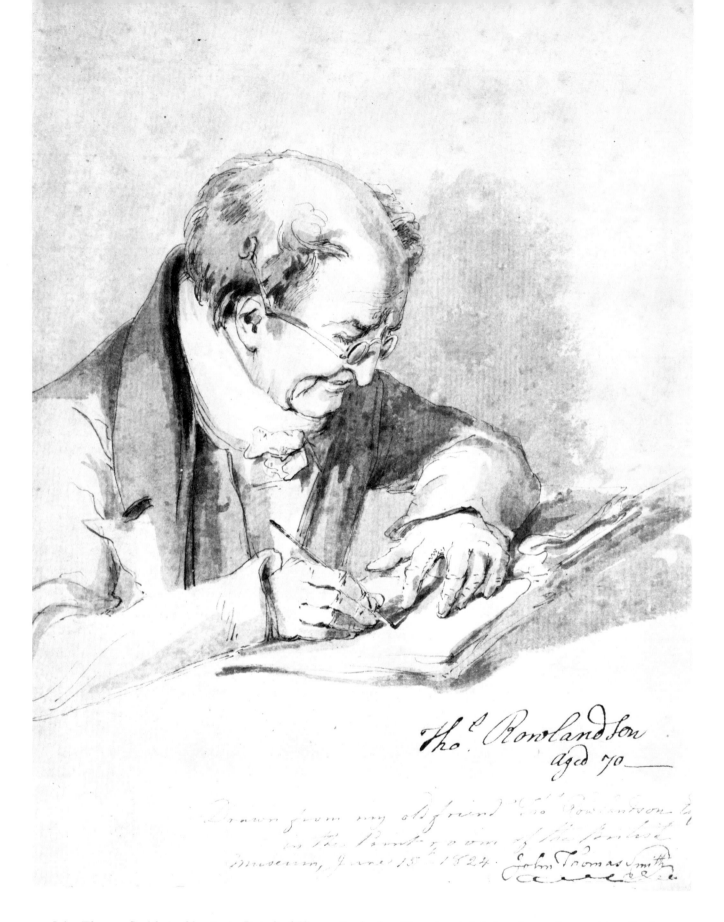

Tho.^s Rowlandson aged 70

11. John Thomas Smith (1766–1833): *Portrait of Thomas Rowlandson.* Signed and dated 15 June 1824, and inscribed. Also inscribed by Rowlandson, who gives his age as 70: this statement cannot be reconciled with any other evidence about Rowlandson's age and seems to be an error, possibly made at a later date when Rowlandson *was* 70. Pen and wash, 9⅜ × 7⅛ in. (238 × 181 mm.). New York, Metropolitan Museum of Art

wounded, 'was then making his will; his comrades were standing by, consoling him, some grasping his hand, shedding tears. This scene was too much for me, and made such an impression on my mind that I hastened away; but I could not persuade Rowlandson to follow me, his inclination to make a sketch of the dying moment getting the better of his feelings'.[41]

Only the most occasional glimpses of Rowlandson's social life seem to have survived, though naturally much is to be deduced from the drawings and prints. There are the gambling sessions and convivial evenings at Michell's already noted, the trips to the country, the visits to Enfield and Cornwall. Farington records Rowlandson and Wigstead at the dinner for the Westminster Election in June 1796, when 'Wigstead brought with him some impressions of a caricature print, which He has designed, Fox's Head off, & the Devil hawling Tooke, Thelwall, & Hardy, into Hell.'[42] Angelo tells us that for many years he 'always kept Good Friday at some little distance from town; my companions usually were Bannister, James Heath, and Rowlandson,'[43] and that he, Bannister and Rowlandson 'for years were constant companions' in walks near London, Greenwich being Rowlandson's favourite resort: there is a specific account of one of these occasions, when Laurie, the printseller, was of the party, and they boarded the Albion East Indiaman at Blackwall.[44] He also records a party given by Louis Weltjé, the wealthy chef, at his house in Hammersmith Mall, when Rowlandson was present.[45] Pyne notes that Rowlandson was a frequenter of Greenwood's candlelight auctions, in the company of Bannister and Michell;[46] and J. T. Smith records that he 'frequently made drawings of Hutchins and his print auctions'.[47] He is also described as being a crony of Gillray's,[48] which seems likely enough, as the two are known to have combined their efforts in the case of certain political prints; and he was no doubt acquainted with many of his fellow artists, though evidence is lacking save in the cases of Farington, Jackson, Morland, the Smiths, Isaac Cruikshank and the caricaturists with whom he collaborated, Nixon, Woodward and others.

One of the main reasons why it is difficult to find out much about Rowlandson's life is the almost complete lack of correspondence, either to or from the artist. Twenty years ago the only letter known was Rowlandson's note to James Heath, the engraver, dated 1 March 1804: this refers, in a parenthesis, to the poor state of his finances and his inability to secure the patronage of 'the long pursed gentry', but gives us no other more personal information. A second letter, of a more interesting nature from the biographical point of view, has since come to light and is reproduced here in full (Figure 12). This was written on a visit to Mrs Michell at Grove House the year after her husband's death, and is addressed to some mutual friends, the Landons, amateur artists, then at St Neots: 'we are pleased to find you are in a Picturesque country and that Mr L has resumed the pleasures of the Pencil,' he writes. The letter shows Rowlandson in the pleasant light of a solicitous family friend, chatting about Mrs Michell's state of health and the comings and goings at Grove House; and his obvious enjoyment of the pleasantries of ordinary middle-class social life is a useful corrective to the view of Rowlandson which divides him into the furiously active draughtsman and the drunken gamester, allowing for nothing in between.

Rowlandson is supposed to have been lazy about finding fresh means of employment, and though this is somewhat hard to believe, it is true that much of his professional activity in the second half of his career was stimulated by the energy and

Mrs Landon

Grove House Nov.r 16. 1820

Dear Madam

At the request of Mr.s Michell
I have undertaken the Office of Secretary. and you
will soon perceive one less qualified for that Station
never held a Pen —— She returns you many
thanks for transmitting so kind and pleasant a
description of your pursuits. and the reestablishment
of health in the rest of your Family ——

The Loss of the society of the Lively Miss Fanny
Wallis is very great. which however is soon to be
filled up by a Visit from her eldest Sister
Miss Julia, who is a most amiable tempered young
Lady rather more sedate —— Grove house has been
enlivened by a Visit from a Sprightly Widow of Seventy
two Years of age who has buried Three Husbands without
being much the worse for wear. her memory as also all the

12. Letter from Thomas Rowlandson to Mrs Landon, Grove House, dated 16 November 1820. San Marino, California, Henry E. Huntington Library and Art Gallery

24

rest of her faculties remaining in full blossom —

it seems she has treasured up bags of anecdotes of her former Lovers and the pranks she played them — which has caused great Laughter and has greatly kept up the spirits of Mrs M. — and have the satisfaction to acquaint you the violent and acute pains in her head have greatly abated. but have left her in a very weak state. but hope with careful nursing through the Winter she will recover her health and enjoy the society of her Friends the ensuing spring — Miss Wallis often regretted the disapointment of not being able to accompany you & Mr Landon in your Sketching parties. — we are pleased to find your are in a Picturesque country and that Mr L has resumed the pleasures of the Pencil. Mrs Mr looks forward with pleasure and expectation to welcome you as her Guests I beg leave to join also and hope I may have the good Fortune once more to meet and shake hands with you both with Sincere wishes remain Your Obedient Hble Ser

Thos Rowlandson

P.S. am sorry the Caprice of the Cognoscenti was so pitiful last spring that there was no power of turning the Picture by Zoffany into Cash

enterprise of one man, the publisher Rudolph Ackermann. Ackermann first employed Rowlandson in 1798, and their earliest major production was the *Loyal Volunteers of London*, which came out in 1799. Of the stream of publications that followed the most important were *The Microcosm of London*, 1808–10, for which Augustus Pugin was brought in to co-operate on the drawings, *The Three Tours of Doctor Syntax*, 1812–21, and *The English Dance of Death*, 1815–16. Rowlandson's last work for Ackermann seems to have been *The History of Johnny Quae Genus*, published in 1822. He also produced numerous individual prints for the same publisher and the quality of even the boldest of these contrasts sharply with the coarse and crudely coloured prints put out by Thomas Tegg, of Cheapside, who used Rowlandson's drawings from 1807 onwards. At this stage in his career, as Martin Hardie so aptly puts it, 'he must have visited the offices of Ackermann or Tegg almost daily, like the leader-writer of a newspaper.'[49] Much of Rowlandson's work in this popular field was concerned, inevitably, with anti-Napoleonic caricature, and it is significant that after 1815 the flow of occasional prints derived from Rowlandson's drawings dwindled to almost nothing. Rowlandson's erotic prints date from the middle and later part of his career, and reflect his healthy animalism and sense of good fun. Some, such as *A Peep into Kensington Gardens*, are witty enough in their invention, but the range is narrow, there are no sophisticated perversities, and most of the prints are fundamentally no different from Rowlandson's other subjects featuring sensual activities—and this is really the point: Rowlandson was the most normal of human beings.

Not much is known about Rowlandson's later life. In common with many other English artists anxious to see the art treasures looted by Napoleon, he seems to have visited Paris in 1814;[50] and five large drawings of classical vases reputed to have been in the Louvre[51] may well have been done then (Figure 58). He probably stayed with the Michells with some frequency, and we know that he was at Grove House in November 1820; he bought several pictures, including a *Toilet of Venus* attributed to Paris Bordone, at the Michell sale, and one of the witnesses to his will, which he made in 1818, was Jonathan Hodsoll, a member of the banking firm of which Michell was a partner. Sometime after 1820 he was in Italy, making careful studies from the antique,[52] and in 1822 he was engaged on a study of comparative anatomy;[53] these occupations may have absorbed a good deal of his time in these last years since, though we know from J. T. Smith's sketch of him in the print room of the British Museum that he was still active as a draughtsman in June 1824, only two works—a study of types of laughter[54] and the line drawing of a *Band* (Figure 13), which are on paper watermarked 1825 and 1826 respectively—survive from after this year.

By the spring of 1825 Rowlandson must have suffered an irremediable breakdown in health, possibly a stroke, since he is described as being severely ill for two years prior to his death in April 1827. The *Gentleman's Magazine* obituarist, who provides us with this information, correctly gives his age as seventy at the time of his death. Rowlandson was buried in the church of St Paul's, Covent Garden, and 'his remains were followed to the grave by the two friends of his youth, Mr. Bannister and Mr. Angelo sen., and by his constant friend and liberal employer, Mr. Ackermann'.[55]

The executrix of Rowlandson's will was Betsey Winter, who had evidently looked after him for some years. In the eyes of many she was clearly regarded as Rowlandson's widow, since she was described as 'Mrs Rowlandson' in the auctioneers' copy of the catalogue of the Rowlandson sale held in June 1828, and as 'Elizabeth Rowlandson'

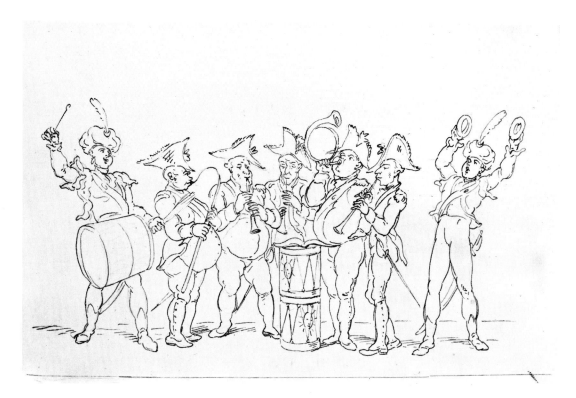

13. Rowlandson: *The Band*. Watermarked 1826. Pen over pencil, $4\frac{1}{2} \times 7$ in. (114×178 mm.). San Marino, California, Henry E. Huntington Library and Art Gallery

in the rate-books for 1 James Street, where she continued to live until 1829. There is no doubt that she thought so herself, for as Betsey Rowlandson she died, at the age of fifty-eight, in 1835. But, though she was Rowlandson's companion, and no doubt nurse in his last years, and the sole legatee of his will, which was valued for probate at the respectable sum of 'under' three thousand pounds, she was not his legal wife. Rowlandson never married, nor had children of whom there is record; and these are the two facts about him most difficult to reconcile with one's understanding of his character and outlook on life.

Style

As we have seen, Rowlandson was an art student in the seventies: he was on the books of the Academy Schools from 1772 till 1778. What was happening in the London art world during those impressionable years when he was learning his craft? To whom would he have looked for inspiration and artistic guidance? The previous decade had been a period of revolutionary change in British painting: Hogarth, who had dominated the scene for over thirty years, died in 1764; the academic and neo-classical ideals represented by Reynolds, Gavin Hamilton and West had firmly replaced the rococo; Wilson was at the head of landscape painting; and Joseph Wright had painted his greatest genre subjects, the *Orrery* and the *Air Pump*, those magisterial studies of human endeavour and human wonderment reflecting the first expectancies of the scientific and industrial revolutions. But it was also the moment when art was beginning to be touched by the stirrings of early romantic literature and by the Shakespeare revival: one may recall Runciman's *King Lear in the Storm*, and the fact that the young Fuseli chose to spend six years in London, from 1764 till 1770. By the early 1770s Wright was exhibiting pictures as dramatic and macabre as his *Miravan* and the *Old Man and Death*, and Mortimer, that strange and erratic genius, was be-

ginning to explore the whole gamut of romantic subject-matter. Obviously it would be foolish to discount the immense influence of Reynolds or to disregard such other champions of the grand manner as Barry, who was to become Professor of Painting at the Academy in 1782, but nevertheless it was Mortimer who proved to be the seminal figure of the seventies: no doubt it was his magnetic and daredevil personality as much as his energy and talents and the restlessness of his imagination that contributed to his hold over the younger generation. His work in oils may often be unimpressive, causing us to wonder sometimes what all the fuss was about; but he was a brilliant draughtsman, and his influence on Rowlandson was clearly considerable.

Rowlandson's early style, which was dominated by Mortimer, is known to us from only a handful of drawings; and of all his lost works the one which art historians would most dearly love to recover is his first Academy exhibit, the *Samson and Delilah* of 1775. Is it chance that Mortimer had already essayed this precise subject, in a drawing of

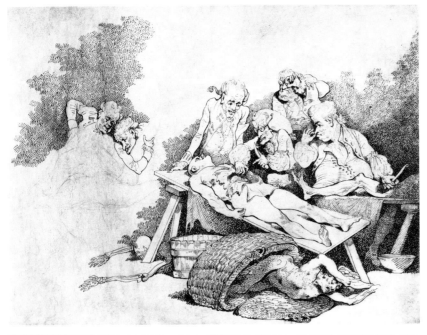

14. Rowlandson: *The Dissection*. About 1775–80. Unfinished. Pen over pencil, 14 × 19 in. (356 × 483 mm.). San Marino, California, Henry E. Huntington Library and Art Gallery

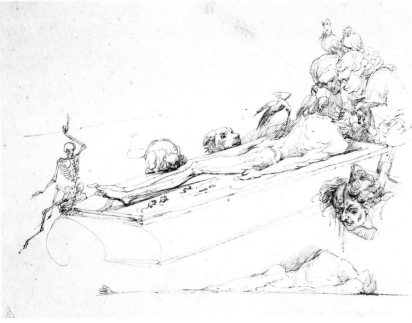

15. John Hamilton Mortimer (1740–79): *Doctors Dissecting*. About 1770–9. Pen, 8¼ × 10½ in. (210 × 267 mm.). New Haven, Connecticut, Yale Medical Library (Fry Print Collection)

about 1770 now in the Ashmolean Museum? In the case of Rowlandson's recently discovered early drawing of a dissection (Figure 14), a subject quite outside his normal range, and for some reason left incomplete, there is no need for conjecture. The strong diagonal composition, the body at the foot of the dissecting table, the skeleton under the table, all suggest that he was aware of Mortimer's drawing, now at Yale (Figure 15). The taut, wiry line, especially evident in the legs of the two corpses under dissection, and certain of the mannerisms characteristic of a drawing intended for engraving—the hatching, the stippling technique, the mesh of zig-zags creating the shadows—undeniably derive from Mortimer. We know that Rowlandson carefully preserved what Mortimer drawings he had been able to acquire, as there were fifty-two in the sale of his possessions; and contemporaries were fully conscious of the close connection between the work of the two artists, the *Gentleman's Magazine* obituarist going so far as to claim that 'his studies from the human figure, at the Royal Academy, were scarcely inferior to those of the justly admired Mortimer.'

However, Rowlandson was no slavish imitator, even as a student. It is interesting that he should even have attempted such a macabre subject, but the differences between his and Mortimer's treatment of a dissection are many and significant. Mortimer stresses less the dissection itself than the innate cruelty and inconsequence which lie behind the process of human dying and decomposition: the concentration of the prosperous surgeons on matters of professional detail, the crows and mice and worms already waiting to prey on the flesh, the crude decapitation of the head beside the table. The detail is gruesome and absorbing, yet the composition has a baroque sweep and inevitability, culminating in the figures of the surgeons on the right. Admittedly, Rowlandson makes some of the same points. The coarse profile of the surgeon turning away from his own job and taking a pinch of snuff as he looks at the progress of his colleagues is disturbing enough. But the other three central figures are already on the way to being typical Rowlandson caricature heads. And though the composition is highly organized—the poses of the limbs on the left, for instance, being carefully arranged to echo those on the right—the thinking is essentially diffuse. One's eye is distracted by the erotic comedy on the left (see Plate 1); and the legs of the central corpse are sinuously drawn, conveying not the least hint of incipient decay. The truth is that Rowlandson had more feeling for individual comic incident than for an artistic or intellectual whole; his larger compositions, complex and skilful though they often are, seem very often to be imposed upon the material rather than a truly organic growth from the nature of the subject-matter.

Another early, unfinished drawing is similarly atypical of Rowlandson's usual run of subject-matter, and similarly contains overtones which suggest derivation from Mortimer. This is the sketch showing a nude figure being dragged along feet first by a couple of Red Indians, with a Red Indian family squatting on the right (Plate 2). The episode would seem to have been prompted by some *banditti* subject of Mortimer's,[56] but again, the treatment is tame as compared with his, and the line (especially in the trees) fluent and rococo, not vigorous and sharply broken, as one might expect in such a subject.

Rowlandson's earliest surviving dated drawing is his sketch of a bench of artists, inscribed as made at the Academy in 1776 (Figure 16). The heads, with the exception of that on the left, which one could match in almost any later Rowlandson, are clearly reasonable likenesses, and the drawing reminds us that most of Rowlandson's

earliest exhibited work was portraiture. The technical mannerisms deriving from Mortimer (Figure 17) are again pronounced, stipple and very regular hatching in the shadows of the heads, similar hatching in some of the legs, the stool, the shades and part of the bench, rough zig-zags for the remaining areas in shadow.

In *The School of Eloquence* (Figure 18), engraved in 1780 but perhaps drawn earlier, the Mortimer mannerisms have become more fully absorbed into Rowlandson's pen technique: can one imagine in Mortimer the rapid scratches and zig-zags which so brilliantly suggest the fall and amplitude of the dress of the central character? Brilliant penwork is of the essence of this fine early drawing, though lapses into undescriptive mannerism do occur, as in the legs of the figure seated second from the right. Compositionally, it builds up into a superb diagonal; yet the groups seem

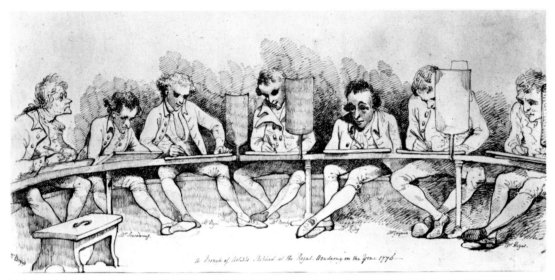

16. Rowlandson: *A Bench of Artists*. Dated 1776 and inscribed. Pen over pencil, 10×21 in. (254× 533 mm.). London, D. L. T. Oppé

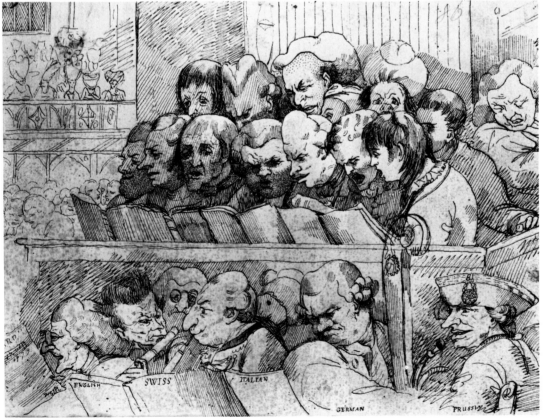

17. John Hamilton Mortimer (1740–79): *Choir and Orchestra*. Dated 1779. Pen, 8¼×11⅛ in. (210× 283 mm.). Windsor Castle (reproduced by gracious permission of Her Majesty The Queen)

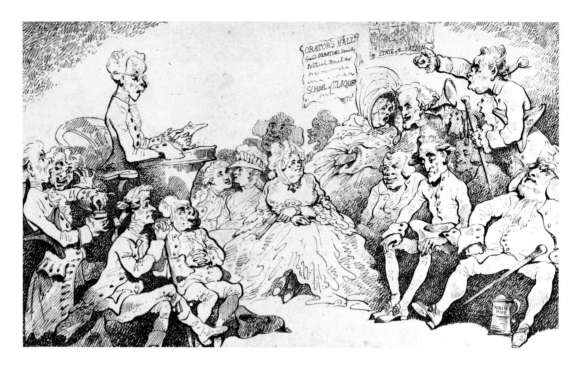

18. Rowlandson:
The School of Eloquence.
About 1778–80.
Etched and published
by Archibald
Robertson, 18 July
1780. Pen over pencil,
11⅝ × 19½ in. (295×
495 mm.). Windsor
Castle (reproduced
by gracious
permission of Her
Majesty The Queen)

19. Pier Leone Ghezzi
(1674–1755): *Couple
with Servant Boy with
Tray.* Signed and
dated 1727. Pen,
11¾ × 10¼ in. (298×
261 mm.). Oxford,
Ashmolean Museum

20. Rowlandson:
*Portrait of George
Michael Moser, Keeper
of the Royal Academy.*
About 1780. Inscribed
in a later hand. Pen,
5 11/16 × 5 3/16 in. (144×
132 mm.). London,
British Museum

unrelated, the man seated third from the right is there solely as a linking device, but
unsuccessfully so, and the pair in the background are mere cardboard figures. Many of
the types derive from the 'caricatura' tradition of Pier Leone Ghezzi (Figure 19),
whose technique Rowlandson imitated so closely in his portrait of Moser (Figure 20);
and the whole drawing is closely related to the caricature groups of Thomas Patch.
The subject itself may possibly have been influenced by de Loutherbourg's *A Midsum-
mer Afternoon with a Methodist Preacher* (Figure 21), a picture which was shown at the
Academy in 1777 and singled out for special praise by the contemporary critics.

Other drawings that can be dated to the later 1770s, on account of the fashionable

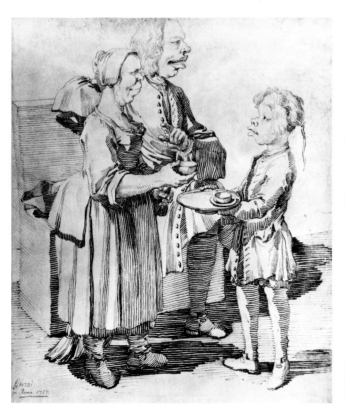

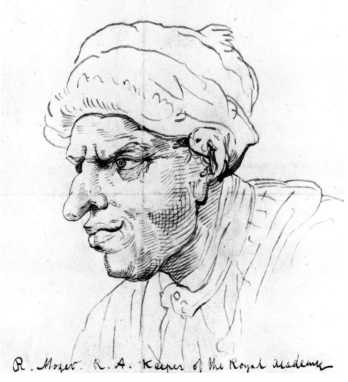

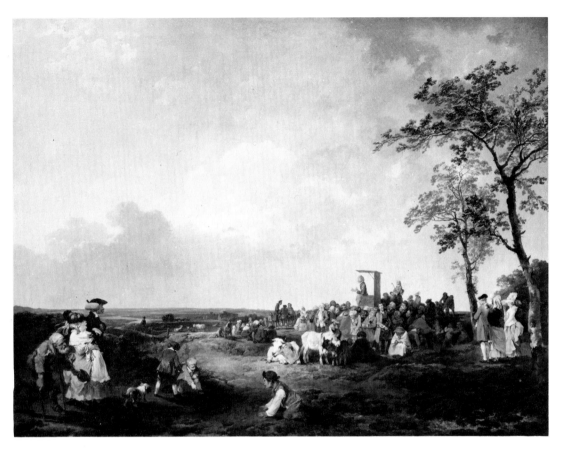

21. Jacques Philippe de Loutherbourg (1740–1812): *A Midsummer Afternoon with a Methodist Preacher*. Signed and dated 1777. Exhibited Royal Academy 1777. Oil on canvas, 38 × 49¾ in. (965 × 1,264 mm.). Ottawa, National Gallery of Canada

high-piled hair, are the scenes showing a courting couple in the Oppé and Witt collections (Plates 6 and 7). In the former there is the same stippling and zig-zag technique, but, in this case, Rowlandson has begun to use gradations of grey wash as the medium for most of the middle tints and shadows. Mannerisms derived from Mortimer continue to dominate Rowlandson's etchings, and presumably therefore the drawings for them, into the mid-1780s, and his print *Britannia Roused*, dated 1784, one of Rowlandson's most powerful images, has its source in one of Mortimer's monsters; but by this date the style of most of his work had changed radically and for good.

Unfortunately, the transitional period between drawings from the second half of the seventies like *The Dissection* and *The School of Eloquence* and the great watercolours of 1784 is almost impossible to reconstruct, and the influences which may have determined so profound a shift in direction are difficult to pin down.[57] If the student of Rowlandson would give anything to find his early *Samson and Delilah*, he would give as much again to have a dated drawing of, say, 1781 which provided the visual clues to this dramatic change in style. As it is, we must take one of the 1784 watercolours—the 1786 version of *Skaters on the Serpentine* (Figure 22) will serve as well as any—and see what we can deduce from the mature work of this date.

In the first place, Rowlandson is now working firmly in the tradition of the tinted drawing, common to most watercolourists of the day. Wheatley is the comparison that comes most naturally to mind, since the arrangement of the groups of figures in the *Skaters on the Serpentine*, forming a continuous rococo undulation across the whole of the design, is close to, though far more complex than, some of Wheatley's designs (Figure 23), and Wheatley was one of the artists Rowlandson included in his set of *Imitations of Modern Drawings*, published about 1788. The basic composition of the drawing, as has been pointed out before, clearly owes something to de Louther-

22. Rowlandson:
Skaters on the Serpentine.
Signed and dated 1786.
Repetition of the
watercolour exhibited
Royal Academy 1784.
Pen and watercolour
over pencil, $19\frac{1}{8} \times 29\frac{3}{8}$
in. (486×746 mm.).
London, London
Museum

bourg's *A Midsummer Afternoon with a Methodist Preacher*, and Rowlandson (in common with other artists, such as Dighton (Figure 46)) may also have been influenced towards large-scale comic genre by a work such as this, which combined genuine narrative with the prominent use of caricature types. However, though the drawing is replete with comic incident and blowsy types, the main impression is one of elegance: elegance of arrangement, elegance in certain of the figures, elegance in colour. This is surely unmistakably French—and we may recall that Rowlandson was travelling on the Continent in 1782–3, probably finishing up in Paris. There is also a hint, in figures like the couple on the left, of Gainsborough's own new departure in genre, *The Mall*, painted in the autumn of 1783, though Gainsborough's sentiment has been transformed into a swagger more characteristic of Rowlandson. Also

23. Francis Wheatley
(1747–1801): *Irish
Fair.* Dated 1783.
Watercolour,
$15 \times 21\frac{5}{16}$ in.
(382×542 mm.).
London, Victoria
and Albert Museum

personal to Rowlandson are the lively background figures, brilliantly sketched in the lightest of washes, and the highly expressive, flexible pen line of which he is now a master: this rich development in his technique may be contrasted with his earlier, more spidery use of the pen. This new vigorous pen line is encountered already in the *Bookseller and Author*, etched in 1784 (Plate 11), and more strikingly, in the drawing in Ottawa of doctors in consultation (Plate 10): here Mortimer's hatching and zig-zag technique are still in plentiful use, but the types no longer recall Patch, and the weight of stylistic evidence inclines to the view that this is one of the few Rowlandson drawings it is possible to date with safety to the transitional period of the early 1780s.

Rowlandson's mature style is best studied in the series of watercolours he worked up from the just on seventy sketches he made during his tour to the Isle of Wight with Wigstead in the autumn of 1784 (Plates 18–21).[58] These are not only among the very finest watercolours Rowlandson ever did, but, by fortunate accident, also among the best preserved. Here Rowlandson is seen at the very height of his descriptive powers. No detail of the incidents attending the journey was too trivial for him to record, and he recorded it with the mobility and candour of the snapshot; trained by long practice and the habit of always carrying a sketchbook to speed, accuracy, vigour and economy of line, he caught to perfection the 'feel' of an incident, the vagaries of wind and weather, the *genius loci*, whether of sea-shore, countryside or small town, the momentary tension, stance and movement of the human body, the fleeting expression, the quirk of behaviour. In front of almost any of these drawings one would hardly wish to dispute Osbert Sitwell's pronouncement that Rowlandson was 'the greatest master of pure line that England has ever had the good fortune to produce'.[59]

The sketch was Rowlandson's forte; so much so that in some of his later work the dividing line between a true sketch and a 'finished' drawing was apt to become distinctly blurred. His speed of execution is indicated by the way in which he sometimes blocked out heads with a single line, or perhaps two, then built features on (Plate 44); his washes, brilliantly suggestive, did not always follow form or shadows (Plate 36). He had the ability to create a character in a few deft lines: perhaps one

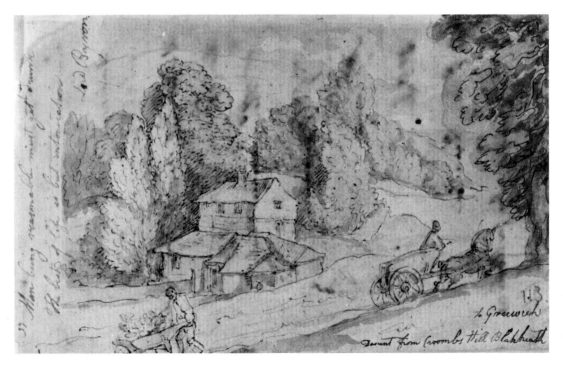

24. Rowlandson: *The Descent from Croom's Hill, Blackheath.* About 1821–5. Inscribed. Pen and watercolour over pencil, 3½ × 6 in. (90 × 152 mm.). Auckland, City Art Gallery

should say 'figure', for one must add that, outside a series like the *Tour in a Post Chaise*, where he was sketching from the life, his characters are usually repetitive—types more than individuals—and live through the urgency of the line rather than as independent beings. Rowlandson, for all his admiration of Hogarth, was not Hogarth reincarnated; Gillray was nearer to inheriting that mantle. But, if he was denied the great novelist's gift of creating individual characters destined to enrich the collective imagination, he could invest his figures with superabundant life and energy and movement: the rapid but unerring penwork happily suggesting the benign rather than the inebriating influence of the bottle in his *High Spirits* (Plate 62) is a miracle of draughtsmanship. Naturally, not all his figure sketches of this degree of freedom reach so high a level of accomplishment; and the variation in quality is exemplified by the pair of sketches representing a tragedian and a comic actor rehearsing their parts (Plates 70 and 71), though there are passages, as in the modelling of the leg in the latter drawing, where the impact of Rowlandson's powerful and astonishingly flexible descriptive line is forcible enough.

Rough sketches from nature are comparatively rare in Rowlandson's *œuvre*, though it is clear from his topographical work that he must always have carried a sketchbook with him, even in later life, and the page recording a scene on Croom's Hill, Blackheath (Figure 24), which seems to date from the early 1820s, provides a

25. Rowlandson's palette. Executed on the verso of *After the Fight*. About 1815. One of the most elaborate of a number of cases in which Rowlandson has tried out his colours, partly to explore gradations of tone. The blues are indigo, the reds vermilion, and the greens probably *terre verte*; the umber flecked with vermilion was used for the contours in his drawing on the verso. The paints are of exceptional quality, and it is clear that Rowlandson must have used a very good colourman. (I am greatly indebted to Mr Stephen Rees-Jones, who kindly examined this sheet.) Watercolour, $5\frac{1}{4} \times 8\frac{1}{2}$ in. (133 × 216 mm.). London, Private Collection

useful corrective to the accepted view.[60] Rowlandson's pen or pen-and-wash sketches are the least known of his drawings—he is prized now as he was then for his finished watercolours—but they were his most personal creations, and doubtless the genesis of more elaborate works, though, oddly, there are hardly any instances where this can actually be demonstrated. One would certainly expect such sketches as *A Tavern Scene* (Plate 44) to be worked up later, but the *Return from the Hunt*, signed and dated 1787 (Plate 35), the *Review of the Light Horse Volunteers on Wimbledon Common*, which dates from 1798, and the *Fairlop Fair* of 1815–18 (Plate 141) are among the few important subjects at present known where one of Rowlandson's compositions can be followed through from a preliminary sketch. Fortunately, the *Review of the Light Horse Volunteers* happens to be particularly instructive about the way in which Rowlandson's mind worked. To take the figures on the right, which, in the sketch

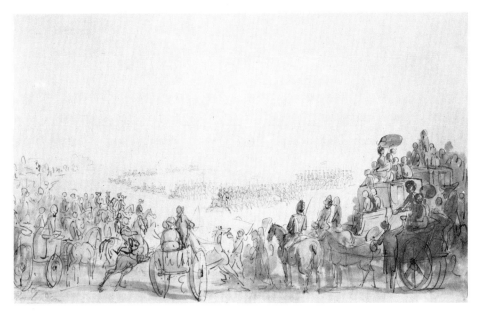

26. Rowlandson: *The Review of the Light Horse Volunteers on Wimbledon Common.* 1798. Falsely signed. Pen and watercolour, $9\frac{7}{8} \times 16\frac{1}{2}$ in. (251 × 419 mm.). From the collection of Mr and Mrs Paul Mellon

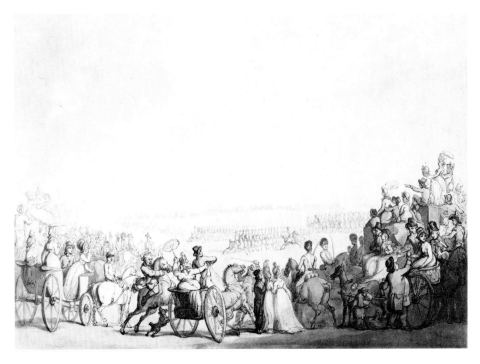

27. Rowlandson: *The Review of the Light Horse Volunteers on Wimbledon Common.* Etched and published by Henry Angelo, 18 July 1798. Pen and watercolour, $12\frac{5}{8} \times 17\frac{9}{16}$ in. (321 × 445 mm.). Boston, Public Library (Wiggin Collection)

(Figure 26), seem very naturally and effectively grouped, Rowlandson has obviously been at pains to build up two very carefully integrated and continuous diagonals for the finished work (Figure 27), and has also introduced two incidental flirtation scenes to add extra interest. The result is distinctly less subtle. Then there is the problem, common to so many of Rowlandson's major compositions, of how the elaborately built-up masses of figures on left and right can satisfactorily be linked. In this case, Rowlandson has solved the problem successfully by fitting into the foreground an incident that attracts immediate attention, a horse jibbing at a gig, and by repeating the principal diagonals in the arrangement of the troops behind.

Rowlandson's preference for diagonal or serpentine compositions is very apparent, though he also employed spoke-like or purely lateral designs. *Repoussoirs* were a device he used commonly, and his backgrounds are often stagey, shadowy or simply undeveloped, roughly sketched in and nothing more, unless they are intended to represent a real place, architectural or interior settings usually being entirely subordinated to the action of the figures. In his landscapes he came close to Gainsborough (whom he almost certainly knew well) not only in the gentle, undulating quality of so many of his pastoral scenes, but also in his linear emphasis and the way in which forms are sometimes swept up into a strongly pulsating rhythm which seems to shake the very landscape. But the restless, tortuous spiralling of the tree forms and branches in some of his compositions went far beyond Gainsborough and provides a strange and unexpected bridge between the playful world of the rococo and the morbid energy of late nineteenth-century expressionism.

It is clear from his ideals of human beauty that he admired Rubens—the *Gentleman's Magazine* obituarist went out of his way to remark that 'some of his drawings would have done honour' to that master—and the piled-up figures which recur so often in his work, the surging movement of horses and dogs pouring over fields and hedges in certain of his hunting scenes, no doubt also the furiously galloping runaway horses in those tragi-comic disasters to rider, gig or chariot so beloved of Rowlandson, were probably inspired ultimately by Rubens, a source equally at the root of so much in Gainsborough.

Winding, curving, billowing rococo shapes are the very essence both of his figure style and of the relationships between his figures; in some of his compositions, like the *View of Samer* (Plate 42), the serpentine line formed by the figures, horses and other features is so obviously contrived as to seem almost a parody of his own manner. The instincts of his designing, his primary interest in the quality of line, his love of gay and decorative colour, his sympathies with French eighteenth-century style, and his almost total disregard of current artistic movements, all indicate his fundamental predilections. Rowlandson was stylistically a man out of his time, the last great exponent of the rococo in England.

If it is not too hard to analyse the constituents of his style—Rowlandson was in many ways a transparent artist—it is less easy to be sure about some of his technical procedures and methods of work, and to determine how they may have been modified over the course of years. We have seen already how the transitional lines between the technique of his early work, influenced by Mortimer, and the technique of the mid-1780s have become blurred through insufficient evidence. In discussing the later work, we have to be wary of repetitions, studio copies, imitations and fakes, false signatures and dates on genuine drawings, even dates added by Rowlandson himself

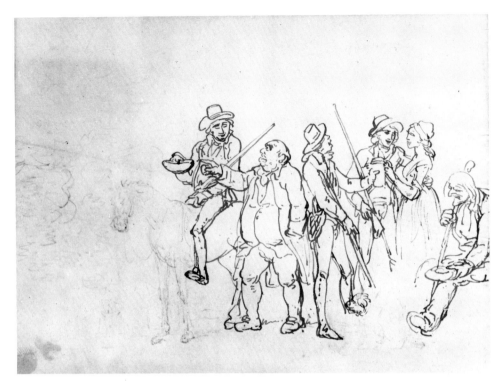

28. Rowlandson: *Group of Rustics*. About 1790–1800. Unfinished. Pen over pencil, 6½ × 9 in. (165 × 229 mm.). Private Collection

which can be shown to be wrong on the evidence of watermarked paper.[61] With such shifting sands to complicate a detailed picture, it is sensible to confine oneself to what is certainly demonstrable.

His characteristic technique, from the mid-1780s and for the rest of his career, was the tinted drawing, though one should add that his method of proceeding differed in some degree from normal eighteenth-century practice—the application of washes, more or less subtly modulated, over a firm but undifferentiated pen outline.

In many cases, Rowlandson must have made a preliminary sketch, usually in pen or pen and wash (Plate 112). He then started his composition as a pencil outline (Plate 4 or Figure 28), so that details could easily be changed or modified in the course of elaborating his idea (one suspects Rowlandson, like Gainsborough, of being very much an *ad hoc* artist). Only after this initial gestation did he bring into play the most exciting tool in his technical armoury, his pen. This he used primarily to supply contours which ebbed and swelled with astonishing subtlety and vigour as they unerringly created full three-dimensional form (Plate 8), bringing an entire composition immediately and miraculously to life; penwork he also employed to assist in internal modelling and to rough out areas of shadow (Plate 11). In many of his later drawings he used the tip of the brush rather than the pen for the delineation of contours (see Plate 134 and contrast with Plate 135).

Colour normally came next, though in certain drawings (see Plate 78) it can be shown that colouring preceded the penwork. In his earlier style, he often applied local colour in perfectly simple, even washes without any attempt at gradations of tone, adding grey washes over the colour to reinforce certain contours, to create shadows and to suggest weight and mass (Plates 54 or 95). The touches of colour in the heads of his figures, and in certain other passages, were presumably added last of all. In his later work he continued his practice of using grey wash over colour, but employed watercolour with less broadly decorative intent and rather more feeling for natural modulations in tint, especially in landscape. Technical analysis has demonstrated

also Rowlandson's initial concern for the quality of the paints he used (Figure 25). None the less, he remained what he had always been, a draughtsman who also used colour rather than a true watercolour painter.

Rowlandson normally used a black or brownish-black ink in the 1780s; from the late 1790s onwards he also employed vermilion. The effect could be doubly powerful. Yet almost simultaneously with this enrichment of his technique, Rowlandson began to modify his expressive penwork in favour of a thinner, less substantial kind of contour line (Plate 129). This modification corresponded with a change in style, which became pronounced in later work, a change which led in the direction of the neo-classical (Figure 29): attenuated proportions combined with wiriness of outline to link Rowlandson with Flaxman (Figure 30) and Stothard, links which were remarked upon by early critics. However, there were undoubtedly other reasons also

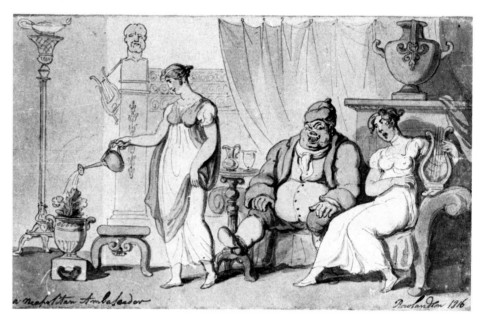

29. Rowlandson: *A Neapolitan Ambassador*. Signed and dated 1816, and inscribed. Pen and watercolour over pencil, 4½ × 7⅜ in. (115 × 187 mm.). London, Courtauld Institute of Art (Witt Collection)

30. John Flaxman (1755–1826): *Pandora Attired*. Pen over pencil, 5 15/16 × 6½ in. (151 × 165 mm.). London, British Museum

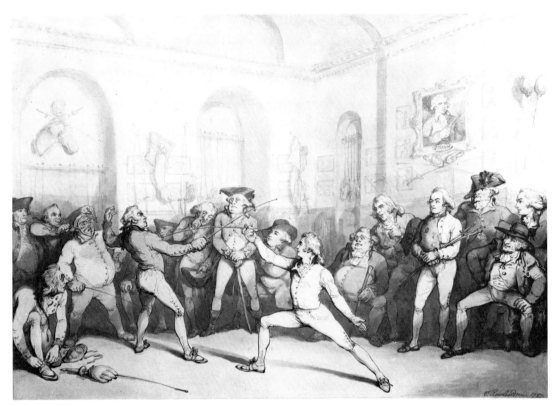

31. Rowlandson:
*Henry Angelo's Fencing
Academy*. Signed and
dated 1787. Pen and
watercolour over
pencil, $13\frac{5}{8} \times 20\frac{1}{4}$ in.
(346×514 mm.).
Bedford, Cecil
Higgins Art Gallery

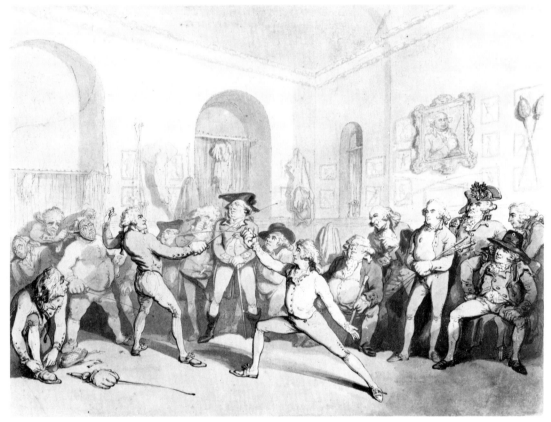

32. Rowlandson:
*Henry Angelo's Fencing
Academy*. About 1790.
Pen and watercolour,
$15\frac{1}{8} \times 20\frac{1}{2}$ in.
(384×521 mm.).
Cambridge,
Massachusetts, Fogg
Art Museum

behind this modification in technique. Rowlandson's early penwork was almost
impossible to copy and, with the need to increase his output, coupled no doubt, as
in the case of Canaletto, with demands from clients for versions of a popular composi-
tion, copying of one kind or another was essential. Documentary evidence that this
became normal procedure is provided by the title-page of the catalogue of his sale in

1828, which announced the inclusion of 'several of his most celebrated subjects, many of them the original from which he made duplicate drawings'.

Much of Rowlandson's copying must have been straightforward repetition, and comparison of existing versions shows how this practice inevitably tended to dilute his style. The detail in the Fogg Museum's version of *Angelo's Fencing Academy* (Figure 32) or in repetitions of other well-known subjects (Figures 33, 34 and 35) is more flaccid and superficial wherever one chooses to look, though, if one were not making direct comparison with the originals, these repetitions might be accepted as fine or typical enough drawings in their own right. But the production of repetitions to order was obviously a tiresome business, and Rowlandson eventually adopted other methods as well. Tracing was one obvious solution; naturally, examples of tracings do not normally survive, but a Dr Syntax subject on tracing paper, now in the Metropolitan Museum, proves that he used this method. Even more mechanical reproductive processes were possible, and his technique for counterproofing is described in detail in one of the early sources:

If at any time collectors should be surprised at finding that five or six of his productions are almost exactly similar in outline, and scarcely different in colour, they may rest assured that all are by him, and were considered by him to be equally originals. The process of production was simple. Rowlandson would call in the Strand, ask for paper, vermilion, a brush, water, a saucer, and a reed; then, making of the reed such a pen as he liked, he drew the outline of a subject (generally taking care to reverse the arms of his figures), and hand the paper to Mr. Ackermann to be treated as if it were a copper-plate. This was taken to the press, where some well-damped paper was laid upon the sketch, and the two were subjected to a pressure that turned them out as a right and left outline. The operation would be performed with other pieces of damp paper in succession, until the original would

33. Rowlandson:
The Dutch Packet.
Left-hand half.
Signed and dated
1791, and inscribed.
Pen and watercolour
over pencil, $7\frac{3}{4} \times 10\frac{3}{4}$
in. (197×273 mm.).
From the collection
of Mr and Mrs Paul
Mellon

34. Rowlandson:
The Dutch Packet.
Left-hand half.
About 1791–1800.
Pen and watercolour
over pencil, $7\frac{3}{4} \times 10\frac{3}{4}$
in. (197×273 mm.).
Private Collection

35. Rowlandson:
The Dutch Packet.
Left-hand half.
About 1791–1820.
Pen and watercolour,
$7\frac{1}{2} \times 10\frac{3}{4}$ in. ($191 \times$
273 mm.). Earl of
Stair

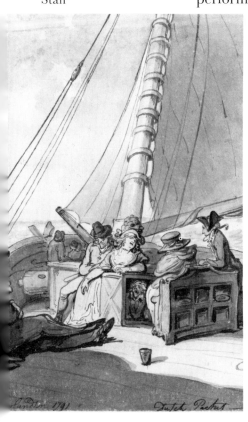
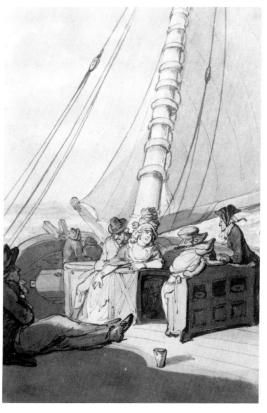
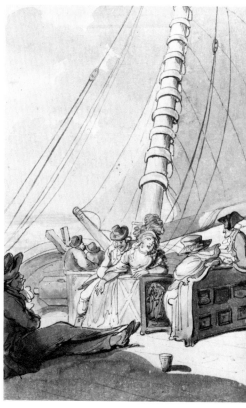

41

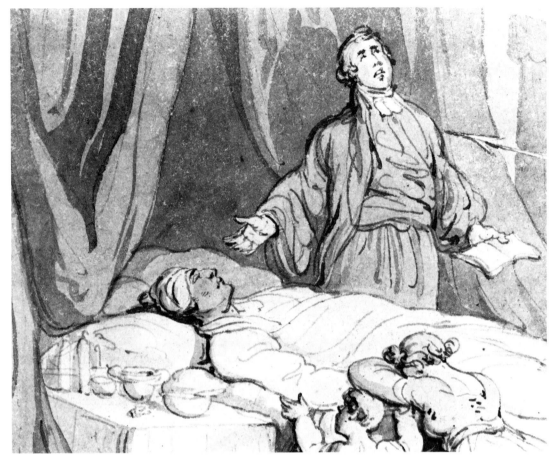

36. Rowlandson:
*The Good Man,
Death and the Doctor.*
Enlarged detail.
From *The English
Dance of Death*, about
1814–16. Pen and
watercolour, $4\frac{3}{4} \times$
$8\frac{1}{16}$ in. (121 × 205
mm.). San Marino,
California, Henry E.
Huntington Library
and Art Gallery

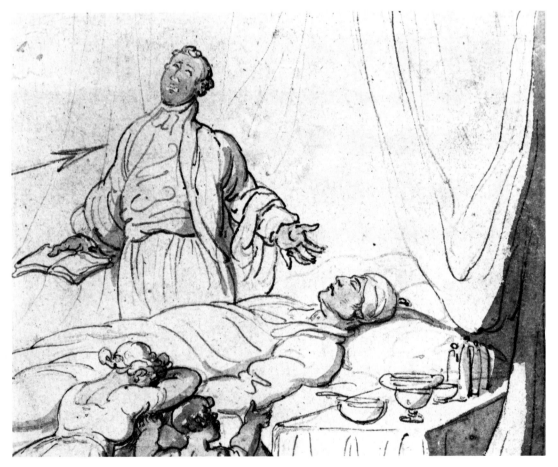

37. Rowlandson: *The
Good Man, Death and
the Doctor.* Enlarged
detail. About 1815–20.
Counterproof derived
from Figure 36. Pen
and watercolour, $4\frac{3}{4} \times$
8 in. (121 × 203 mm.).
San Marino,
California, Henry E.
Huntington Library
and Art Gallery

not part with vermilion enough to indicate an outline; then that original became useless, and Rowlandson proceeded to reline the replicas, and to tint them according to the fancy of the moment.[62]

This highly circumstantial account has been rejected out of hand by some quite recent critics,[63] and of course there are elements in it which may certainly be questioned: Rowlandson had no need to call on Ackermann as he had a printing press of his own,[64] he was not in fact always sufficiently careful about reversing arms or other important details, such as lettering on signs and the like, and the number of counterproofs pulled would seem to be exaggerated since so far no more than one counterproof version of a given subject has been located. But the basic accuracy of the description can be demonstrated from numerous surviving drawings, notably replicas of subjects from the *English Dance of Death* (Figures 36 and 37). In most cases, the replicas were retouched by Rowlandson after they had been pulled, but to reinforce an entire drawing would obviously be scarcely less work than to make a straightforward repetition, and one normally finds, in the counterproof drawings, sucked out lines which betray the process of reproduction side by side with reinforcing lines (Figure 38). Whether or not Rowlandson employed assistants to make replicas or retouch the contours and add the colour in his counterproofs is unknown: the tradition that certain drawings were executed for him by a Miss Howitt has now been shown to have been based on a misreading of the documentary evidence connected with the four *English Dance of Death* drawings in the Ashmolean Museum.[65] Given that Rowlandson was perfectly prepared to copy his own work, one is inclined to doubt whether an artist as nimble as he was would have needed assistants, or thought it worth while to pay for their services.

Copyists and imitators of course there were, but unconnected with the work of his own studio. His brother-in-law Samuel Howitt, the sporting artist, produced work very much in his vein, though rather more prettified and far less free and vigorous in

38. Rowlandson: *Richmond Park*. About 1800–10. Pen and watercolour, 4½ × 6½ in. (114 × 165 mm.). The enlargement shows the sucked out lines. From the collection of Mr and Mrs Paul Mellon

39. Samuel Howitt (1756–1822): *Full Cry*. Signed and dated 1791. Pen and watercolour, $8\frac{5}{8} \times 12\frac{7}{8}$ in. (219×327 mm.). San Marino, California, Henry E. Huntington Library and Art Gallery

40. Rowlandson: *The Chase*. About 1790. Pen and watercolour, 10×13 in. (254×330 mm.). London, Courtauld Institute of Art (Spooner Bequest)

draughtsmanship (Figures 39 and 40). More interesting is the case of Wigstead, who is credited with the design of a number of Rowlandson's prints, notably the celebrated *Box-Lobby Loungers* of 1786 (Plate 29), and may have assisted Rowlandson's invention more than we shall ever be in a position to realize. The two men were, after all, intimate friends over a long period of time. Wigstead also drew in a manner close to Rowlandson's, so close, indeed, that the critic of the *St James's Chronicle* suspected him of passing off Rowlandson's drawings for his own at the Academy of 1785 (Figure 41);[66] but his work can be detected by the thin, less supple quality of his pen line and by the comparative emptiness of his characterization.

Rowlandson collaborated with many fellow caricaturists, such as Gillray, Bunbury, Woodward and Nixon, and was accustomed to working in close collaboration with publishers, especially, of course, Ackermann. These habits may have had effects on his style as well as his manner of working, and what evidence there is suggests that he was a very modest and considerate person with whom to work. The preliminary sketches for *The Microcosm of London*, a project on which he worked with Augustus Pugin, the architectural draughtsman, are scored with Pugin's criticisms of his figure arrangements, but there is only one comment by Rowlandson on Pugin, and that most tactfully phrased: 'With submission to M.' Pugin's better judgement M.' Rowlandson conceives if the light came in the other side of ye Picture, the figures would be sett off to better advantage' (Figure 42).

There is a sense in which Rowlandson might be equated less with the artist than with the architect or cabinet-maker used to producing a selection of decorative ideas for the consideration of his clients; he had the instincts of a craftsman, in an age of very talented craftsmen. But it would be wrong to consider him as merely a craftsman, merely an illustrator, merely interested in output. The extraordinarily individual quality of his penwork and the teeming richness of his invention raise him far above this level. Already by the mid-1780s, when he was just turning thirty, Rowlandson was in the front rank of British artists, the praise of Reynolds and West ringing in his ears;[67] and he set the seal on his reputation with his exhibited drawings of 1786, the magnificent *English* and *French Reviews* (Plates 49 and 50). These were the *Skaters on the Serpentine* (Figure 22) done over, but with denser, more compact groupings of figures, so beautifully integrated in fact as to rather dominate and overset the balance of the drawings as a whole. The following year, in the *Prize-Fight* (Plate 37), he set himself the same ambitious task; here the boxing ring constituted the necessary point of resolution for the groups of figures which he had been unable to supply in other compositions, and he succeeded triumphantly. But never again was he to attempt the Raphaelesque: compositions that required so much careful management, so much

41. Henry Wigstead (d. 1800): *John Gilpin's Return to London*. Signed and dated 1785. Exhibited Royal Academy 1785. Etched by Wigstead and aquatinted by F. Jukes, and published 1785. Pen and watercolour, $15\frac{7}{8} \times 25$ in. (403 × 635 mm.). London, Victoria and Albert Museum

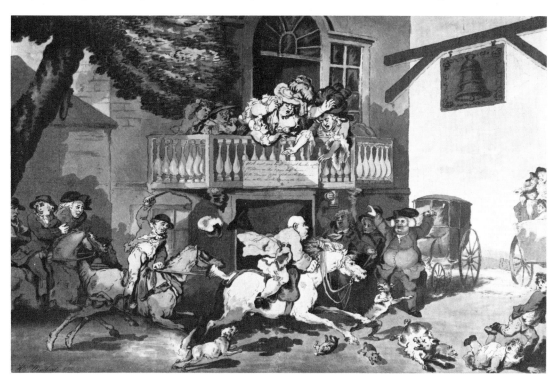

With submission to Mr Pugins better judgment Mr Rowlandson conceives if the light came in the other Side of ye Picture, the figures would be sett off to better advantage —

42. Rowlandson: *Westminster Election, Covent Garden*. About 1808. Sketch for Plate 26 of the *Microcosm of London*. Inscribed. Pencil, $6\frac{3}{8} \times 7\frac{3}{4}$ in. (161 × 196 mm.). Chicago, Art Institute

intricate balancing and counterbalancing of forms and masses. The *Exhibition 'Stare-Case'* (Plate 101), with its great spiral of closely interwoven and collapsing figures, was something different. The surge of violent movement was where Rowlandson excelled. Yet, in spite of this, he remained detached from the visual turmoil of the romantics. There are hints in his work that he was aware of Fuseli, Blake, Goya, Turner—but only hints. He took up an idea, used it once or twice, then returned unaffected to his own world of images and forms. In 1784, for instance, he adapted Fuseli's painting for his print of the *Covent Garden Nightmare*, an obvious borrowing to use, and Rowlandson was often obvious; in 1790 he included one of Fuseli's devastating *demi-mondaines* in a drawing entitled the *Lock Up* (Plate 76); in 1796 he did a drawing of a boat carrying survivors from a shipwreck struggling in heavy seas,[68] presumably in emulation of Turner's first Academy sea-piece, exhibited that year. Rowlandson was clearly conscious of everything that was going on in the arts, just as he was conscious of the whole European artistic tradition (he owned several thousand fine engravings, of all schools); but he did not choose to respond. Isaac Cruikshank admired him particularly for his marine studies, which he compared to those of Van de Velde, and for his landscapes[69]—but, as far as landscape was concerned, Girtin, Turner and Constable might never have existed for all that Rowlandson cared. His last works in this genre have precisely the same pastoral and rococo quality as his earlier ones. And this is the nub of the matter. The Rowlandson of the 1790s, or of 1805, or 1820, was fundamentally the same as the Rowlandson of 1785. Of course he was enormously prolific, pouring out drawings as Schubert did songs (a *catalogue raisonné* of his work would be an unimaginable task). But it is not surprising that he ceased to develop, that his technique became progressively less

vital, that he inclined more and more towards carelessness of execution, that he indulged in various reproductive processes. All this is not to say that he did not produce many exceptionally fine drawings in those later years—to judge him by his own early style is, after all, to judge him by very high standards—but, as a creative artist, he was played out long before he actually died.

Imagination

We have seen that Rowlandson began his career as a devotee of Mortimer; but Mortimer's savage, mordant attitude towards life, which accurately reflected the brutality and uncertainties underlying eighteenth-century existence, and is clearly so sympathetic to our own disenchanted generation, was alien to Rowlandson. Rowlandson was a more serious person than is often supposed—we shall come to that in a moment—and he was tough; but he could be unemotional, detached, even bored, the last surely an odd characteristic for an artist. For all his preoccupation with the bawdy, he could be as close to Jane Austen as he was to Smollett,[70] so that, in adopting Mortimer's subjects and Mortimer's imagery—probably far more extensively than we are aware of now, so few are the early drawings to survive—he tended to de-fuse the emotional charge. In a horrific situation he would ignore the horrific and emphasize the incidental humour.

For he looked back to the traditions of mid-eighteenth-century art with a different eye. From the teeming world of Hogarth's prints he absorbed not the satire, the pathos or even the sympathy, but the love of comic incident, and the ability to find it in strange places. The example of the printseller Matthew Darly and of draughtsmen such as Bunbury (Figure 43), already successfully exploiting the comic as a genre,[71]

43. Henry William Bunbury (1750–1811): *An Englishman in Paris*. Dated 1767, and inscribed. Private Collection

47

must have supported his leanings in this direction, which were to become the key-note of his art. By the time he had fully matured, 'drolls', as these comic drawings were called, were being produced by numerous artists, many of them amateurs, and were all the rage (Figures 44 and 45). Malcolm, who admittedly was concerned chiefly with political caricature, cited 'the number of persons employed in this way, and the number of shops appropriated to the sale of Caricatures, as a proof of the importance the Publick has attached to them';[72] and Laurie and Whittle, who were among the main stockists of drolls in Rowlandson's day, described their list in their 1795 catalogue as 'consisting of the greatest variety of whimsical, satiral and burlesque subjects (but not political). They are well calculated for the shop windows of country booksellers and stationers.'[73] The craze seems to have been nation wide, not just confined to London; Rowlandson was clearly right in the swim.

In common with certain other comic draughtsmen of his age, straightforward humour more than satire was what Rowlandson drew from the related but earlier tradition of 'caricatura', a genre which had been popularized by Pier Leone Ghezzi (Figure 19), and taken up by no less a figure than Reynolds as well as by Hogarth, Collet, Patch, Mortimer, Brandoin, de Loutherbourg and amateurs like Lord Townshend. This art-form used exaggerations of facial features sometimes for their own sake, sometimes, as cartoonists do today, in order to isolate the salient characteristics of individual people (and Rowlandson was quite capable of gross personal caricature), but perhaps most often to create burlesque types. This is what we find in Collet and de Loutherbourg in the sixties and seventies; this is what we find in *The School of Eloquence* (Figure 18). Caricature, not only of figures but of incidents and manners, was an obvious and important element in the content of Rowlandson's drolls as it was in the work of most of his contemporaries in this fashionable field.

But we must remember that Rowlandson was also well schooled in drawing the

44. John Nixon (d. 1818): *Interior of the Old Pump Room at Bath*. Signed and dated 1792. Water-colour, $14\frac{1}{4} \times 20\frac{1}{8}$ in. (361×510 mm.). London, Courtauld Institute of Art (Witt Collection)

45. George Moutard Woodward (1760–1809): *Caricature Figure*. Coloured wash, $10 \times 6\frac{1}{16}$ in. (253×154 mm.). London, Courtauld Institute of Art (Witt Collection)

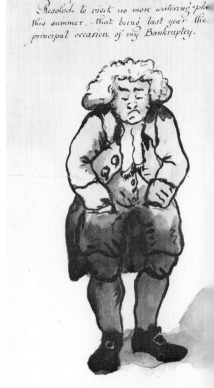

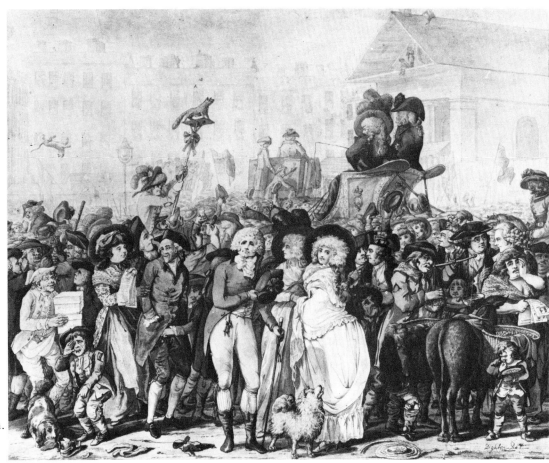

46. Robert Dighton
(about 1752–1814):
*The Westminster
Election of 1788*.
Signed. Pen and
watercolour, $15\frac{1}{2} \times 19$ in.
(394 × 483 mm.).
Private Collection

human figure. This was an aptitude he is supposed to have gained in Paris,[74] and certainly he could compete, when he wished, with the brilliance of Fragonard. Unlike so many of his English contemporaries in the field of watercolour, he was never so wholly absorbed in nature, that is to say, in exact topographical delineation; and most of his early exhibits at the Academy were in fact small portraits. His splendid early studies of George Morland (Plate 38) and of George IV as Prince of Wales[75] are probably his finest surviving portraits of identifiable persons—in later life he was prone to work from engravings[76]—but perhaps most characteristic of the 1780s are his highly attractive drawings of young women, sometimes rather prettified or simpering in treatment, much in the manner of Wheatley or of his friend J. R. Smith (Plates 22 and 15). He also introduced portraits, many of them depicting leading members of London society, into the action of such large-scale watercolours as *Vauxhall Gardens* (Plates 16 and 17);[77] some of these portraits are mildly caricatured, and it is apparent that Rowlandson's contemporaries were quite used to the idea of being represented in this way, just as they were amused to be the subject of caricatures by Reynolds or Patch.

The influence of Wheatley, noted above, is found again in Rowlandson's idealization of family contentment, drawings where the children are seen grouped about their devoted and admiring parents (Plate 56); but scenes of such unalloyed sentiment are rather rare in Rowlandson. His pair of drawings entitled *Courtship* and *Matrimony* (Plates 30 and 31), gently chiding the husband as opposed to the lover, is in a slightly different vein but derives from the same source; the supporting cast of dogs respectively

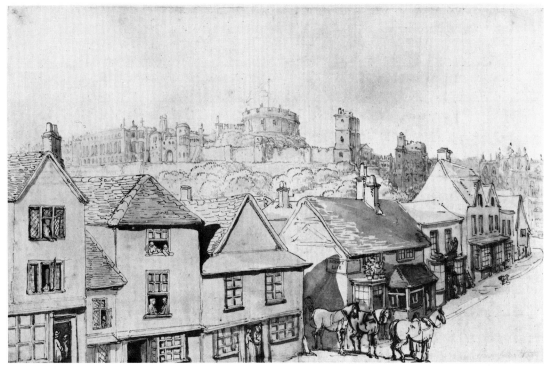

courting and chained together is an amusing extension of Hogarthian invention, outdoing the master at his own game.

The narrative watercolour, however, was a peculiarly French genre, and such full-blown set pieces as *Vauxhall Gardens* or *Boodles's Club Fête to George III at Ranelagh* may be compared with the promenade or festival scenes of artists like Gabriel de Saint Aubin or Moreau le Jeune. What sets these large-scale compositions aside from the French or from the genre of Wheatley and his followers—and gives them a special place in the history of art—is the dichotomy observed by Oppé between the pretty and the comic,[78] which is especially marked in the *Place des Victoires* (Plate 13). This contrast, between charming and elegant figures, delicate colour and sinuous line on the one hand, and grotesque, coarse or comic types and incident on the other, recurs again and again in Rowlandson, and may owe something to the spirit of contemporary French comedy, with which he would certainly have been familiar. Apart from his expressive penwork, it is perhaps the most distinctive characteristic of Rowlandson's style, and a detailed study which focused on this aspect of the drawings would take us very near the heart of his imagination.

In the great watercolours of the 1780s the contrast is truly dichotomous in character, since there is no correlation between the two; the incident is enormously varied, and there is no significant connection between the elegant and the caricatured or between the figures engaged in decorous, and those involved in indecorous, activities. But in many of his less complex subjects the contrasts are overt. Chief among these are those marital comedies where an elderly and gouty husband is cuckolded, almost within sight, by a young lover; here one thinks of Beaumarchais's Dr Bartolo, and specifically of the episode of Rosina's singing lesson in *Le Barbier de Séville* (Figure 60). But contrasts between the young and the old, the beautiful and the ugly, the sprightly and the decrepit, the brave and the cowardly, are legion, and in the *English Dance of Death* they form a constant and sinister refrain. There is nothing particularly sophisticated about this method of developing a story from the ingredients of the

comédie humaine, but then there is nothing particularly sophisticated about Rowlandson. There are no hidden layers of meaning, no great depths to plumb, in anything he did. He was enormously inventive, but he was not profound. Serious, when he wished, but not intellectual.

Rowlandson's seriousness and good sense comes out well in his correspondence and notes, such as we know of them. There is nothing raffish about either the style or the content of his letter to Mrs Landon. It is the letter of an amusing but sensible and thoughtful middle-class person from any walk of life. Sensible too is the long and careful description of his impressions of Düsseldorf and its picture gallery he wrote on the back of a large watercolour he executed of the market place and town hall (Figure 5). These are the kind of notes we would expect from a well-educated traveller, and they abound in the diaries of the period; but from Rowlandson, the artist of *Skaters on the Serpentine* and a thousand other comic scenes, they are unexpected. Moreover, if he took the trouble to write a commentary of this length about one city, he probably did it for many others. Perhaps we should not be too surprised, though; much of Rowlandson's later work was connected with the production of illustrated books, and for many of these he would have had to inform himself about the subjects concerned. Possibly he envisaged a publication of his Continental drawings, and his attitude towards Düsseldorf might be regarded in much the same light as his attitude towards the Highland broadsword or the uniforms of the Loyal Volunteers.

Rowlandson's drawings of the principal buildings and squares of the foreign cities he visited, Antwerp, Amsterdam and so on, are among his finest productions; and we know from views like *Netley Abbey*[79] that he was fully capable of working in the contemporary picturesque topographical tradition. But closer scrutiny of these drawings shows that he was no dedicated topographer or antiquarian. Detail tends to be abbreviated or left out (Figures 47 and 48), and relationships between buildings

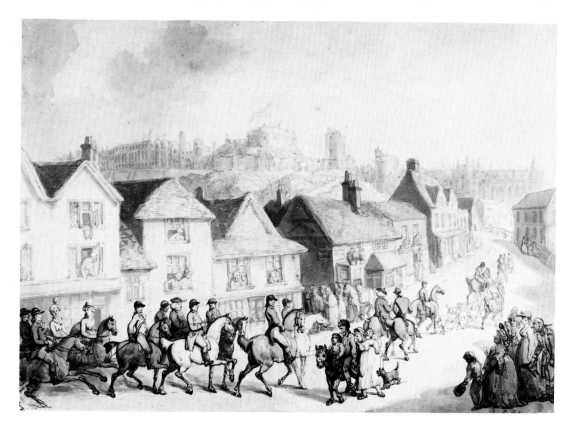

48. Rowlandson: *View of Windsor Castle from Eton*. About 1790–5. The signature has been partially cut off. Etched, date unknown. Pen and watercolour, $14\frac{7}{8} \times 20\frac{7}{8}$ in. (378 × 530 mm.). Windsor Castle (reproduced by gracious permission of Her Majesty The Queen)

could be wilfully altered—in the *Place des Victoires*, for instance, he inserted Notre-Dame in the background simply to make it clear that the setting was Paris. In *Netley Abbey* all the details seems to be on the point of trembling into rococo feeling, and the breadth of undulating line is what dominates. Rolling countryside was undoubtedly his forte when it came to landscape, and if he drew mountains, cliffs or rocks he could not help reducing them to his own rococo formulas (Plate 134). It is plain that he was far less interested in accuracy than he was in effect or composition; so far as the subject was concerned, plausible suggestion was quite sufficient. Emotional engagement was just lacking.

Now this is also true of his other work. It is certainly true of his political caricature, which was neither caustic nor trenchant. The point is that he did not care enough one way or the other; as a result his pen lacked bite. This was why he found it difficult to create real characters; the involvement was simply not there. Unlike Hogarth, who had no need to caricature to create a striking image, Rowlandson found it necessary to exaggerate to make his point. It is interesting that of all Rowlandson's figures the only one to emerge with any conviction from his gallery of types was Dr Syntax. But even he is really a paste-board character; he does not develop; he is swayed hither and thither by the events that befall him, and endures by sheer force of repetition more than anything else.

As far as Rowlandson was concerned, the Syntax series was simply an excuse for a chain of comic incidents, many of them highly improbable: there is more than an element of fantasy in the worthy Doctor's adventures (Plate 135). This is also true, as Wark points out, of the *English Dance of Death*.[80] Rowlandson totally ignored the traditional significance of the theme, the concept of Death as the great leveller, and made no attempt to moralize; what absorbed him were the infinite possibilities for story-telling opened up by the impact of Death upon the human stage, and it is significant that, as usual with Rowlandson, there is a strong element of comedy in many of the scenes (Plate 138). This series more than any other brings home the essential point that Rowlandson was principally interested in incident, in situation, and usually

49. Rowlandson: *A Coach Overturned*. About 1815. Pen and watercolour over pencil, $5\frac{3}{4} \times 9\frac{3}{8}$ in. (146×238 mm.). Formerly London, Spink & Son Ltd

everyday situation, the familiar domestic mishap, even if he turns it into burlesque or fantasy. In Rowlandson's world, the whole panorama of contemporary life passes before our eyes. House-breaking (Plate 57), hotel or theatre fires, runaway vehicles (Plate 96), seasickness and other fears and dangers that were part of the public sub-conscious Rowlandson made light of by subjecting them to caricature. He was as well aware as any of the reality of the dangers—and, in his sketch of the extraordinary riding accident which befell a certain Mr Cuthbert Lambert, his concern was for the young man's providential escape from almost certain death, as the accompanying text shows[81]—but his caricatures have a cathartic effect, like Westerns or an episode in Buster Keeton. The sight of a coach-load of passengers being tipped over the parapet of a bridge was a signal for hilarity, not sympathetic apprehension (Figure 49). He had a quick eye for the ridiculous: one thinks of the sportsman unseated from his mount gazing up, startled, at the hound jumping through his upturned legs (Plate 93). And his humour is usually broad: it tends to be the fat farmer who gets knocked off his horse by the bough of a tree, the blowsy woman whose backside is exposed. For Rowlandson was undeniably coarse. Bare, voluptuous breasts and enormous paunches are part of his stock-in-trade, and the corpulent middle-aged ogler figures constantly in his *dramatis personae* (Plate 115). His characters get up to all sorts of boyish pranks: attempts to steal a kiss in the unlikeliest circumstances or elope-ments from a young ladies' boarding school (Plate 92) are a constant source of merriment. Scenes of carousing or jollification, the hunt supper in which all the participants have drunk themselves into a stupor (Figure 50), the game of hazard (Plate 95), the domestic quarrel, these were among Rowlandson's other favourite subjects. On the whole, he was content to poke gentle fun at most types of people or activity; only occasionally does one suspect stronger feelings, and these were usually reserved for the earnest, the pedantic and the spoil-sport.

Rowlandson's creative faculty was incredibly fertile, and for the most part he appears to have relied upon the resources of his own imagination for his invention. The *Dance of Death* series is a useful test case, since one might well expect him to have borrowed liberally from earlier exponents of the theme; in fact, he seems not to have done so at all. Yet we should remember that he had a deep knowledge of the history of art, and owned a vast collection of engravings. These must have been serviceable to him in a number of ways, and though the nature and extent of his borrowings is a subject still to be explored, it is worth enumerating some of the more obvious connections with earlier artists, especially Hogarth.

Hogarth was coming firmly back into public favour in Rowlandson's early maturity: his prints were noted as being in 'high request' by 1786,[82] Boydell's publica-tion of the engravings dates from 1790, and Ireland's biography from 1791. It would be strange, therefore, if Rowlandson had not been affected by Hogarth, and there is a certain amount of evidence to suggest that he used his work to good advantage. He studied his crowd scenes to good effect. The way in which subsidiary detail is so often deployed to echo the main theme, especially in scenes of violence or disorder, is thoroughly Hogarthian if less organized in character, and so is the use of allegorical pictures within the picture.[83] Of course his method of proceeding was far less premeditated and richly allusive than Hogarth's, and a comparative study would reveal the essential superficiality of his content; but in his use of short and snappy captions to give extra punch to a visual point, he went beyond Hogarth, as Wark

points out,[84] and anticipated the practice of modern cartoonists. He copied his famous *Five Days Peregrination* as early as 1781,[85] and this Hogarthian tour may well have been the ultimate stimulus for his *Tour in a Post Chaise* of three years later. He also made free copies of other Hogarth material, such as the *Shrimp Girl*[86] and the *Idle Apprentice Betrayed by his Whore*.[87] Certain of his own designs, such as *Dressing for a Masquerade* (Plate 72), the *Hunt Supper* (compare Figures 50 and 51) and *The Chamber of Genius* (Plate 133), have general iconographical connections with Hogarth subjects;[88] and it is possible to point to a few cases of direct borrowing, such as the

50. Rowlandson: *The Hunt Supper*. About 1790. Pen and watercolour over pencil, $8\frac{11}{16} \times 12\frac{1}{4}$ in. (221 × 311 mm.). London, Victoria and Albert Museum

51. William Hogarth (1697–1764): *A Midnight Modern Conversation*. Engraving published March 1732/3. London, British Museum

52. William Hogarth (1697–1764): *The Lady's Last Stake*. Painted 1758–9. Oil on canvas, 36×41½ in. (914×1,054 mm.). Buffalo, New York, Albright-Knox Art Gallery.

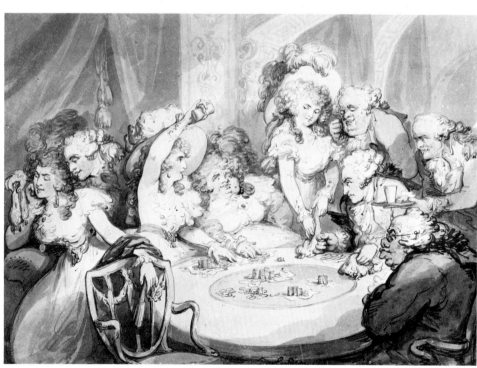

53. Rowlandson: *A Gaming Table at Devonshire House*. Signed and dated 1791. Pen and watercolour over pencil, 12⅛× 17⅛ in. (308×435 mm.). New York, Metropolitan Museum of Art

baffled doctor with his cane-head pressed to his nostrils,[89] the fat woman being bundled into a coach, possibly also the young officer trying to seduce the girl who has lost everything at cards with the offer of a fresh purse (Figures 52 and 53). Rowlandson must surely have absorbed most of Hogarth's characters and incidents into his artistic consciousness, even if he chose to exploit them only occasionally.

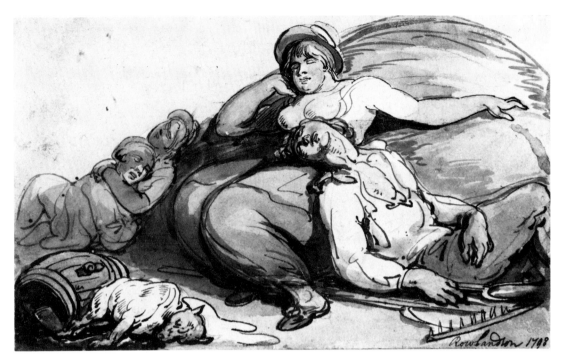

Other specific copies we know of were of Correggio's *Education of Cupid*,[90] and Reynolds's *Fortune Teller*[91] and *Death of Dido*.[92] He made a free variant of Gains-borough's *Haymaker and Sleeping Girl* (Figures 54 and 55) and used the girl for the pose in another drawing dated the same year (Figure 56); he also made a number of nude

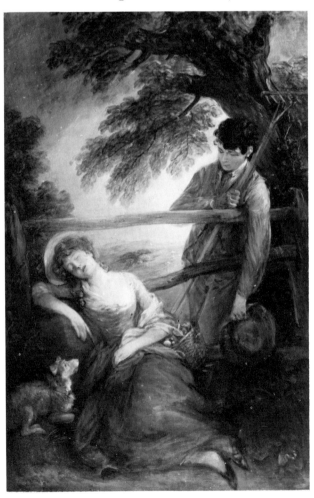

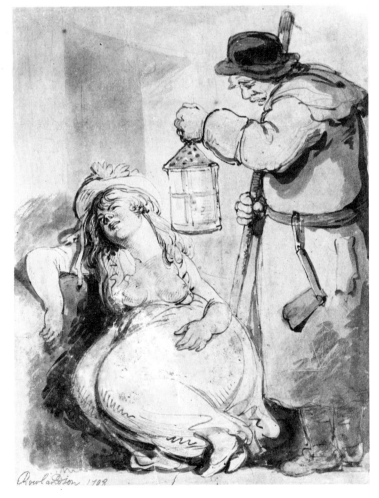

studies after Salviati,[93] Maratta, Boucher and others (Figure 57) which were used as the basis for compositions like his *Nymphs Bathing* of 1794.[94] He copied a series of antique vases, possibly in the Louvre in 1814 (Figure 58), and towards the end of his life made numerous sketches of antique busts, sculpture and decorative objects and of subjects from Egyptian art.[95] The purpose of these studies, many of which he seems to have made on a visit to Italy,[96] is unknown. Also at this late stage in his career he made studies of types of laughter[97] and comparisons between human and animal heads (Figure 59): possibly these were intended as preparations for publication, since there exist projected title-pages for a work on comparative anatomy.[98]

Much of Rowlandson's borrowing was from his own work. He adapted earlier subjects—*Dr Syntax and the Bookseller* derived from his early *Bookseller and Author*, and some of the Dance of Death scenes are re-workings of previous designs—and produced variations on his own themes, such as the *Lecture on Extravagance*, the *Music Master* (Figures 60 and 61) and *4 O'Clock in the Country*, repeating his types endlessly. His range of subject-matter may have been considerable, but he was too prolific not

57. Rowlandson: *Sheet of Studies of Nudes* (after various artists). About 1810–20. Inscribed. Pen and wash over pencil, 14⅝ × 18¾ in. (371 × 467 mm.). Manchester, University (Whitworth Art Gallery)

58. Rowlandson: *Study of a Vase*
(after the Antique). About 1814.
Pen, $11\frac{15}{16} \times 8\frac{15}{16}$ in. (303×227
mm.). Clonterbrook,
G. D. Lockett

59. Rowlandson: *Sheet
of Studies of Comparisons
between Human and
Animal Heads*. About
1820–1. Inscribed. Pen
and watercolour over
pencil, $8\frac{7}{8} \times 7\frac{1}{4}$ in.
(226×184 mm.).
London, Courtauld
Institute of Art (Witt
Collection)

60. Rowlandson:
The Music Master.
About 1790–8. From
*Mathew Bramble's
Trip to Bath*, but not
among those
engraved in 1798
as *The Comforts of
Bath.* Pen and water-
colour over pencil,
$4\frac{3}{4} \times 7\frac{1}{2}$ in. (121 ×
191 mm.). From the
collection of Mr and
Mrs Paul Mellon

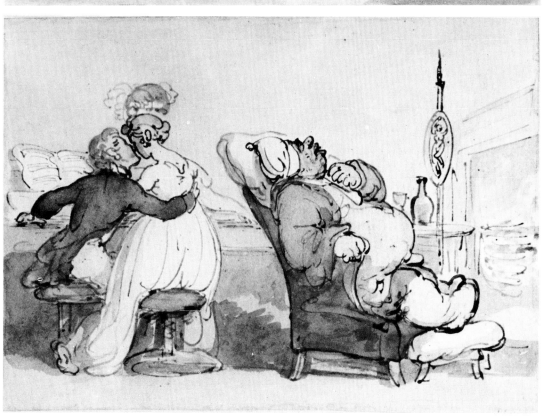

61. Rowlandson:
The Music Master.
About 1800–5. Pen
and watercolour
over pencil. Van-
couver, N. M.
Fleishman

to repeat himself, and in any case there were limits to his experience. On the whole,
it was the world which came before the notice of the comfortable middle class that he
pictured in his distorting mirror. He had little acquaintance with high society—the
Duchess of Portland's Drawing-Room[99] is emphatically not an aristocratic salon—and his
knowledge of the seamy side of life in no way approached Hogarth's. Nor was his
emotional range extensive. The comic and the everyday were what appealed to him;
the grand manner, the pathetic and the tragic were beyond his capabilities and
beyond the techniques and artistic vocabulary he employed. When he overstepped

59

the boundary, the result could be banal: the reactions in *The Suicide* (Plate 47), for instance, are stock reactions, ham acting, if you like, and entirely lacking in the poignancy of, say, Fuseli's *Lear Mourning over the Dead Cordelia*,[100] where the artistic means employed fully measure up to the situation.

For all his prodigious and varied output, perhaps one should say because of it, Rowlandson was in many ways a limited and superficial artist. The essentials of the man are in his line, his exuberance, and the content and humour of his *reportage*; his world is the ordinary world and the ordinary man's response to it.

1. Rowlandson to James Heath, 1 March 1804 (B.M. Add. Ms. 29300 f. 26).

2. See A. P. Oppé, *English Drawings . . . at Windsor Castle*, London, 1950, under Cat. Nos. 517, 510, 511, 530 and 541.

3. Earl Grosvenor sale, Christie's, 13 October 1802 (Lugt 6503), Lot 10 bt. Seger (= Seguier).

4. The Brodie drawings, now in the Mellon Collection, were bought by George, 5th Duke of Gordon (1770–1836); those at Brodick are likely to have been bought by Alexander, 10th Duke of Hamilton (1767–1852), unless they were among pictures inherited from his father-in-law, William Beckford.

5. Martin Hardie, *Water-Colour Painting in Britain 1. The Eighteenth Century*, London, 1966, p. 213. Another set is said to have been executed for the Prince Regent (A. P. Oppé, *Thomas Rowlandson: His Drawings and Water-Colours*, London, 1923, p. 21). A set catalogued as 'Cock Fighting; Bull Baiting; Billiards; and Instructions to a Jockey, *circles*, CAPITAL' was in the artist's sale at Sotheby's, 23 June 1828 ff. (Lugt 11790) 1st Day Lot 92. The sources for the statements made by Hardie and Oppé are not known.

6. Twelve drawings were published in 1798 as *The Comforts of Bath* for a new edition of Christopher Anstey's *New Bath Guide*, and the nine acquired by Sir James Lake were presumably bought subsequently. Lake composed a series of verses based on Anstey, and the volume containing both the drawings and the manuscript verses remained in the possession of the Lake family until 1946.

7. Henry Angelo, *Reminiscences*, London, 1830, Vol. 2, p. 325.

8. They were sold at Sotheby's on 29 June 1818 ff. (Lugt 9417) and 14 April 1819 ff. (Lugt 9559).

9. Oppé, *English Drawings*, under Cat. No. 516.

10. Thomas Rowlandson sale, Sotheby's, 23 June 1828 ff. (Lugt 11790).

11. Hardie, op. cit., p. 217.

12. Osbert Sitwell, 'Thomas Rowlandson', essay published in *Sing High! Sing Low!*, London, 1944, p. 117.

13. Oppé, *Rowlandson*, p. 1.

14. William Bates, 'Thomas Rowlandson, Artist', *Notes and Queries*, 2 October 1869, p. 278.

15. F. G. Stephens, 'Thomas Rowlandson, the Humourist', *Portfolio*, Vol. 22, 1891, p. 144.

16. Bernard Falk, *Thomas Rowlandson: His Life and Art*, London, [1949], pp. 34–5. The biographical facts which follow are drawn from Falk unless separate sources are cited.

17. Published by Sidney C. Hutchison in 'The Royal Academy Schools, 1768–1830', *Walpole Society*, Vol. XXXVIII, 1962, pp. 123–91.

18. See Gilbert Davis's introduction to the catalogue of the exhibition *Watercolours & Drawings by Thomas Rowlandson*, Arts Council, 1950, p. 2.

19. Angelo, *Reminiscences*, Vol. 1, p. 262. A portrait of Moser by Rowlandson is reproduced as Figure 20.

20. Joseph Grego, *Rowlandson the Caricaturist*, London, 1880, Vol. 1, p. 52.

21. Angelo, *Reminiscences*, Vol. 1, pp. 236–7.

22. Ibid., Vol. 2, p. 325.

23. Pierre Jeannerat stated specifically that he 'shared the sprightly existence of pupils at the Académie Royale' ('Thomas Rowlandson', *Daily Mail Ideal Homes Exhibition Catalogue*, London, 1948, p. 141), but Falk (*Rowlandson*, p. 10) was unable to substantiate the story of his having been a student at a French academy.

24. It is worth noting that the illustrations Rowlandson provided for Ackermann's *Naples and the Campagna Felice*, 1815, were of social scenes that needed nothing but his own invention. The views of Pompeii etc., and the engravings of the paintings from Herculaneum, were executed by other artists.

25. See under Plate 49. This point was first made by Oppé (*English Drawings*, under Cat. No. 518).

26. Angelo, *Reminiscences*, Vol. 2, p. 223.

27. The drawing, signed and dated 1785, is in the Victoria and Albert Museum (P. 118—1931).

28. Now in the Henry E. Huntington Library. See Robert R. Wark, *Rowlandson's Drawings for a Tour in a Post Chaise*, San Marino, 1963.

29. Ibid., pp. 4–5.

30. See the obituary in the *Gentleman's Magazine*, October 1800, p. 1008.

31. She is described as living in Poland Street in an affidavit dated 17 April 1789 (P.R.O. Prob. 10/3112).

32. Angelo, *Reminiscences*, Vol. 2, pp. 324–6. The incident was recorded in the daily press, and it is of interest to note that Rowlandson was already sufficiently well known to be recognized by his assailant, the paper reporting that 'the fellow appeared to have some presentiment of this Artist's forte, for he desired him to deliver his watch and money without making any *wry faces*!' (*Morning Herald*, 25 December 1786).

33. P.R.O. Prob. 10/3112.

34. B.M. 1901–10–30–2 (55): pasted into a scrapbook of Rowlandson drawings (press-mark 201.a.12).

35. Rowlandson to James Heath, 1 March 1804 (B.M. Add. Ms. 29300 f. 26).

36. He is recorded in the rate-books as living there from 1803 (*Survey of London*, Vol. XVIII, London, 1937, p. 112).

37. Angelo, *Reminiscences*, Vol. 1, pp. 238–9 and Vol. 2, p. 439.

38. John Thomas Smith, *A Book for a Rainy Day*, 2nd ed., London, 1845, p. 103.

39. Angelo, *Reminiscences*, Vol. 1, p. 240.

40. W. H. Pyne [Ephraim Hardcastle], *Wine and Walnuts*, 2nd ed., London, 1824, Vol. 2, p. 327.

41. Angelo, *Reminiscences*, Vol. 2, p. 293.

42. *Farington Diary*, 8 June 1796 (from the typescript in the B.M. Print Room, p. 656).

43. Angelo, op. cit., Vol. 2, p. 403.

44. Henry Angelo, *Angelo's Pic Nic*, London, 1834, pp. 144–5.

45. Angelo, *Reminiscences*, Vol. 2, p. 47.

46. Pyne, *Wine and Walnuts*, Vol. 2, p. 360.

47. Smith, *A Book for a Rainy Day*, p. 105.

48. W.P., 'Thomas Rowlandson, Artist', *Notes and Queries*, 31 July 1869, p. 89.

49. Hardie, *Water-Colour Painting*, p. 210.

50. A Rowlandson drawing in Berlin is inscribed in his own hand: *Madame Very Restaurateur Palais Royale a Paris 1814*, and both this and a companion drawing entitled *La Belle Liminaudière au Caffee de Mille Collone Palais Royale* were engraved in the same year.

51. Now in the collection of Mr G. D. Lockett.

52. The sketchbook in the Victoria and Albert Museum (E. 3242–3340–1938) containing numerous studies of antique sculpture, vases, armour etc., some noted as being in the Vatican Museum, is made up of paper watermarked 1820. Undoubtedly some of the studies are taken from books, but it would seem unlikely that the majority are, and there is a certain amount of internal evidence to suggest that Rowlandson was actually in Italy: on page 55 the sketch of a bas-relief is accompanied by a reference to 'the Sculptor who is restoring it', on page 66 objects are noted as being 'lately removed from the Villa Medici to Florence', and on page 80 there is a rough pencil sketch of the Rialto. This sketchbook would clearly repay closer investigation: in particular, it would be interesting to discover just why Rowlandson was bothering to spend so much time on studies of classical art.

53. A sketchbook watermarked 1822 containing studies of this subject (some of them, including a title-page, pasted in) is in the British Museum (press-mark 201. a. 13); two further sketchbooks, one containing another similar title-page, are in the Houghton Library at Harvard.

54. This drawing, formerly in the Gilbert Davis collection, is described in the catalogue of the exhibition *Watercolours & Drawings by Thomas Rowlandson*, Arts Council, 1950, No. 132.

55. *Gentleman's Magazine*, June 1827, p. 565.

56. Rowlandson owned a number of Mortimer prints of *banditti* (Thomas Rowlandson sale, Sotheby's, 23 June 1828 ff. (Lugt 11790) 1st Day Lots 7 and 8).

57. The principal desideratum is a study of the lesser French draughtsmen and watercolourists of the period.

58. See Wark, *Tour in a Post Chaise*.

59. Sitwell, '*Thomas Rowlandson*', p. 132. This view is firmly held by Wark (see *Ten British Pictures*, San Marino, 1971, p. 77).

60. An illustration of another sketch of Croom's Hill in the *Illustrated London News* for 20 August 1938 is noted as being part of a sketchbook recently sold in London.

61. See Oppé, *Rowlandson*, pp. 5–6.

62. W.P., 'Thomas Rowlandson, Artist', p. 89. The author states in a later note that he derived much of his information about Rowlandson from a friend who knew the artist (*Notes and Queries*, 4 December 1869, p. 490).

63. Desmond Coke called it a 'cock-and-bull story' (*Confessions of an Incurable Collector*, London, 1928, p. 131) and was followed in this view by Falk (*Rowlandson*, p. 194).

64. Thomas Rowlandson sale, Sotheby's, 23 June 1828 ff. (Lugt 11790) 4th Day Lot 461.

65. Robert R. Wark, *Rowlandson's Drawings for the English Dance of Death*, San Marino, 1966, p. 24.

66. William T. Whitley, *Artists and their Friends in England 1700–1799*, London, 1928, Vol. 2, pp. 396–7.

67. *Gentleman's Magazine*, June 1827, p. 565; Angelo, *Reminiscences*, Vol. 1, pp. 234–5.

68. This is now in the Wiggin Collection, Boston Public Library.

69. Grego, *Rowlandson the Caricaturist*, Vol. 1, pp. 18–19.

70. V. S. Pritchett overstated the case when he wrote that 'to Rowlandson the human race

are cattle or swine, a reeking fat-stock done up in ribbons or breeches, which has got into coffee-houses, beds and drawing-rooms. . . . In these pictures we see the nightmare lying behind the Augustan manner. . . . Smollett and Rowlandson run so closely together in the drawing of these things that one borrows from the other's brutality' (*The Living Novel*, London, 1946, pp. 19–20).

71. M. Dorothy George, *Hogarth to Cruikshank: Social Change in Graphic Satire*, London, 1967, p. 57.

72. J. P. Malcolm, *An Historical Sketch of the Art of Caricaturing*, London, 1813, p. iii. S. W. Fores called their Piccadilly shop the 'Caracatura Warehouse.'

73. Robert R. Wark, *Isaac Cruikshank's Drawings for Drolls*, San Marino, 1968, p. 10.

74. *Gentleman's Magazine*, June 1827, p. 564.

75. Reproduced in Falk, *Rowlandson*, opp. p. 21.

76. Oppé, *English Drawings*, under Cat. No. 544.

77. Angelo, *Reminiscences*, Vol. 2, p. 1.

78. Oppé, *Rowlandson*, p. 7.

79. Victoria and Albert Museum (P. 198–1929).

80. Wark, *English Dance of Death*, p. 10.

81. See Falk, *Rowlandson*, opp. p. 148.

82. Smith, *A Book for a Rainy Day*, p. 104.

83. An interesting extension of this practice is the park scene signed and dated 1799, formerly with Leger Galleries, where a couple of sculptured figures on a pedestal are depicted kissing and evidently reflect the expectations of a young lady out with her boy friend.

84. Wark, *Ten British Pictures*, p. 77.

85. See A. P. Oppé, *The Drawings of William Hogarth*, London, 1948, under Cat. No. 29.

86. Oppé, *English Drawings*, No. 542; reproduced in Falk, *Rowlandson*, opp. p. 56. The Hogarth is in the National Gallery, London.

87. David Berg Collection, New York. The Hogarth is in the British Museum (1896–7–10–20).

88. Compare Hogarth's *Strolling Actors dressing in a Barn* (Ronald Paulson, *Hogarth's Graphic Works*, 2nd ed. revised, New Haven, Connecticut, and London, 1970, Vol. 2, pl. 168), *A Midnight Modern Conversation* and *The Distressed Poet* (Paulson, pl. 156–7).

89. Compare Hogarth's *The Company of Undertakers* (Paulson, *Hogarth's Graphic Works*, Vol. 2, pl. 155).

90. British Museum (1943–11–13–124). The Correggio is in the National Gallery, London.

91. Wiggin Collection, Boston Public Library. The Reynolds is at Waddesdon Manor, Buckinghamshire.

92. Ibid. The Reynolds is in the royal collection.

93. There is a sheet with two compositions of nudes inscribed as after Francesco Salviati in the Widener Collection at Harvard.

94. Last recorded in the Brewerton sale, Christie's, 12 December 1924, Lot 48 bt. Ford.

95. There are two books in the British Museum (pressmarks 201.a.14 and 15), with studies after antique sculpture and busts respectively pasted in, and a sketchbook in the Victoria and Albert Museum (E.3242–3340–1938), with paper watermarked 1820, containing studies of antique and Egyptian subjects.

96. See Note 52.

97. See Note 54.

98. See Note 53.

99. London Museum (John Hayes, *A Catalogue of the Watercolour Drawings of Thomas Rowlandson in the London Museum*, 1960, No. 25, reproduced pl. 14 and 15).

100. Frederick Antal, *Fuseli Studies*, London, 1956, pl. 18a.

Note to the plates

Rowlandson's style changed comparatively little after the 1780s, and he was apt
to work in different manners at the same time, so that the rough dates proposed
for the undocumented drawings illustrated, though controlled by comparison with
dated works and by internal evidence such as costume, should be treated with
some caution. The very difficulty of establishing a chronology for Rowlandson's
drawings made it seem worth while to attempt to date all those illustrated here,
and to reproduce them as far as possible in date order. Details of provenance have
not been given except where they are of exceptional interest. The word 'inscribed'
is used to indicate where an inscription on a drawing is in the artist's own hand.
Dimensions are given in inches and millimetres, height preceding width. No
attempt has been made to distinguish drawings in which contours may have been
executed with the tip of the brush rather than with the pen, and the word 'pen'
has been used throughout for the sake of convenience.

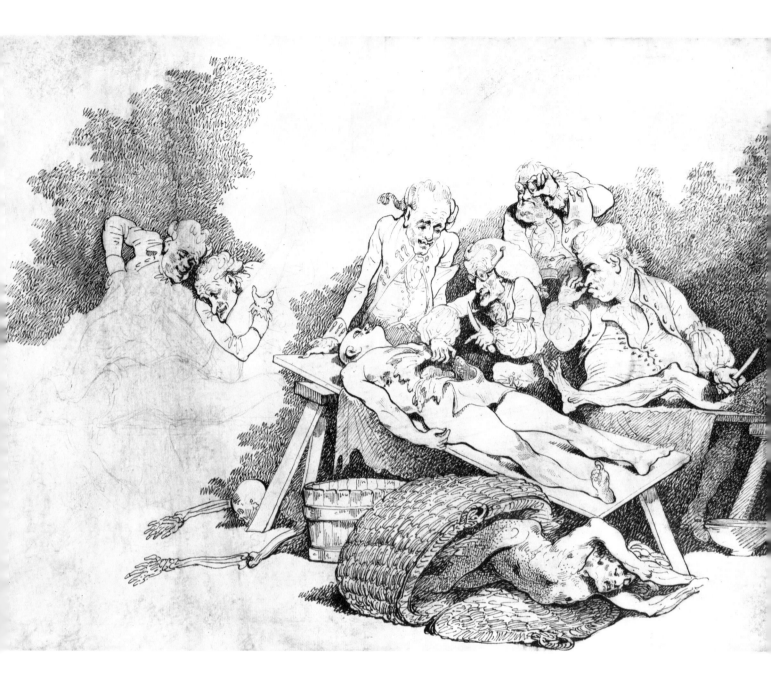

1. The Dissection. About 1775–80. Unfinished. Pen over pencil, 14 × 19 in.
(356 × 483 mm.). *San Marino, California, Henry E. Huntington Library and Art
Gallery*

One of Rowlandson's earliest surviving drawings, probably executed when he was
about twenty. Both the subject-matter and the technique are strongly influenced
by Mortimer (see p. 29 and Figure 15). Characteristic of Rowlandson are the
flexibility of the penwork and the sinuous, rococo quality of the line. Early clues
to his enduring predilections are afforded by the intrusion into so macabre a
subject of slightly caricatured heads and of the extraneous erotic scene on the left,
where the doctors are absorbed, one light-heartedly, the other obsessively, by the
shapely leg and posteriors of the dead woman; the concentrated virulence of
Mortimer is totally lacking. Note how the skeleton under the table seems to be
almost alive, so vital is Rowlandson's pen line.

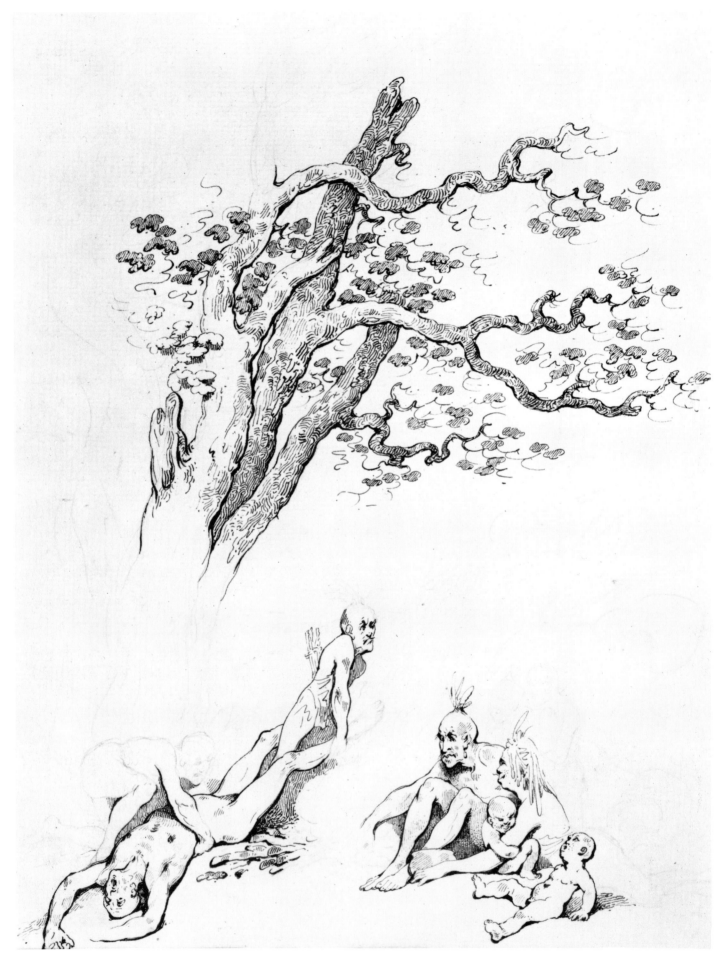

2. The Captive. About 1775–80. Unfinished. Pen over pencil, $10\frac{3}{16} \times 7\frac{7}{8}$ in. (275 × 200 mm.). *London, D. L. T. Oppé*

A subject probably inspired by one of Mortimer's *banditti* prints, of which Rowlandson owned a good number. The potential horror and degradation implicit in the idea of the victim being dragged naked along the ground by a couple of savages is nullified not only by the rococo treatment of the pen line but by the bucolic character of the Red Indian family on the right. The internal modelling of the tree trunks and the tortuous spiralling of the branches and twigs are mannered to a degree.

3. A Bench of Artists. Dated 1776 and inscribed. Pen over pencil, 10×21 in. (254 × 533 mm.). *London, D. L. T. Oppé*

Rowlandson's earliest known dated drawing, a study of some of his contemporaries at the Royal Academy Schools: Beechey is seen in the centre. The profile of Thomas Burgess (on the left) seems to anticipate many of Rowlandson's later caricatures, but the remaining heads are more obviously likenesses of the respective sitters. If one examines the drawing of the legs, it is clear that Rowlandson has not yet mastered anatomical correctness, but the tension of the bodies is admirably expressed. The stippling and regularity of hatching are mannerisms derived from Mortimer rather than Ghezzi (see Figures 17 and 19), though the latter's work was, of course, influential on both artists.

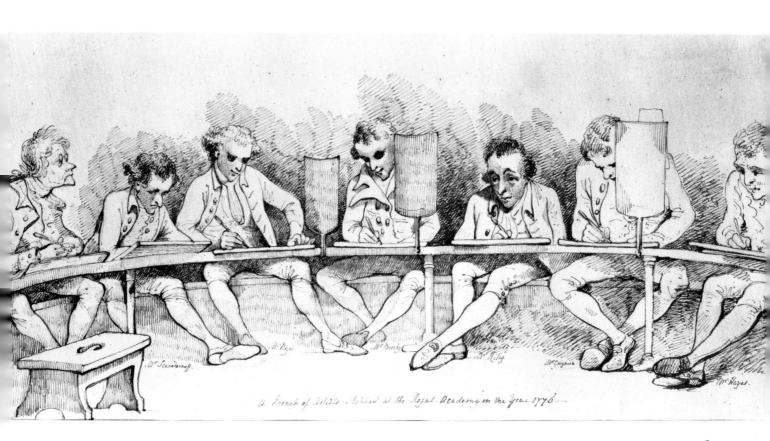

4. The Collapse of a Sedan Chair. About 1775–80. Unfinished. Pen and some watercolour over pencil, $8\frac{1}{4} \times 12\frac{5}{8}$ in. (210×321 mm.). *London, British Museum*

A typically Hogarthian *mélange*. The somewhat indeterminate nature of the pencil drawing is also characteristic of Hogarth: from this imprecision of initial statement Rowlandson was free to select the contour he wished to define. Compare the muscular tension of the arms of the old cobbler with the flatness of the chairman's right arm, only partially outlined with short strokes of the pen.

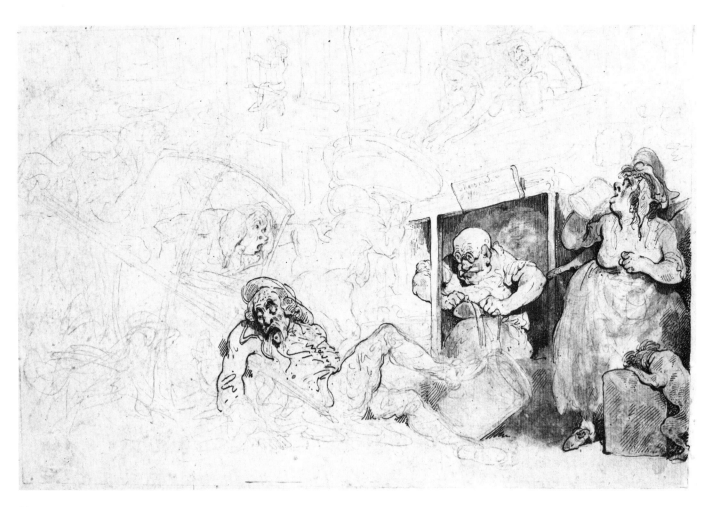

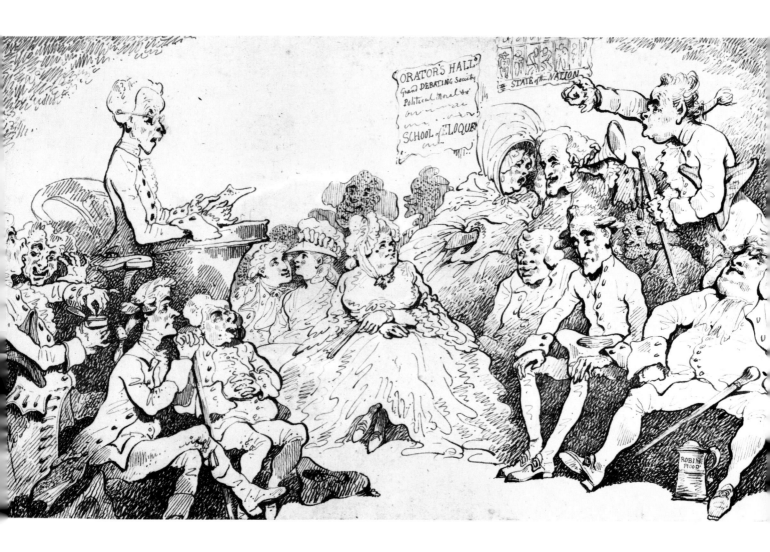

5. The School of Eloquence. About 1778–80. Etched and published by
Archibald Robertson, 18 July 1780. Pen over pencil, $11\frac{5}{8} \times 19\frac{1}{2}$ in.
(295 × 495 mm.). *Windsor Castle (reproduced by gracious permission of Her Majesty
The Queen)*

Purchased by the Prince Regent from Colnaghi in 1812 as 'A Drawing of the
Grand Debating Society'. The composition builds up towards the speaker
gesticulating on the right in a superb diagonal, but the links between the group on
the left and the remainder of the company are not entirely effective. The influence
of Ghezzi and of contemporaries such as Thomas Patch is strongly marked in
certain of the heads caricatured, notably the figure on the extreme left (compare
Figure 19).

6. The Lover. About 1778–80. Falsely signed. Pen and grey wash over pencil, $6\frac{7}{8} \times 7\frac{3}{16}$ in. (175 × 183 mm.). Reproduced original size. *London, D. L. T. Oppé*

For the most part Rowlandson is still using the stippling and zig-zag techniques he derived from Mortimer for the suggestion of shadows and half-tones, but in some areas he has begun to employ wash for this purpose.

7. The Kiss. About 1778–80. Pen and mauve wash over pencil, $8\frac{5}{16} \times 6\frac{15}{16}$ in. (211 × 176 mm.). *London, Courtauld Institute of Art (Witt Collection)*

A drawing in some respects similar to that shown opposite and similarly lacking in communication between the two figures. In this case, however, Rowlandson has discarded Mortimer's technical mannerisms and mastered the use of wash as a medium for suggesting shadow and the fall of light. Though the outlines are more loosely drawn than in previous work the rough, thin strokes indicating the fall of the lady's dress fully convey the weight and mass of the body beneath. On the verso is a slight caricature sketch of a man, in pencil.

8. The Fight. About 1778–80. Pen and grey wash, $4\frac{11}{16} \times 7\frac{5}{16}$ in. (119×186 mm.). Reproduced original size. *London, British Museum*

One of the most brilliant of Rowlandson's early sketches, and an ideal drawing in which to study the variety of his use of line. Thick, solid contours are used to outline the figures of the two boxers and these have a tremendous force of their own, but the sense of movement and violence is further reinforced by the whirling, sketchier lines of the figures in the background. On the verso is an academic study of the musculature of an arm in the manner of Annibale Carracci, doubtfully by Rowlandson.

9. Portrait of Jack Bannister in His Dressing Room at Drury Lane.

Dated 23 December 1783 and inscribed. Pen and grey wash, with a little pink wash, $6\frac{3}{4} \times 4\frac{9}{16}$ in. (171 × 116 mm.). *From the collection of Mr and Mrs Paul Mellon*

A vigorous sketch from the life, also executed directly with the pen. The concentration of the hairdresser has been caught perfectly, and the drawing has a snapshot effect. John Bannister (1760–1836), the great comic actor, was a fellow student of Rowlandson's at the Royal Academy Schools, and the two became lifelong friends. See also Plates 39 and 77.

10. Doctors Differ. About 1780–4. Etched by S. Alken and published by
S. W. Fores, 28 November 1785. Pen and grey wash over pencil, $7\frac{3}{16} \times 10\frac{1}{16}$ in.
(183 × 256 mm.). *Ottawa, National Gallery of Canada*

In this drawing Rowlandson has used short, thick strokes of the pen to create
contours, sometimes, as in the case of the doctor with his back to the spectator,
breaking the line in an abrupt and incisive manner foreshadowing the highly
personal calligraphy of the tailpiece from *A Tour in a Post Chaise* (see p. 214).
Internal modelling is suggested in odd squiggles and hatching. Wash is used in
addition to Mortimer-like zig-zag penwork for the background shadows.

11. **Bookseller and Author.** About 1780–4. Etched and published by
J. R. Smith, 25 September 1784. Pen and watercolour, $9\frac{1}{8} \times 11\frac{1}{8}$ in.
(232 × 257 mm.). *Windsor Castle (reproduced by gracious permission of Her Majesty The Queen)*

Similar in technique to the drawing reproduced opposite. As usual with Rowlandson, shape is created entirely by line, the pot-belly of the pompous book-seller, for instance, being intimated largely by the foreshortening of his coat buttons: the wash brushed across his leg is independent of shape and serves no descriptive purpose. The rather bilious countenance of the subservient author is modelled in touches of grey, grey-blue and orange, and this use of varying tints in the flesh tones is characteristic of the work of the mid-1780s. According to the inscription on the print, Rowlandson's friend Wigstead was responsible for the design.

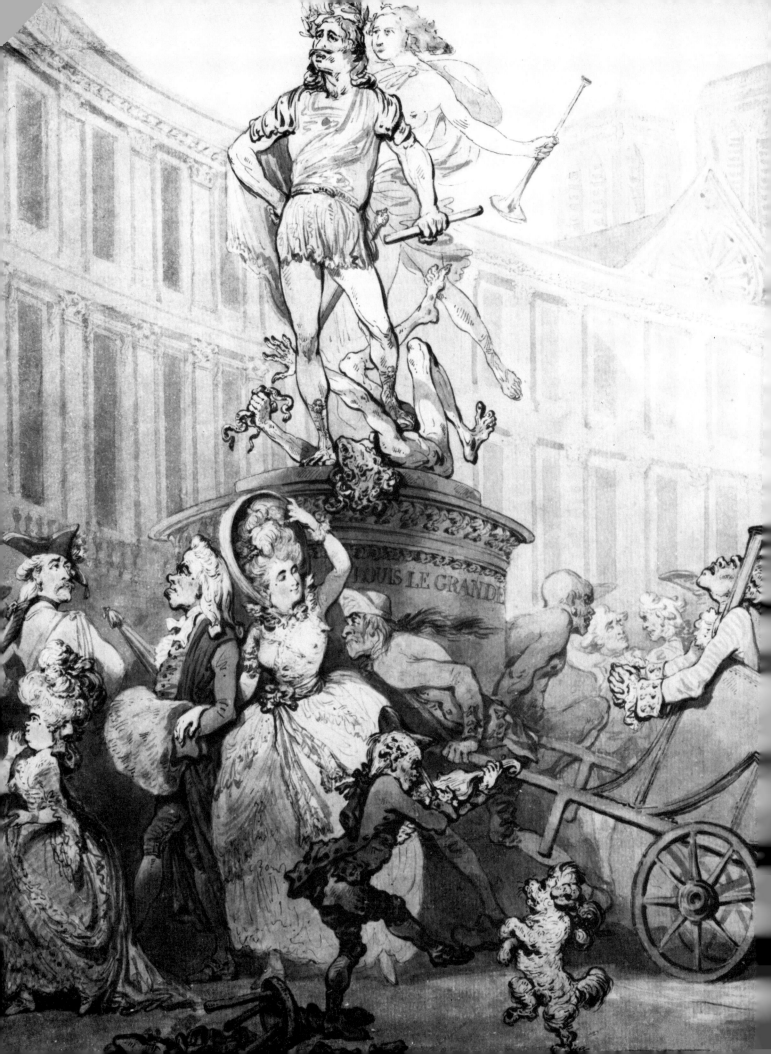

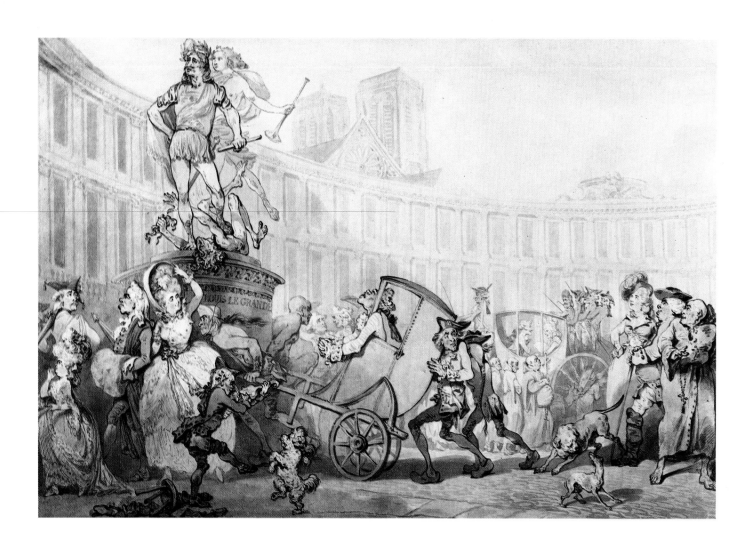

12, 13. Place des Victoires, Paris. Perhaps exhibited Society of Artists 1783 (223). Etched and published by S. Alken, November 1789. Pen and watercolour over pencil, 14⅛ × 20¾ in. (359 × 527 mm.). *Cambridge, Massachusetts, Dr Joseph R. Goldyne*

A view of the monument to Louis XIV, which was erected in the Place des Victoires by the duc de la Feuillade in 1686 and destroyed during the French Revolution. The group shows *le Grand Monarque* being crowned by Fame and trampling on a figure representing the enemies of France; it is strongly emphasized compositionally by the sweep of the crescent behind. Among incidents ridiculing the French (one of Rowlandson's favourite diversions) are the poodle dressed in a peruke being taught to dance by a shoeblack, the chariot of an overfervent admirer of Louis being shoved along by a couple of chairmen, and the procession of monks in the background. A couple of English tourists are sensibly oblivious of the happenings around them. The topography is somewhat fanciful, since the towers of Notre-Dame would not have been visible from this point (the cathedral is actually three-quarters of a mile away): the point of their being there is clearly to suggest Paris unequivocally to the English spectator. Another version of this composition is signed and dated 1784; unless Rowlandson repeated the design a number of times, it seems likely that the present watercolour is the one originally exhibited at the Society of Artists.

14. Rowlandson and the Fair Sitters. About 1783–4. Pen and watercolour over pencil, 6¼ × 8 in. (159 × 203 mm.). *San Marino, California, Henry E. Huntington Library and Art Gallery*

Self-portrait of the artist sketching an attractive and fashionably dressed young charmer. Rowlandson exhibited several watercolour portraits at the Royal Academy between 1778 and 1781, and a number of portraits survive of young women, though few of the sitters' names are recorded. The drawing style is similar to that in *The Kiss* (Plate 7), and the background is highly simplified.

15. Portrait of Miss Baker. About 1783–4. Inscribed. Pen and watercolour over pencil, 10½ × 7¾ in. (267 × 187 mm.). *Formerly London, Hazlitt Gallery*

A particularly appealing example of Rowlandson's portraiture of the mid-1780s, couched in the slightly sentimental vein characteristic of one side of late eighteenth-century British art and literature. The hat seems to be an afterthought. Note the extreme economy with which Rowlandson has suggested, in a few rapid strokes of the pen, the weight and fullness of the young lady's skirt. Nothing is known about Miss Baker.

79

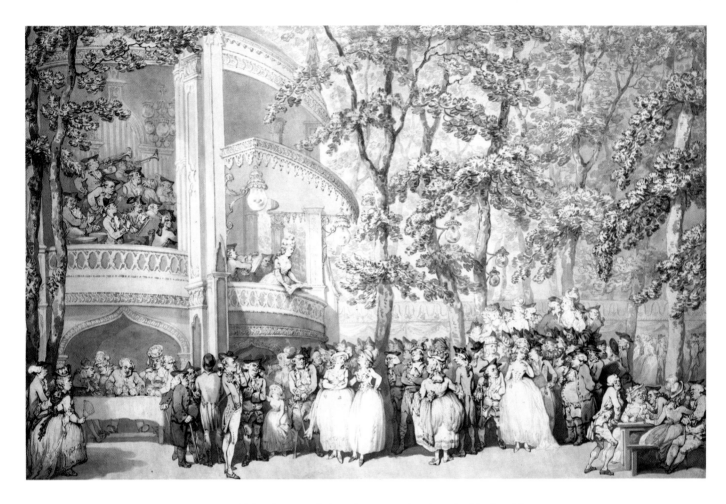

16, 17. Vauxhall Gardens. Exhibited Royal Academy 1784 (503). Etched by
R. Pollard, aquatinted by F. Jukes, and published by J. R. Smith,
28 June 1785. Pen and watercolour over pencil, 19 × 29½ in. (483 ×
749 mm.). *London, Victoria and Albert Museum*

Perhaps Rowlandson's most famous watercolour, and one of the finest examples of
his large-scale exhibition drawings. The colour (now sadly somewhat faded) and
the general effect are of extreme elegance, but closer examination reveals a wealth
of comic expression and incident throughout the composition. The figure
arrangement is somewhat schematic and lacking in that natural disposition in
space one finds in, for example, Manet's *Concert in the Tuileries Gardens*; but the
design has a compensating nobility, largely the product of the dominating
verticals. Vauxhall was one of the most fashionable of all the London pleasure
gardens, and Rowlandson has included a number of portraits of leading members
of London society in the foreground, notably, on the right, the Prince of Wales
and 'Perdita' Robinson. The detail (opposite) shows the vocalist, Mrs Weichsel,
mother of the more celebrated Mrs Billington. Among the company assembled
below are Captain Topham, owner and editor of the *World*, described by
Rowlandson's friend Angelo as 'the macaroni of the day', who is quizzing the
Duchess of Devonshire and Lady Bessborough (see also Plate 75), the
wooden-legged Admiral Paisley, Sir Henry Bate-Dudley, editor of the *Morning
Herald* (behind the tree), and James Perry, editor of the *Morning Chronicle* (in
Highland dress). A smaller version of this subject is in the collection of Mr and
Mrs Paul Mellon.

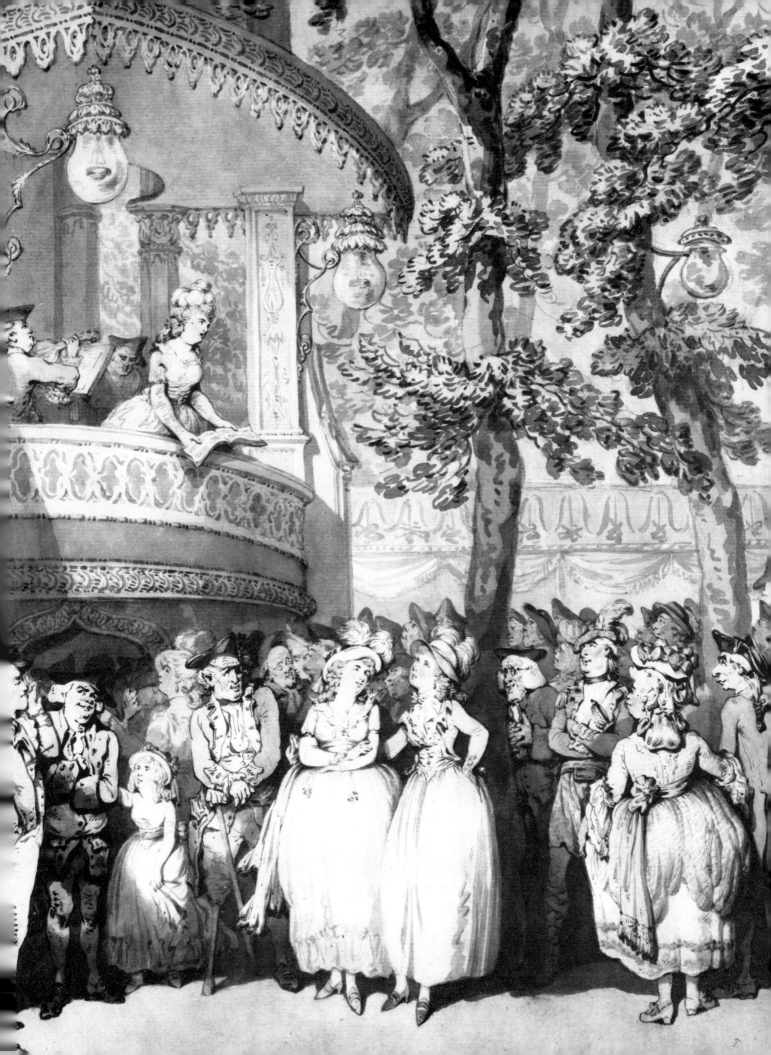

18. Buying Leather Breeches—Previous to our Journey. From *A Tour in a Post Chaise*, September 1784. Inscribed on the verso. Pen and watercolour, $4\frac{15}{16} \times 7\frac{7}{8}$ in. (125 × 200 mm.). *San Marino, California, Henry E. Huntington Library and Art Gallery*

In September–October 1784 Rowlandson and his friend Wigstead made a twelve-day tour to the Isle of Wight and back, possibly to see the wreck of the *Royal George*, which had foundered off Spithead in 1782. Rowlandson worked up nearly seventy watercolours from drawings made on the journey, and it seems probable that, as in the case of later tours with Wigstead, publication was intended. Such, however, did not take place. This masterly sketch, Rowlandson at the peak of his form, shows the artist and his portly friend being fitted out with breeches preparatory to the journey. Notice the way in which the cutters worked, seated cross-legged on a long bench.

19. A Monument in Salisbury Cathedral. From *A Tour in a Post Chaise*, September–October 1784. Pen and watercolour over pencil, $4\frac{7}{8} \times 7\frac{15}{16}$ in. (124×202 mm.). *San Marino, California, Henry E. Huntington Library and Art Gallery*

Rowlandson and Wigstead spent at least a couple of days in Salisbury visiting the sights, notably the cathedral, Stonehenge and Wilton House, before going on to Southampton. The solid character of the pen line may be contrasted with the incisiveness of the previous sketch (Plate 18). A sketch for this drawing is on the verso of another watercolour in the same series.

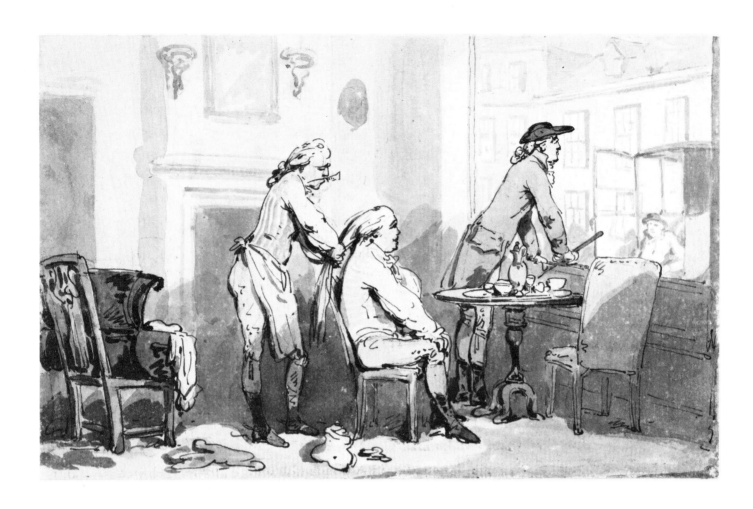

20. The Chaise Waiting to Carry Us to Lymington. From *A Tour in a Post
Chaise*, September–October 1784. Pen and watercolour over pencil, $5 \times 7\frac{15}{16}$ in.
(127 × 202 mm.). *San Marino, California, Henry E. Huntington Library and Art
Gallery*

Rowlandson and Wigstead preparing for departure from the Coach & Horses
at Southampton. Rowlandson's artistry in suggesting the stance and
concentration of the barber is comparable with his sketch of Jack Bannister
(Plate 9). Notice how the shape of the barber's trunk is indicated with a few
touches of Indian ink applied with the tip of the brush. The background, mostly
unimportant to the scene, is hardly more than washed in; the pen lines
describing the left side of the window are clearly put in over the wash, and provide
useful evidence for the view that, in this series of drawings as in certain other
works, Rowlandson reserved his most powerful instrument, the reed pen, for the
last stage in the design, as a means of pulling the composition together.

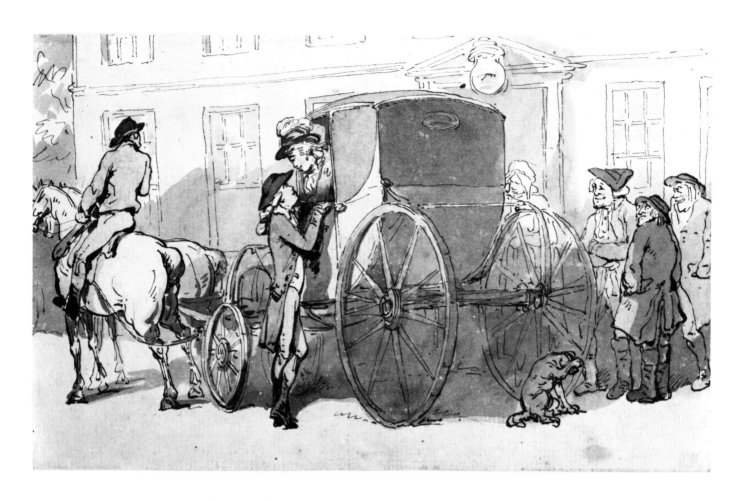

21. Rowlandson Talking with a Lady outside the Angel, Lymington.
From *A Tour in a Post Chaise*, September–October 1784. Pen and watercolour over pencil, $5 \times 8\frac{1}{16}$ in. (127 × 205 mm.). *San Marino, California, Henry E. Huntington Library and Art Gallery*

Rowlandson and Wigstead spent several days at Lymington before crossing to the Isle of Wight. The reason for their delay in this comparatively uninteresting small town may be indicated in the present drawing. Rowlandson's flexible and descriptive pen line is enriched in certain passages by shadows put in with the brush, a technique most evident in the figure of the postillion.

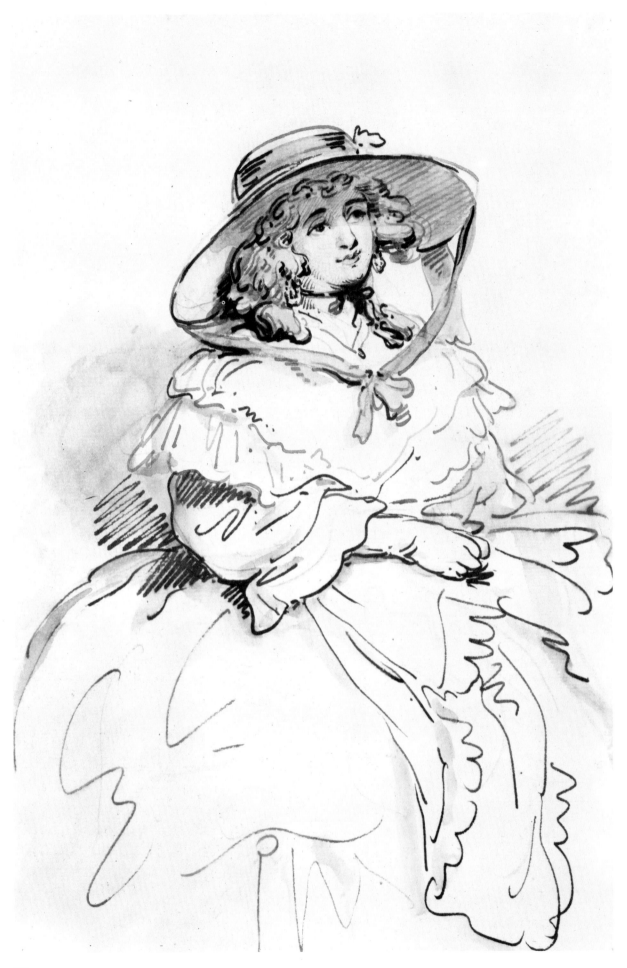

22. Portrait of a Young Lady in a Blue Hat. About 1783–4. Pen and water-colour over pencil, $11\frac{15}{16} \times 7\frac{7}{8}$ in. (303 × 200 mm.). *Cambridge, Massachusetts, Fogg Art Museum*

The whole conception of the portrait and the gentle, slightly wistful expression of the sitter are very much in the manner of Wheatley, but the bold, loose squiggles suggesting the fall of the costume are rather out of key with this mood, and reminiscent of Farington's pen technique.

23. A Young Lady Reading, Watched by a Young Man. About 1783–4. Signed. Pen and watercolour over pencil. *Vancouver, N. M. Fleishman*

A lively sketch with a vigorous use of wash and exceptionally bold penwork outlining the shape of the young man's leg. The girl's intent concentration on her book is enhanced by this expressive technique.

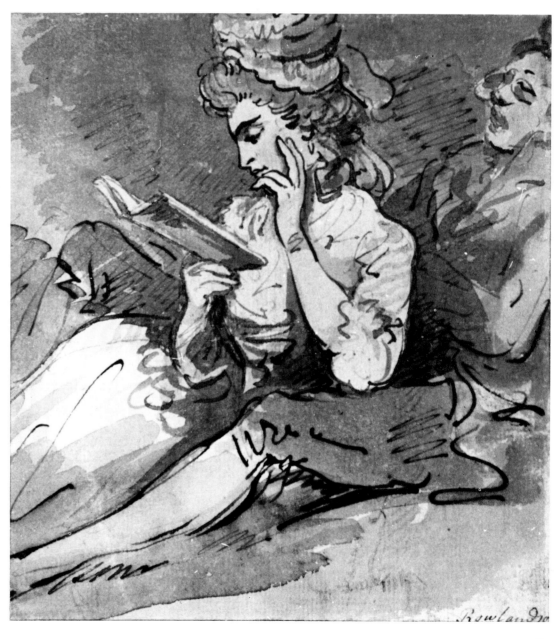

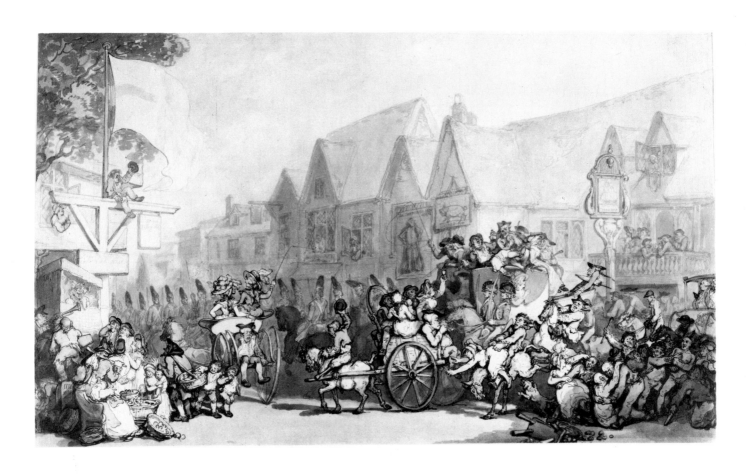

24, 25. George III and Queen Charlotte Driving through Deptford.
About 1785. Unfinished on the left. Pen and watercolour over pencil,
16½ × 27¾ in. (419 × 705 mm.). *Mrs Rosemary Blake-Tyler*

One of Rowlandson's most beautiful and important watercolours, comparable in
size with his great exhibition pieces *Vauxhall Gardens* (Plates 16 and 17) and *Skaters
on the Serpentine* (Figure 22) and in an unusually fine state of preservation. The
scene is the junction of Broadway and High Street, Deptford; the Centurion
tavern, seen on the left, still survives as No. 1 Broadway, but the Old Ship seems
to have been an invention of Rowlandson's. The chariot containing the royal pair
is seen on the extreme right, preceded by a corporal and trooper of the 8th Light
Dragoons and a full escort of Horse Grenadier Guards. It is typical of Rowlandson
that the royal chariot should not occupy a central position, and the procession is
obscured by a mass of people either jumbled onto a passing cart and stage coach,
or else squabbling in the foreground: Rowlandson's figure grouping in these
passages is lively and highly accomplished. The beautiful Watson sisters are seen
riding by in a vis-a-vis (Frontispiece) and the figure in the basket behind the
coach, with an umbrella under his arm, is probably intended for Jonas Hanway.
Patrick Cotter, 'The Surprising Irish Giant', who exhibited himself as a freak at
Bartholomew Fair, and 'The Learned Pig', which caused a sensation with its
mathematical and other tricks in 1784, were the subject of separate prints by
Rowlandson, both dated 1785. The view showing George III and Queen
Charlotte launching a frigate at Deptford Dockyard, now in the Victoria and
Albert Museum, is a companion to this drawing. Neither episode seems to have
been inspired by an actual event.

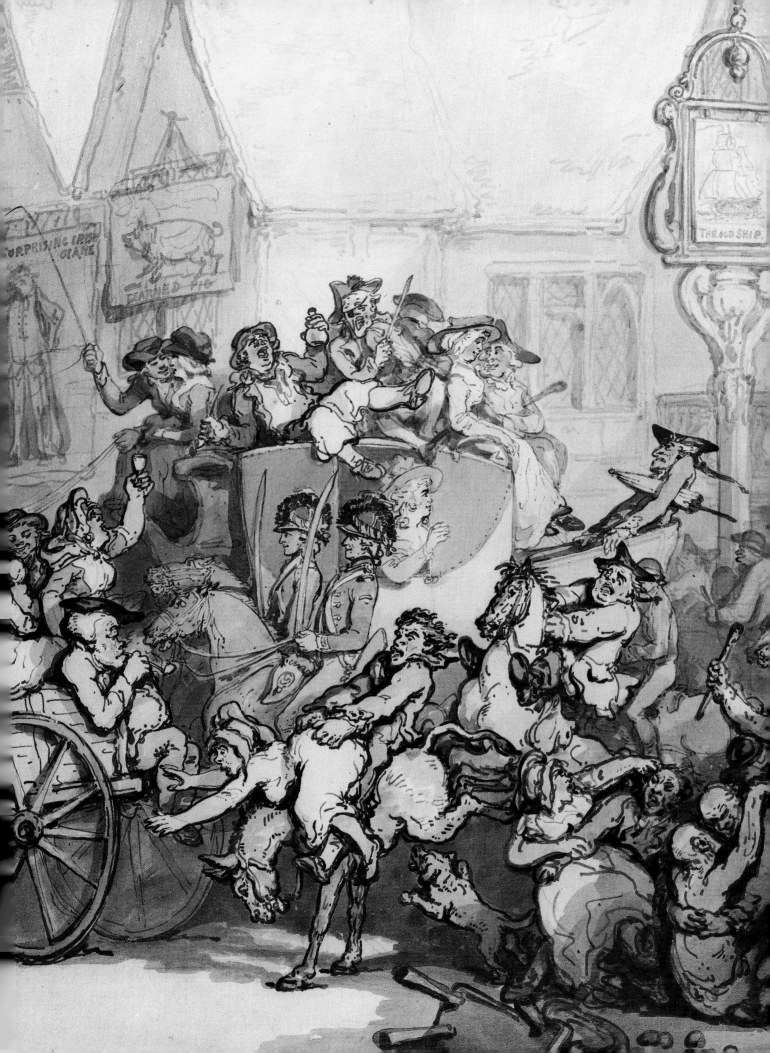

26. The Parish Vestry. Signed and dated 1784. Pen and watercolour over pencil, $10\frac{7}{8} \times 18\frac{5}{8}$ in. (276 × 473 mm.). *London, Victoria and Albert Museum*

A rhythmical semicircular composition; the focal point is emphasized by the official wearing a three-cornered hat, who is ogling, through a pair of spectacles held at the end of his nose, the pretty young girl being interviewed. The dots and dashes modelling the faces are characteristic of this period in Rowlandson, and scratchy penwork is still used in the shadows in certain areas. The group of councillors on the left conversing in a self-satisfied way is well observed.

27. The Painter Disturbed. Etched and published by S. W. Fores, 30 November 1785. Pen and watercolour over pencil. *Formerly Henry S. Reitlinger Collection*

Rowlandson's extraordinarily fluent and assured descriptive pen line is demonstrated here in the drawing of the nude model and of the draperies on which she is reclining; her feeling of shame is reinforced compositionally by the strong diagonals which pull the figures apart. It is typical of Rowlandson's approach to his art that he should be unconcerned with the shape of the couch as it disappears behind the easel.

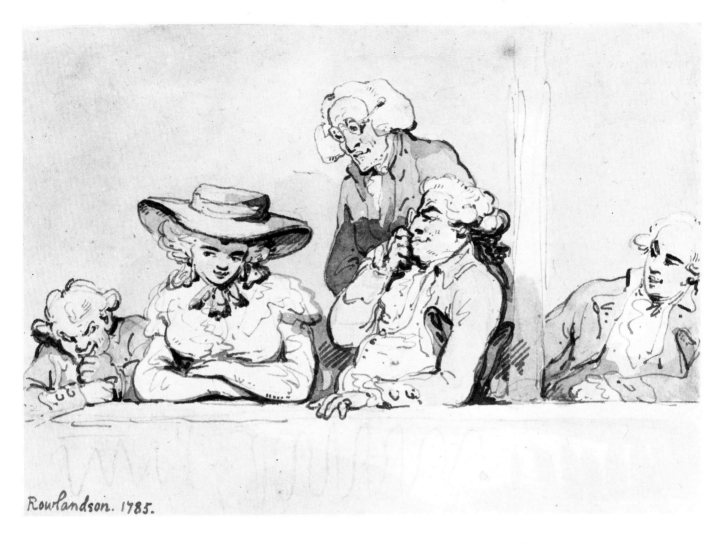

Rowlandson. 1785.

28. A Side Box at the Opera. Signed and dated 1785. Etched about 1785. Pen
and watercolour over pencil, $4\frac{1}{4} \times 6\frac{1}{4}$ in. (108 × 159 mm.). Enlarged.
Cambridge, Massachusetts, Fogg Art Museum

One of a group of four drawings of opera 'boxes', possibly connected with
Rowlandson's *Opera House Gallery*, now missing, exhibited at the Academy of 1786.

29. Box Lobby Loungers. Etched by Rowlandson after a design by Wigstead and published by J. R. Smith, 5 January 1786. Pen and watercolour over pencil, $14\frac{5}{8} \times 22$ in. (371×559 mm.). *Burghfield Common (Berkshire), Major L. M. Dent*

A group of fashionable and other loungers in a theatre lobby. The principal character is Colonel George Hanger, one of the intimates of the Prince of Wales, who is seen in the centre with a thick stick under his arm, admiring a couple of attractive young girls. A more elderly and short-sighted beau on the right has unwittingly put his foot on the skirt of the lady he is ogling. In the print, there is a playbill on the wall advertising 'The Way of the World' and 'Who's the Dupe?', an obvious reference to the varied incidents contained in the drawing. The extent of Wigstead's contribution to Rowlandson's composition is impossible to determine, but clearly he was not involved in the execution in any way.

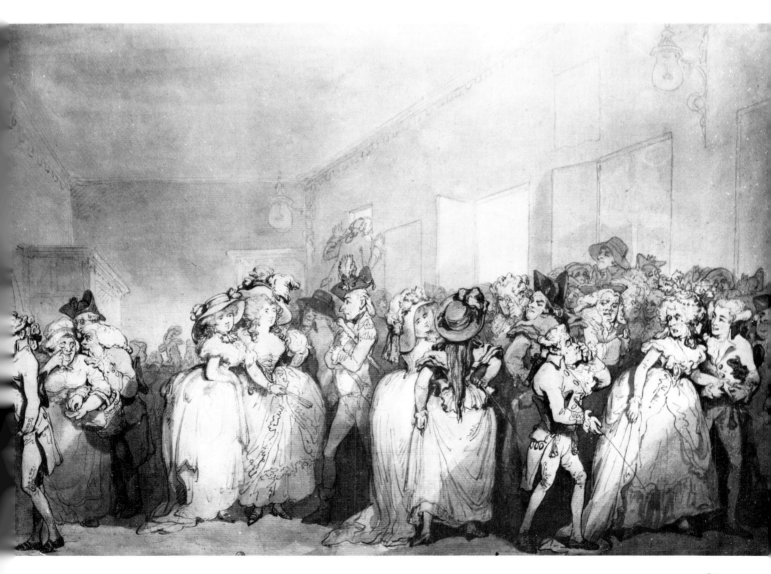

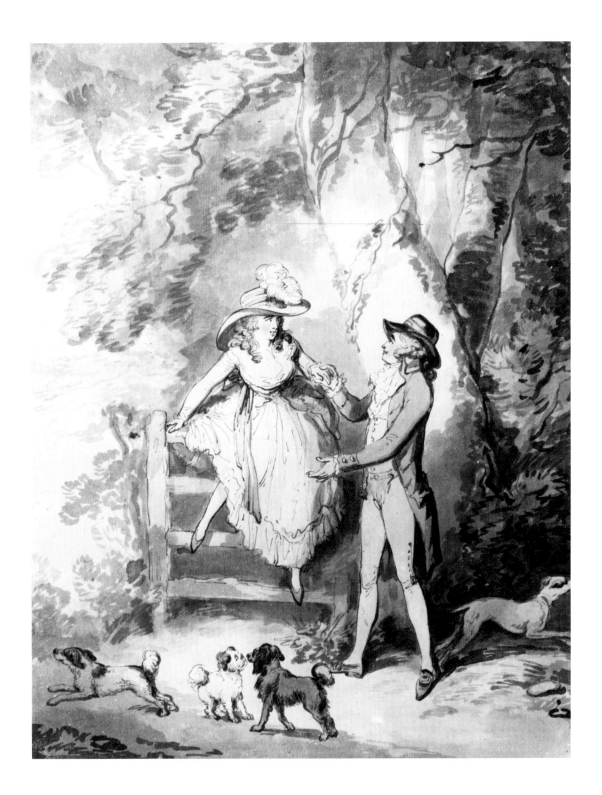

30. Courtship. About 1785–6. Pen and watercolour over pencil, $14 \times 11\frac{1}{4}$ in. (356 × 286 mm.). *England, Private Collection*

An elegant young man is seen helping his loved one over a gate. The couple's feelings towards one another are echoed by the little dogs sniffing happily at each other in the foreground, a motif probably suggested by the marriage scene in Hogarth's *A Rake's Progress*. The sensitive handling of the background trees and foliage is close in character to similar passages in the *Hunt* series (compare Plate 34), and the colouring, in greys and blues and pale russets, is very French in quality.

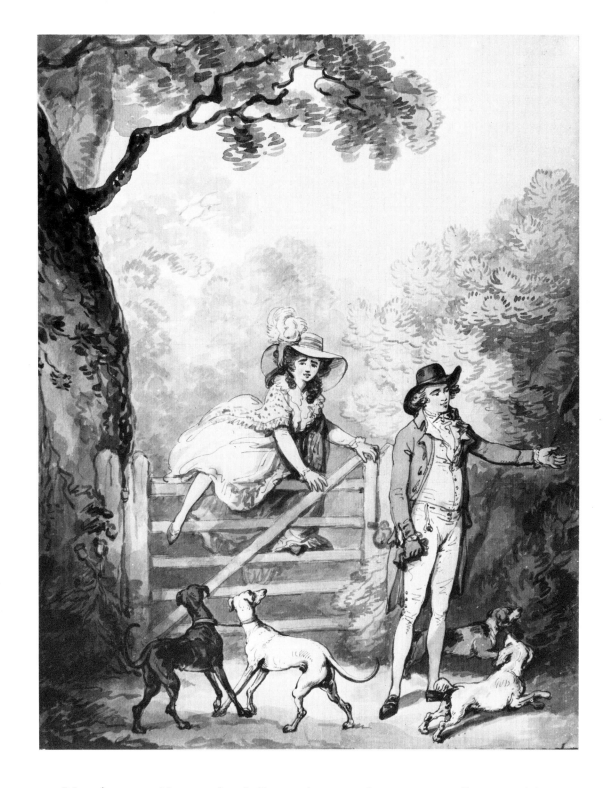

31. Matrimony. About 1785–6. Pen and watercolour over pencil, $14 \times 11\frac{1}{4}$ in. (356 × 286 mm.). *England, Private Collection*

In the sequel to *Courtship* (opposite), the husband is shown leaving his young wife to struggle over a five-barred gate unaided. The two dogs in the foreground are now chained together, and symbolize the changes that are liable to occur to the character of a relationship after the bond of matrimony has been sealed. Two almost identical compositions, with the same titles, were painted by William Williams in 1786: these were aquatinted by Jukes and published by J. R. Smith, 28 May 1787. There seems little doubt that the Rowlandsons were the prototypes.

32. Ode for the New Year. Etched and published 1787. Pen and grey wash, $7\frac{7}{16} \times 9\frac{1}{16}$ in. (189 × 230 mm.). *London, D. L. T. Oppé*

Both George III and the Poet Laureate are seen trying to ride the winged horse Pegasus together; the king is about to be thrown, and the laureate is already unseated—the figure of Harlequin appears on the right. In the print, the poet has lost not only his wig but some sheets entitled 'Ode for New Year'. The Poet Laureate at this time was Thomas Warton (1728–90), whose New Year ode was lampooned in Peter Pindar's poem 'Ode upon Ode', published in 1787, and he is presumably the subject of Rowlandson's drawing; the sketch does not seem to illustrate Peter Pindar's poem, however, or to have been used in conjunction with it. Another of Rowlandson's rapid and boldly drawn sketches, suggesting with extraordinary force the moment of shock caused by the sudden movement of the rearing horse; the collapse of the laureate is accentuated by the diagonal brush strokes modelling the wing on the left of the drawing.

33. The Hunt Breakfast. About 1785–90. Pen and brown and blue wash,
5 × 8 in. (127 × 203 mm.). *From the collection of Mr and Mrs Paul Mellon*

A masterly sketch demonstrating Rowlandson's acute observation of normal
bodily movement and reactions, notably in the group of dogs. Again he has not
bothered to complete legs and other features where this was visually unnecessary—
the fewer the lines, the greater the life.

34. The Kill. 1787. Etched and published 1788. Pen and watercolour over pencil, 14½ × 19½ in. (368 × 495 mm.). *Birmingham, City Museum and Art Gallery (J. Leslie Wright Collection)*

One of a series of six large fox-hunting scenes. In complete contrast to the previous sketch (Plate 33) Rowlandson, no doubt mindful of the needs of the etcher, has concentrated on a graceful continuity of fine line. Rowlandson was capable of varying his style considerably to suit particular requirements, whether practical or aesthetic, a fact which adds greatly to the difficulty of establishing a precise chronology for his work. Notice how he has underlined the diagonal emphasis of the composition by means of the two hounds in the foreground, which also act as a *repoussoir*, directing the spectator's eye into the middle of the subject.

35. The Return. Signed and dated 1787. Etched and published 1788. Pen and watercolour over pencil, $15\frac{1}{2} \times 20\frac{1}{4}$ in. (394 × 514 mm.). *Birmingham City Museum and Art Gallery (J. Leslie Wright Collection)*

The last of the series of large fox-hunting scenes executed in 1787. The hounds massed in the right foreground may be rather an obvious *repoussoir*, but the figure grouping is subtly contrived: the main compositional stress is a diagonal which leads up to the huntsman doffing his cap in salutation and ends in the urn, but the groom leading away the grey horse is visually linked to the three stragglers, a superb Rowlandson vignette, carefully integrated into the design by means of the falling diagonals of the branches and the arched back of the huntsman in the foreground. In the sketch for this composition (illustrated on the cover of the catalogue of Ellis & Smith's Rowlandson exhibition held in 1948) Rowlandson had not yet conceived the idea of the distant group, the hounds are more loosely composed, and the principal huntsman is holding the fox aloft instead of doffing his cap.

36. The Prize-Fight. About 1785–90. Pen and grey wash, $7\frac{9}{16} \times 12\frac{1}{4}$ in. (192 × 311 mm.). *London, British Museum*

One of Rowlandson's most brilliant and exciting rough sketches, in which the figures, their expressions and their gestures, are brought to vivid life with a few rapidly drawn outlines, reinforced by loosely applied wash. The free technique in this sketch may be contrasted with the more highly wrought treatment of the earlier *Fight* (Plate 8).

37. The Prize-Fight. Signed and dated 1787. Pen and watercolour over pencil, $18\frac{1}{2} \times 27\frac{1}{2}$ in. (470×698 mm.). *From the collection of Mr and Mrs Paul Mellon*

Perhaps Rowlandson's most effective and coherent large-scale figure composition, in which the groups, splendidly massed, are bound together by the diamond shape of the ring in the centre. A couple of overturned carts provide characteristic light relief. It has been suggested that the contest was the prize-fight which took place between Richard Humphries and Samuel Martin on Newmarket Heath on 3 May 1786, when the Prince of Wales and many members of both the English and French aristocracy were present.

38. Portrait of George Morland. About 1785. Pen and watercolour over pencil, 12 5/16 × 8 3/8 in. (313 × 213 mm.). *London, British Museum*

One of Rowlandson's most important portrait drawings. The contour is a little uncertain in places, but the stance is assured. As in *Rowlandson and the Fair Sitters* (Plate 14), the background is indicated in fairly loose washes. George Morland (1783–1804), the painter, who became increasingly dissolute and ended his life in the shadow of debt, lived in the same house as Rowlandson for a short time, probably in the late 1790s (see p. 19).

39. Bannister and Parsons in a Scene from 'The Quaker'. About 1785. Pen and watercolour over pencil, 7 3/8 × 9 7/16 in. (187 × 240 mm.). *London, British Museum*

A scene from Charles Dibdin's comic opera *The Quaker*. With Bannister (see also Plates 9 and 77) is William Parsons (1736–95), another distinguished comic actor, primarily associated with Drury Lane. Both the principal figures and the background trees are outlined in broad brushwork rather than with pen, as in the case of certain drawings from *A Tour in a Post Chaise*. The washes in the trees, green in the more distant foliage, yellow-green in the nearer, are unmodulated.

40. The Duel. About 1787–90. Pen and watercolour over pencil, 11 × 15 in. (279 × 381 mm.). *London, W. A. Brandt*

Duelling, with swords or pistols, was a common event in Rowlandson's day; this ridiculous and often tragic way of settling a quarrel was effectively discouraged in 1844, largely due to the intervention of the Prince Consort. The scene here is probably intended for Highgate or Hampstead; London is seen in the distance. The nervous, rather mannered touch in the foliage on the right is close in character to certain watercolours by Nicholas Pocock and Francis Nicholson.

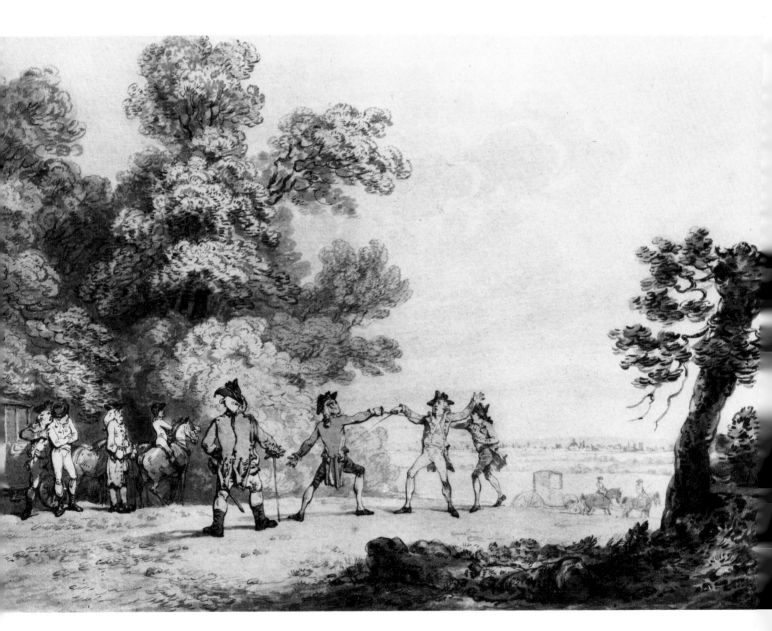

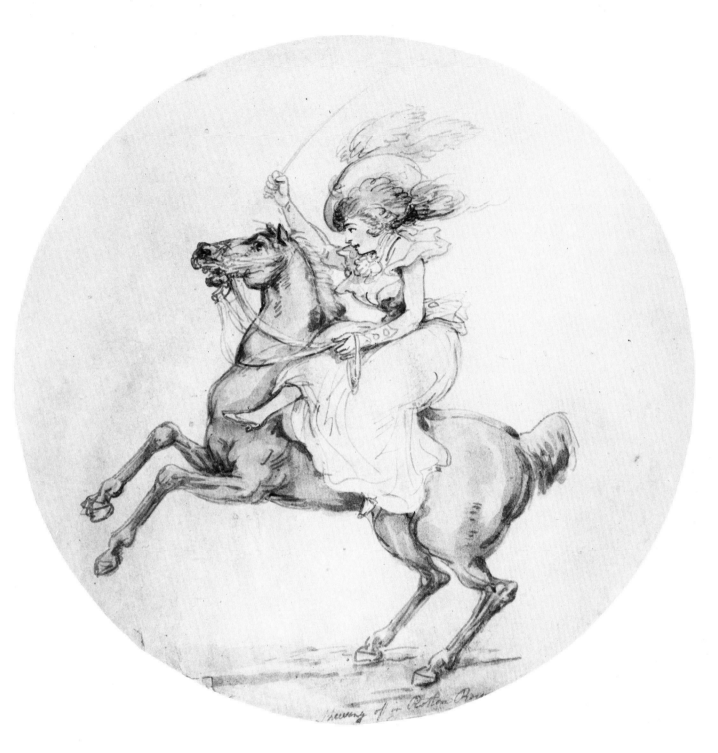

41. Showing Off in Rotten Row. About 1785–90. Inscribed. Pen and water-colour over pencil, 12⅛ in. diameter (308 mm.). *London, London Museum*

A fashionable young lady is showing off the spirit of her mount, as well as the skill of her horsemanship. Rotten Row, the name probably a corruption of *route du roi*, since it was originally the royal road through the park, has been given over to riding since the early eighteenth century, when George II's new road to Kensington was laid out close by. Rowlandson produced a number of circular compositions, all of them associated with sports, games and pastimes (see also Plate 126), some of which seem to have been intended for the decoration of screens (see p. 11 and Note 5).

42. View of Samer, near Boulogne. Signed and dated 1787, and inscribed. Pen and watercolour over pencil, $10\frac{15}{16} \times 19\frac{1}{2}$ in. (277×496 mm.). *Pride's Crossing, Massachusetts, Augustus Loring*

Rowlandson made a number of trips to the Continent in the course of the 1780s and 1790s, some of which can be documented from dated drawings; his inscription to the effect that he drew this view of Samer 'on the Spot' establishes the fact that he made a visit to France in 1787. The composition has a pronounced rococo swing.

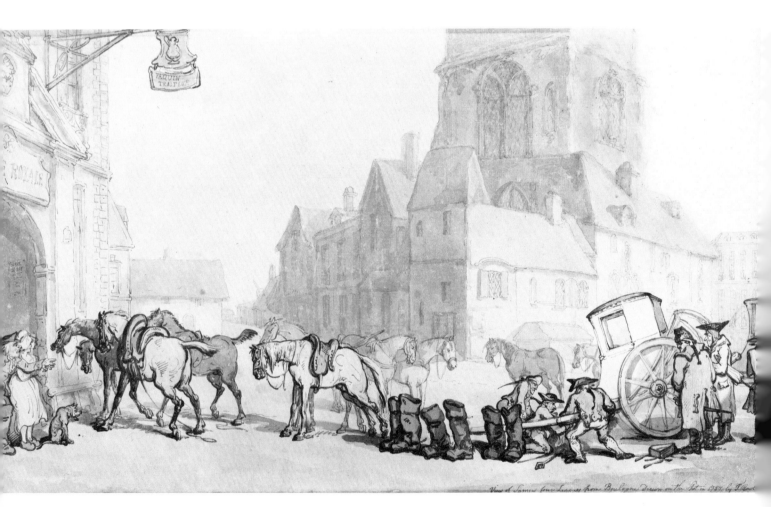

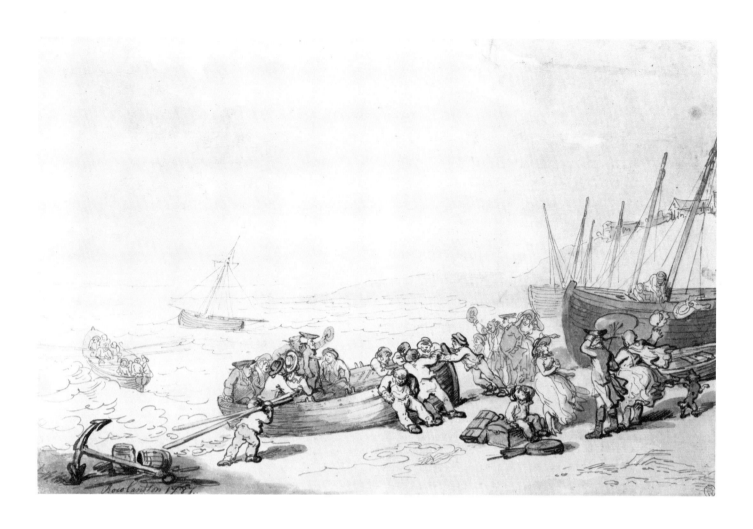

43. View on the Coast. Signed and dated 1787. Pen and grey wash, $9\frac{3}{8} \times 14\frac{1}{2}$ in. (238 × 368 mm.). *Boston, Public Library (Wiggin Collection)*

A scene with a similar undulating composition to the previous drawing (Plate 42), and executed in the same year. Rowlandson's rapid penwork is admirably adapted to expressing the effects of a breezy day. The short, curving touches outlining the breeches of the figure carrying a couple of oars in the foreground are reminiscent of the calligraphy of Canaletto, and this little figure would not look out of place in a Canaletto river scene.

44. A Tavern Scene. About 1785–90. Falsely signed. Pen and wash. *Formerly Henry S. Reitlinger Collection*

Another of Rowlandson's brilliant and rapidly executed sketches. The exchange of conversation between the two men on the left is perfectly rendered. Notice how the heads of the figures are suggested by a few quick strokes of the pen, with wash added in a loose and apparently indiscriminate way.

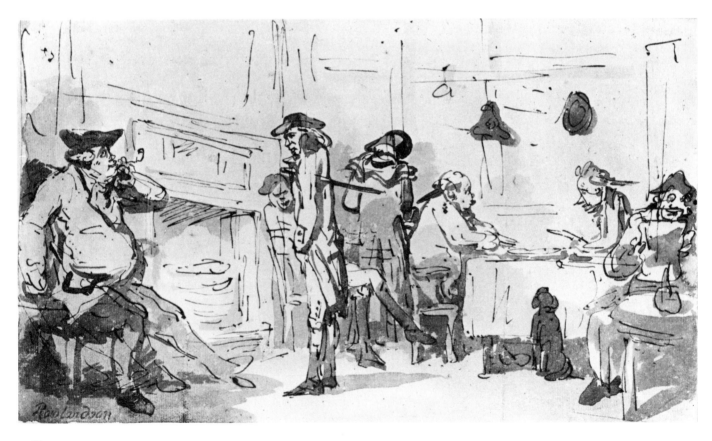

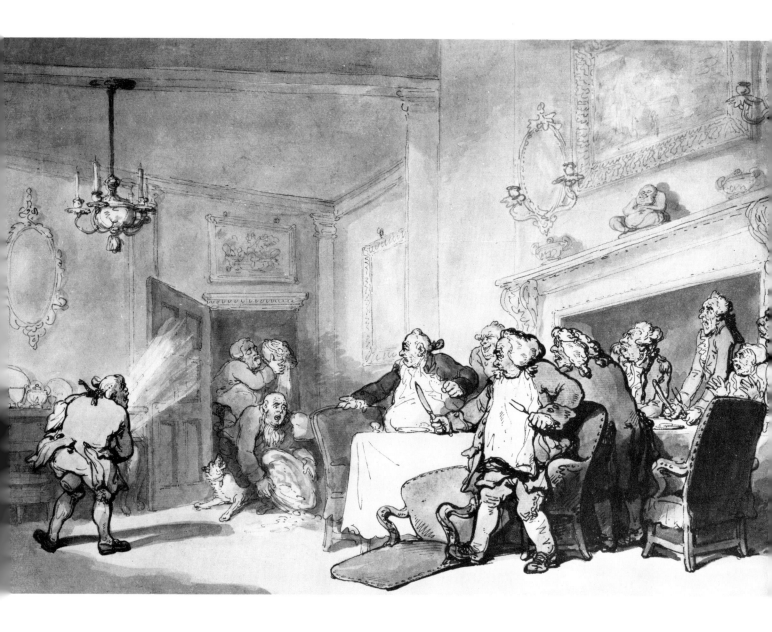

45. The Disappointed Epicures. Etched by Rowlandson and published by J. Harris, 2 June 1787. Pen and watercolour over pencil, 13 × 19¼ in. (330 × 489 mm.). *San Marino, California, Henry E. Huntington Library and Art Gallery*

A typically Rowlandsonian scene of disaster in which one upset has triggered off another; there is no particular reason for the chair in the foreground having fallen over except the artistic one of continuing this chain of mishaps. The Buddha on the mantelpiece is smiling quietly to himself at the whole affair (in a later version of the subject he is more in sympathy with the diners, and averts his gaze with a pained expression).

46. The Challenge. About 1785–90. Pen and watercolour over pencil, $6\frac{3}{16} \times 8$ in. (157 × 203 mm.). *Boston, Public Library (Wiggin Collection)*

There is an element of the theatrical in the exaggerated expression of consternation on the face of the man reading a challenge to a duel. By contrast, the expression of the challenger's second is not just impassive, but distinctly empty, while his arm hangs loosely; these deficiencies of drawing and characterization hint at the later Rowlandson, too prolific in output to maintain the high artistic standards of his early maturity.

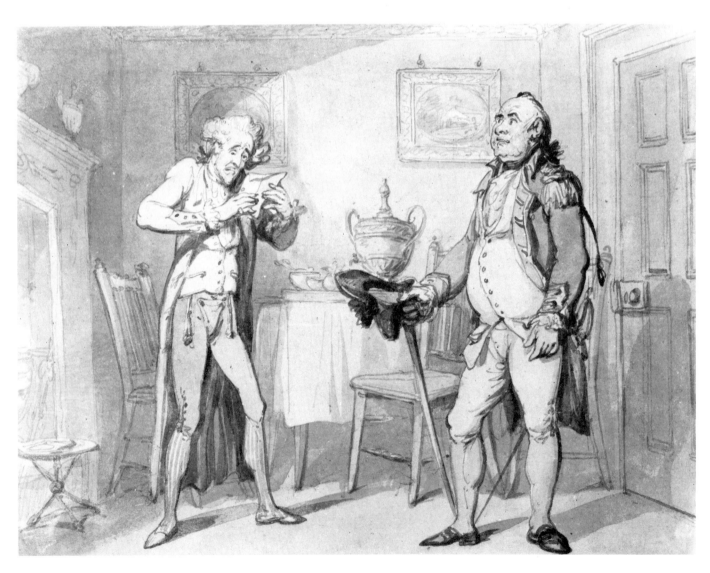

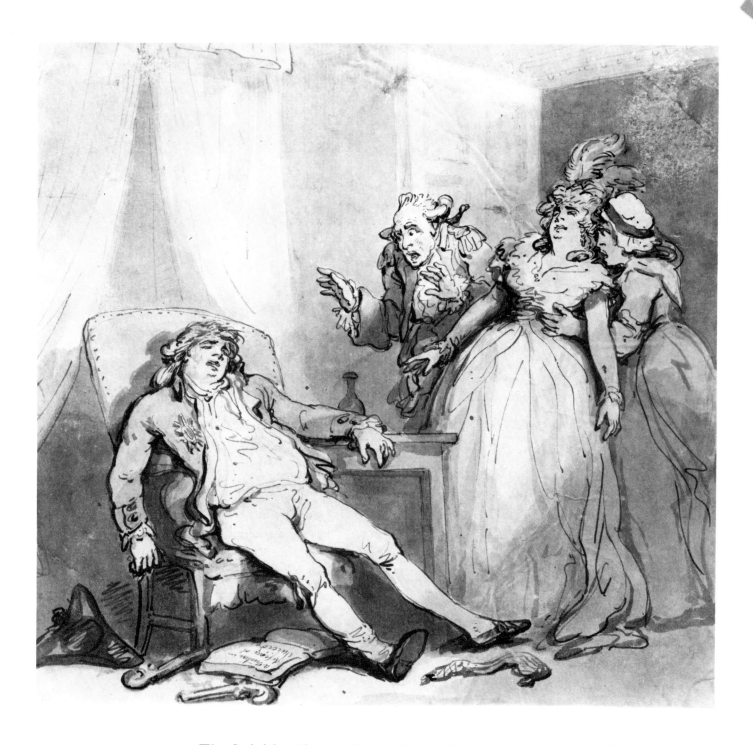

47. The Suicide. About 1785–90. Pen and watercolour over pencil, $9\frac{1}{16} \times 9\frac{5}{8}$ in. (230 × 244 mm.). *Boston, Public Library (Wiggin Collection)*

The young man has evidently shot himself after a night of losses at the gaming table; his empty purse lies on the floor. Beside his pistols is an open book entitled 'A Treatise in defence of Suicide'. As in the drawing reproduced opposite, the reactions to the moment of shock are melodramatic.

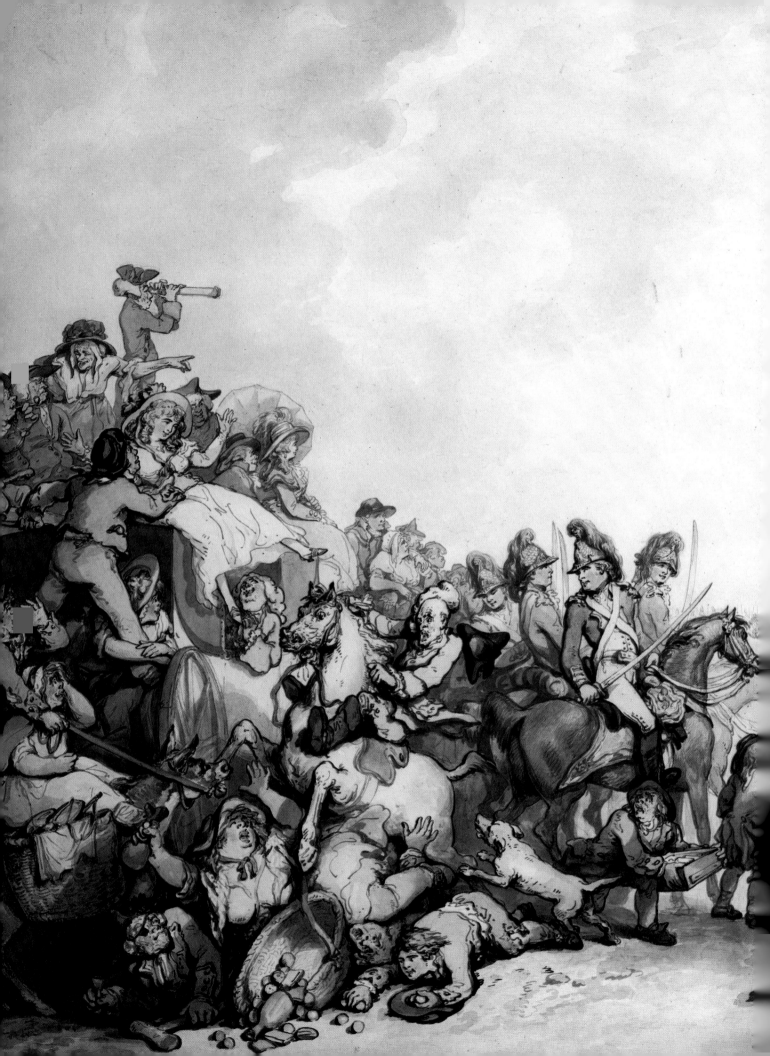

48, 49. The English Review. Exhibited Royal Academy 1786 (575). Pen and watercolour over pencil, 19¾ × 35 in. (502 × 889 mm.). *Windsor Castle (reproduced by gracious permission of Her Majesty The Queen)*

With its companion, the *French Review* (Plates 50 and 51), by far the largest of Rowlandson's watercolours and the grandest of his exhibition pieces; it was supposed to have been bought by the Prince of Wales in 1786 and to have been framed ready for delivery to Carlton House prior to the exhibition (see p. 11 and Note 2). Iconographically, and to a certain extent compositionally, Rowlandson's review subjects may have been inspired by Moreau le Jeune's *La Revue du Roi, à la Plaine des Sablons* in the Louvre, which was exhibited at the Salon of 1781 and later (1789) engraved by Malbeste: this scene includes coaches and crowds of onlookers grouped in the foreground to left and right, and also contains some mildly comic incident. The almost cascading diagonals of figures, for which the cavalry officer looking over his shoulder acts as a fulcrum, are superbly massed, but because of the very power of the left half of the design the composition as a whole lacks balance.

50, 51. The French Review. Exhibited Royal Academy 1786 (583). Pen and
watercolour over pencil, 19¾ × 35¼ in. (502 × 895 mm.). *Windsor Castle
(reproduced by gracious permission of Her Majesty The Queen)*

In this composition the figure grouping is more static than that of its companion
piece, the *English Review* (Plates 48 and 49), but the design is enlivened by
innumerable diagonal emphases which are echoed in the branches of the trees.
The officer on the extreme left, carrying the colours, is easily recognized as one of
Rowlandson's favourite images of the French military (compare the figure on the
left in Plate 13).

52. A Meeting of Creditors. About 1785–90. Pen and watercolour over pencil, $11\frac{3}{4} \times 17$ in. (298 × 432 mm.). *Cambridge, Fitzwilliam Museum*

The bankrupt, who is evidently a gentleman, in sharp contrast to the gross and rather uncouth lot of tradesmen who are dunning him, has evidently no possibility of satisfying his creditors; the prints of *Lord Mansfield* and *The King's Bench Prison* hanging on the wall allude to his probable fate. Though the treatment of the foreground figures is fairly elaborate, with plentiful use of a thick contour line, Rowlandson has drawn the others with less thoroughness, while the prints and hats and coat on the wall are suggested in a technique he normally reserved for his most rapid sketches.

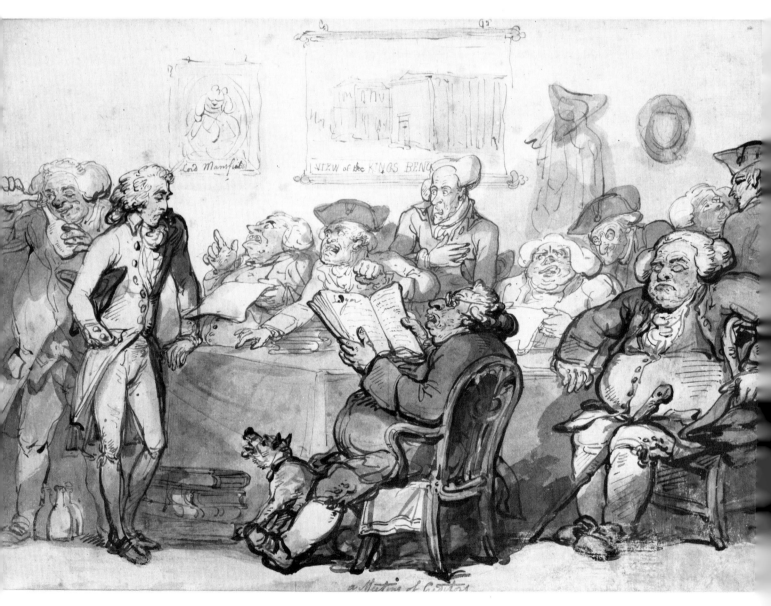

The Wonderful Charms of a Red Coat & Cockade.

53. The Wonderful Charms of a Red Coat and Cockade. About 1785–90.
Inscribed. Pen and watercolour over pencil, 10×8¼ in. (254×210 mm.).
Birmingham, City Museum and Art Gallery (J. Leslie Wright Collection)

An attractive young damsel is shown fastening on to an elderly officer; a church spire is loosely brushed in in the background. The drawing is a more sentimental and less dashing variant of the better known composition he entitled *A French Frigate Towing an English Man-O-War into Port*. The subject may also be linked with his *Luxury and Desire* and *Lust and Avarice*, both engraved 1788. Rowlandson is still using, for the shadows and internal modelling of the soldier's legs, the zig-zags, dots and squiggles which were among the technical mannerisms he had picked up from Mortimer.

54. A Comfortable Nap in a Post Chaise. Etched and published 1788. Pen
and watercolour over pencil, $6\frac{1}{2} \times 9$ in. (165 × 229 mm.). *London, F. H. Potts*

The expressions of bucolic contentment are universal, and might be matched in
any long-distance train journey. Rowlandson's thick contour line, plentifully
reinforced with Indian ink, is much in evidence in this drawing.

55. The Bath Beau and the Country Beau. About 1788–90. Pen and water-
colour over pencil, 12 × 10 in. (305 × 254 mm.). *Birmingham, City Museum and
Art Gallery (J. Leslie Wright Collection)*

The country beau, looking healthy, well-fed and relaxed, is being eyed with disdain
by the slim and foppish Bath beau and with distaste by his rather unpleasant
companion. Rowlandson's sympathies were clearly with the sensible as opposed to
the dandified, as they were with 'John Bull' against the excesses of French
manners and dress.

56. The Happy Family. Etched and published 1786. Pen and watercolour over pencil, 10 × 12 in. (254 × 305 mm.). *Oxford, Private Collection*

An essay in the manner of Wheatley, demonstrating the contentments of domestic life. The subject of the painting on the wall behind underlines this theme. In this drawing, Rowlandson has kept his penwork to the minimum and allowed the colour, pale but sympathetic to the mood of the subject-matter, to sing out in broad, clean washes.

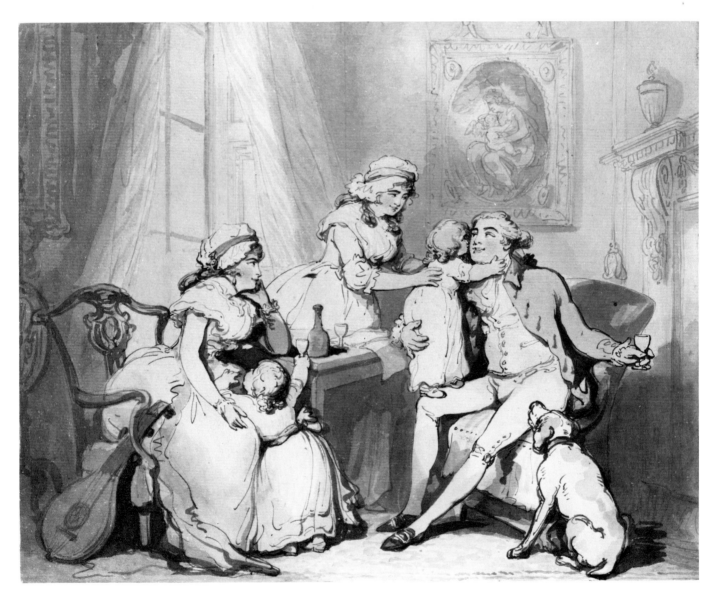

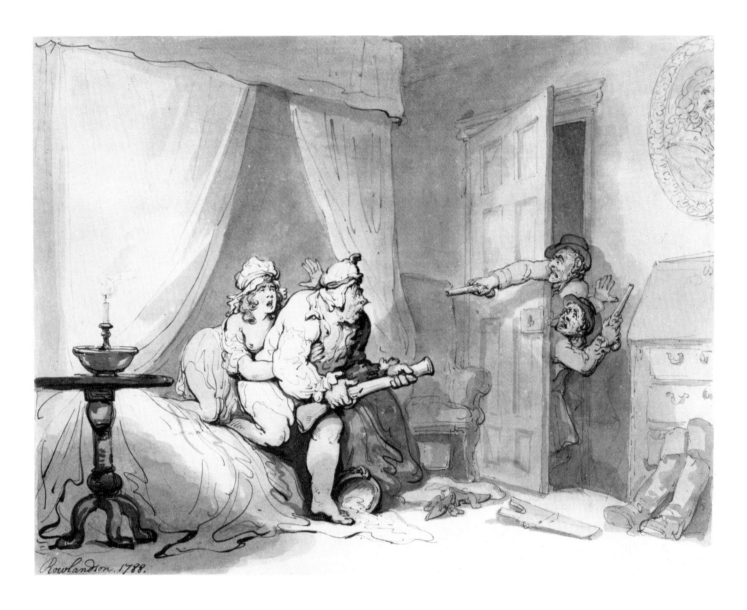

57. Housebreakers. Signed and dated 1788. Etched by Rowlandson, aquatinted
 by T. Malton and published 1788. Pen and watercolour over pencil,
 8¾ × 11¾ in. (222 × 298 mm.). *Formerly London, Fine Art Society*

A couple of ferret-like burglars are seen preparing to bolt as the owner of the
house gets out of bed in hot pursuit, armed with a massive blunderbuss.
Rowlandson has not been able to resist adding a touch of coarse humour to the
situation, in the shape of the overturned chamber-pot.

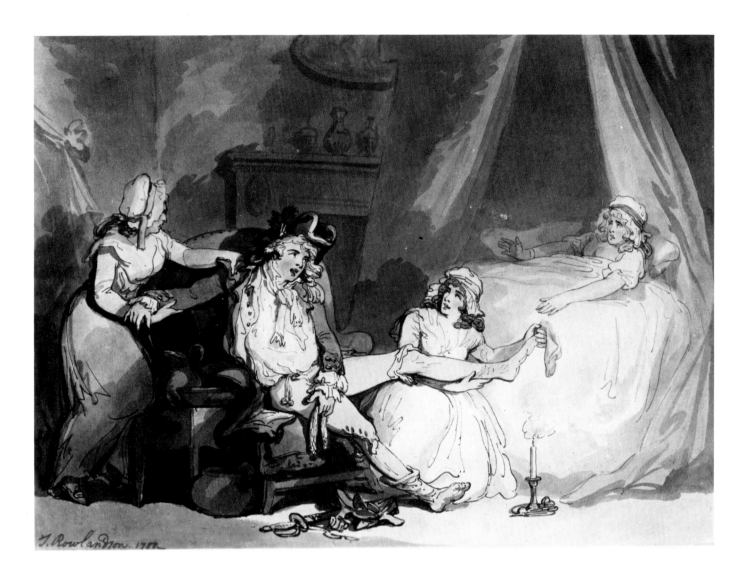

58. Four O'Clock in the Town. Signed and dated 1788. Etched by Rowlandson
and published by S. W. Fores, 20 October 1790. Pen and watercolour over
pencil, $9\frac{1}{4} \times 13$ in. (235 × 330 mm.). *Formerly London, Fine Art Society*

A young man-about-town, drunken and dishevelled, and holding an empty
purse in his hand, is propped up in an armchair in the traditional pose of a bon
viveur (derived ultimately from Hayman's *Wapping Landlady*) while a couple of
maids set about the task of undressing him. His wife looks on with some apprehen-
sion. The composition is based on a series of abrupt, angular lines set against an
unstable background, thus emphasizing the drunken state of the young rake.

59. Four O'Clock in the Country. Signed and dated 1788. Etched by
Rowlandson and published by S. W. Fores, 20 October 1790. Pen and water-
colour over pencil. *Formerly London, Fine Art Society*

Four o'clock in the morning in the country is evidently a different matter: the
day's activity is just beginning. The young sportsman has risen early from his bed
and is seen preparing to leave for a day's hunting. His worthy spouse is pouring
out a glass of cordial to make sure he keeps awake, and, symbol of happy domes-
ticity, a small child is fast asleep in the cot near the bed. The composition, rather
than being disjointed and angular in character, is based on a series of firm uprights
and a strong diagonal indicative of the moment of departure.

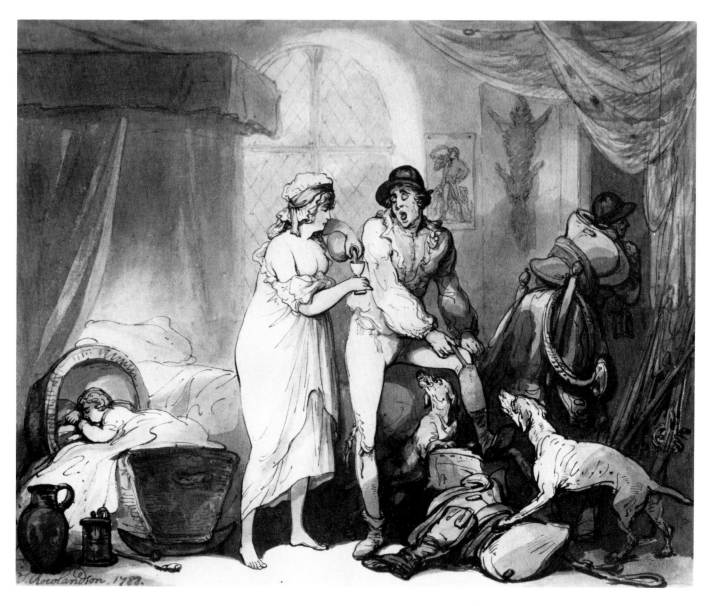

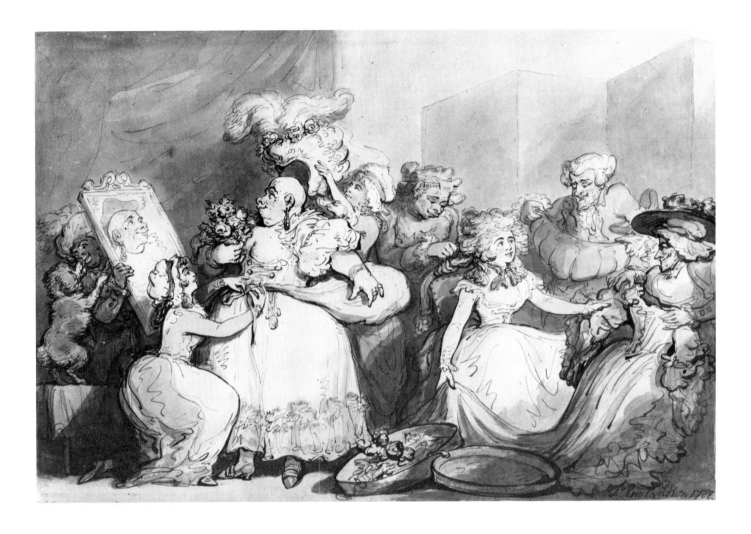

60, 61. Dressing for a Birthday. Signed and dated 1788. Etched by Rowlandson and published by S. W. Fores, 3 March 1789. Pen and watercolour over pencil. *Formerly London, Thomas Agnew & Sons*

A superb example of one of Rowlandson's obsessive subjects, the contrast of youth and age, beauty and ugliness (see also Plate 53). The unsightly bald-headed old woman gazing rapturously at her reflection in the mirror as she has a large feathered wig put on is being dressed by a couple of pretty maids, while the beautiful young girl on the right, presumably her daughter, is attended by an aged crone. An appropriate impression of bustle is given by the crowding of the figures, though, as so often with Rowlandson, they are ranged in the front planes of the composition and the space behind is left empty. The design is based on an elaborate interplay of curving lines and shapes.

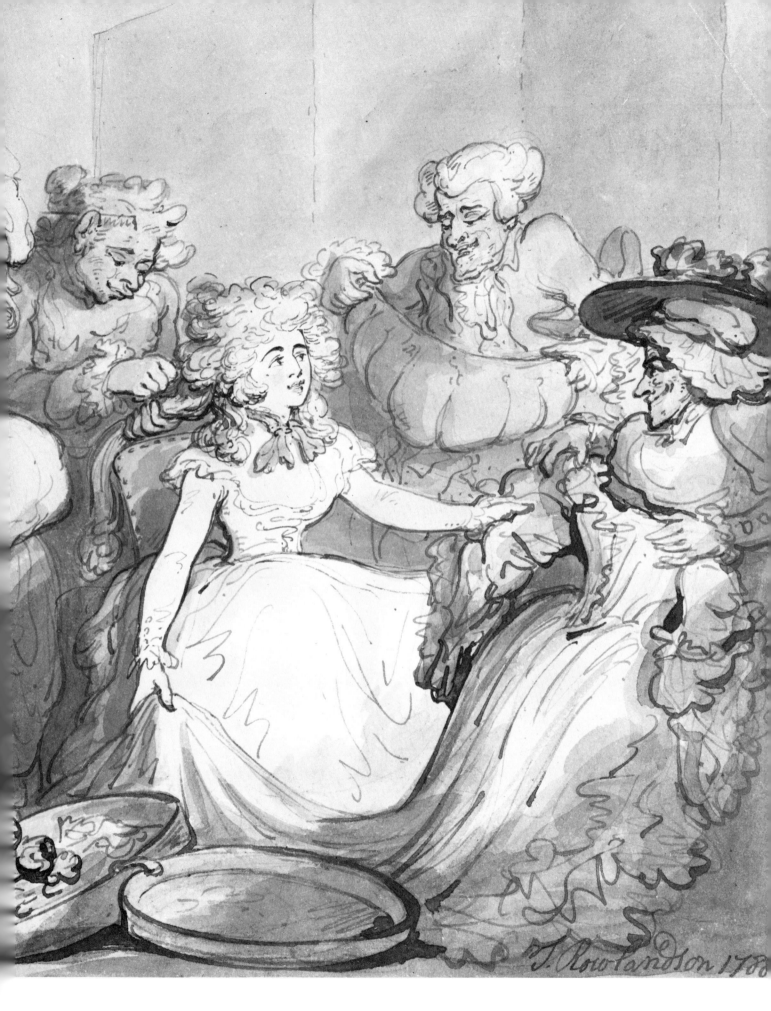

62. High Spirits. About 1790. Pen and watercolour, $8\frac{5}{8} \times 7\frac{1}{8}$ in. (219 × 181 mm.). Reproduced original size. *Windsor Castle (reproduced by gracious permission of Her Majesty The Queen)*

A riot of whirling line amazingly suggestive of form as well as of the mood of gay intoxication induced by the bottle. Notice the firm grip of the left hand which, it is only apparent on close inspection, seems to have no connection with the body at all. Only a highly accomplished draughtsman could have produced so scintillating and free a sketch, and made a success of it.

63. The Storm. About 1790. Pen and grey and greenish-blue wash over pencil, $4\frac{3}{4} \times 8\frac{5}{8}$ in. (121 × 219 mm.). Reproduced original size. *London, Brinsley Ford*

Another incredibly brilliant sketch in which Rowlandson has introduced a mass of swirling lines and broken wash, to a large extent quite independent of form, in order to suggest the plight of the three sailors desperately trying to master the elements. The actual shape of the boat is impossible to make out: indeed, but for the mast and rigging, it gives the appearance of having overturned already. This drawing is exceptional in Rowlandson's *œuvre*, one of the most truly 'romantic' of all his compositions, penetrating to a deeper realism through a form of abstract expressionism anticipating to some degree the vision of late Turner.

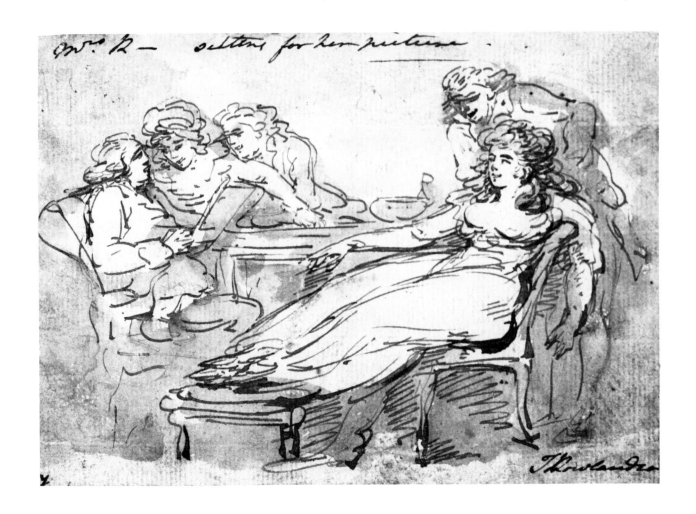

64. A Young Lady Sitting for Her Picture. About 1790. The signature and
inscription appear to have been added by a later hand. Pen and grey wash,
$4\frac{3}{4} \times 6\frac{3}{4}$ in. (121 × 171 mm.). Reproduced original size. *Windsor Castle*
(reproduced by gracious permission of Her Majesty The Queen)

Rowlandson has brought the group on the left to vigorous life through the use of a
short, broken pen line. By contrast, the spirited nature of the glamorous young
lady reclining on the chair and footstool in a slightly abandoned posture is
suggested in a welter of penwork: this is especially evident in the hair, at the
breasts, and in the feet. There is no evidence for the view that the sitter is the
artist's wife. Betsey Winter, with whom Rowlandson is known to have lived in
later life, and who was accepted as 'Mrs' Rowlandson at the time of his death,
would have been thirteen in 1790, and it is not known whether she was an
attractive mistress or simply his housekeeper (the more likely probability).

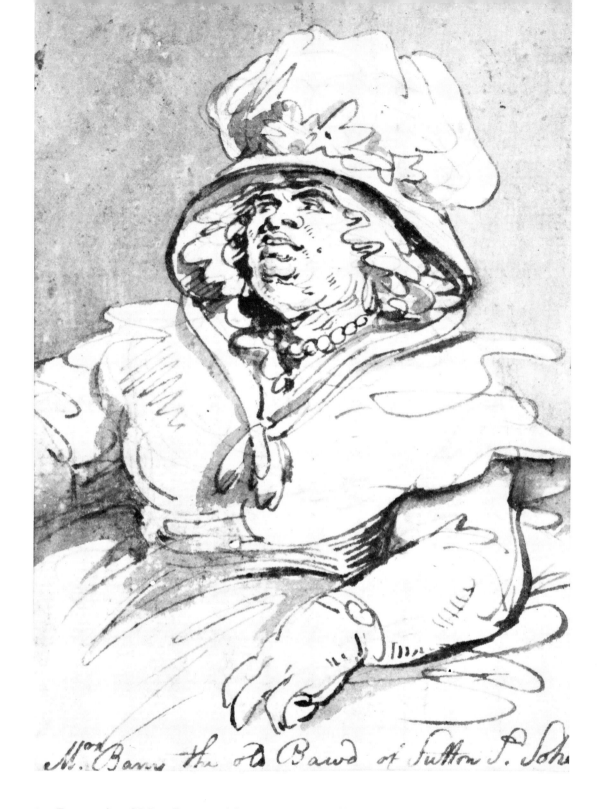

M^{rs} Barry the ^{old} Bawd of Sutton S^t Soho

65. Portrait of Mrs Barry. About 1790. Inscribed. Pen and grey and brown wash over pencil, $5\frac{1}{8} \times 3\frac{9}{16}$ in. (130 × 90 mm.). Enlarged. *London, Brinsley Ford*

A vigorous sketch in a coarse pen line admirably suited to the sitter's calling. Soho, then as now, was a cosmopolitan, bohemian and distinctly licentious part of town, having declined with some rapidity from the solid respectability characteristic of the area in the late seventeenth century. Sutton Street (now Sutton Row) ran off the east side of Soho Square. Mrs Barry would seem to have been a procuress of the tough, alert, but basically motherly, nature familiar to us from the pages of Cleland's *Fanny Hill*.

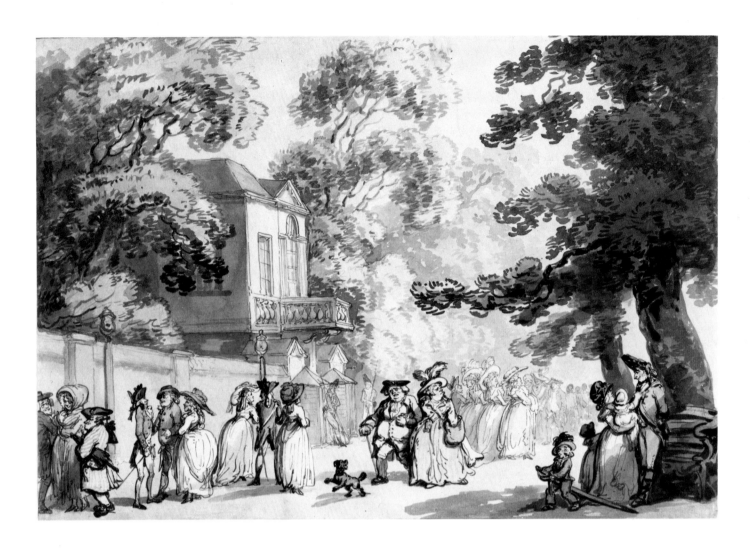

66, 67. Spring Gardens. About 1785–90. Pen and watercolour over pencil, $13\frac{1}{4} \times 18\frac{1}{2}$ in. (337 × 470 mm.). *London, Victoria and Albert Museum*

A fashionable (and not-so-fashionable) throng at the Spring Gardens entrance to the Mall, London's principal promenade since the late seventeenth century. The drawing shows Rowlandson's vivid characterization of isolated groups and incidents. The figure on the left with an umbrella under his arm is close in type to the figure in the basket at the back of the stage coach in Plates 24 and 25, reputedly meant to be Jonas Hanway, who introduced the umbrella from the East. Rowlandson used a very similar building and compositional structure for the *Art of Scaling*, engraved and published about 1787.

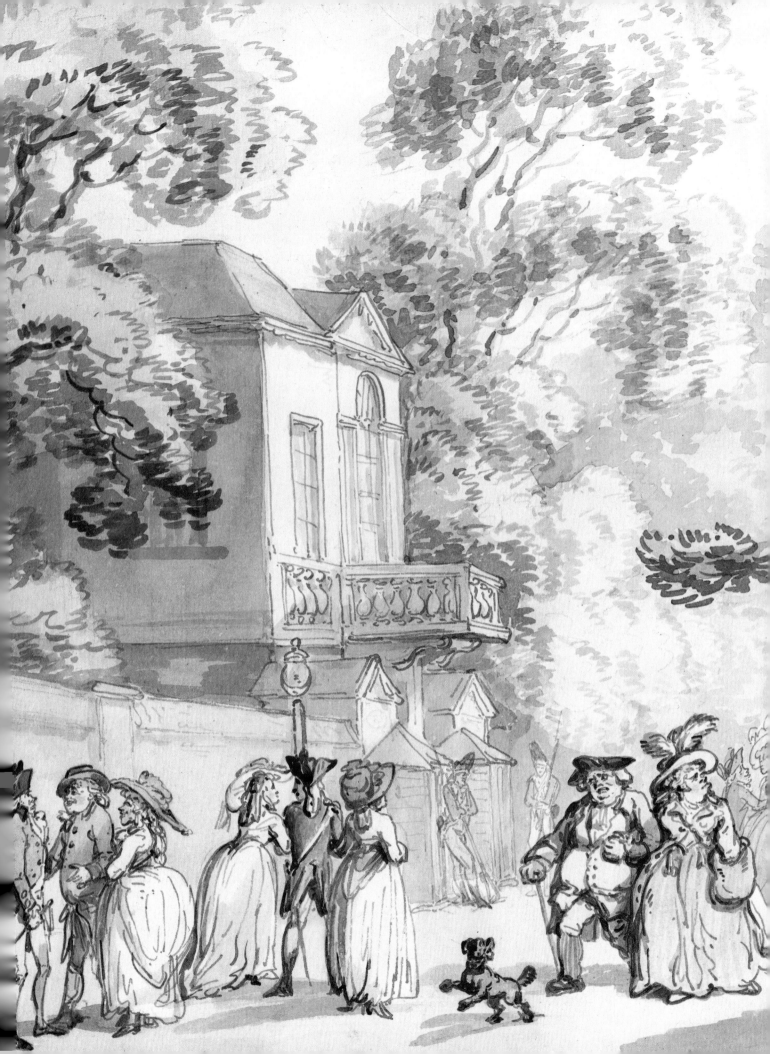

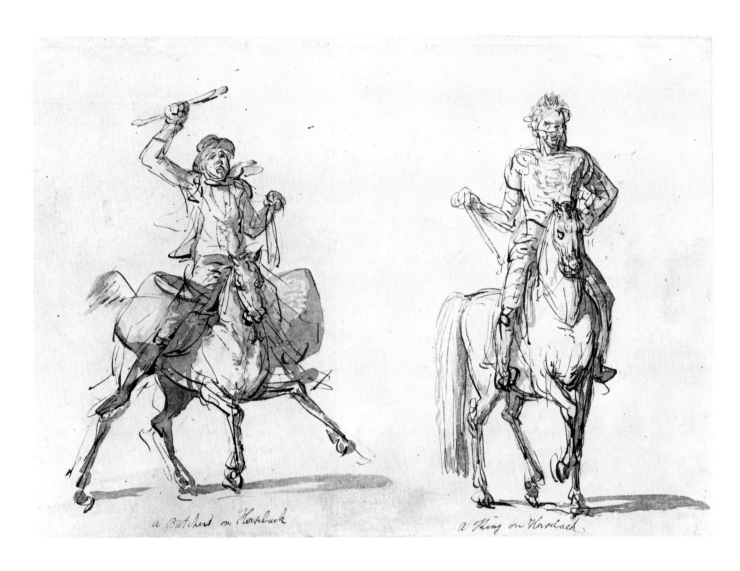

68. A Butcher on Horseback and a King on Horseback. About 1790. Pen
and grey wash, 8⅜ × 12 in. (213 × 305 mm.). *Oxford, Ashmolean Museum*

A sketch executed in a crisp, broken, slightly fussy pen line, contrasting the
difficulty experienced by a butcher in managing his mount with the serene dignity
of a king. The latter pose is reminiscent of Van Dyck.

69. The Fish Dinner. Etched and published 1788. Pen and grey wash, $6\frac{5}{16} \times 8\frac{3}{8}$ in. (160 × 213 mm.). *London, D. L. T. Oppé*

Sketch for the etching entitled *Feast of the Fly Club*, which was published as a frontispiece to Peter Pindar's poem *Peter's Prophecy . . . or, an Important Epistle to Sir J. Banks, on the Approaching Election of a President of the Royal Society, 1788*. The verses are an attack on Sir Joseph Banks, President since 1778, for giving too much weight in the Society to his own interests, natural history. In the drawing, Banks is seen on the right, gnawing a serpent: 'Hell seize the Pack!—unconscionable dogs!—/Snakes, spiders, beetles, chaffers, tadpoles, frogs,/All swallow'd to display what *man* can *do*,/And must the villains still have something new?/Tell, then, each pretty PRESIDENT CREATOR,/G-d d-mn him—that I'll eat an ALLIGATOR.' To which the poet replied: 'Sir Joseph, pray don't eat an Alligator—/Go swallow somewhat of a *softer* nature;/Feast on the arts and sciences, and learn/Sublimity from trifle to discern.'

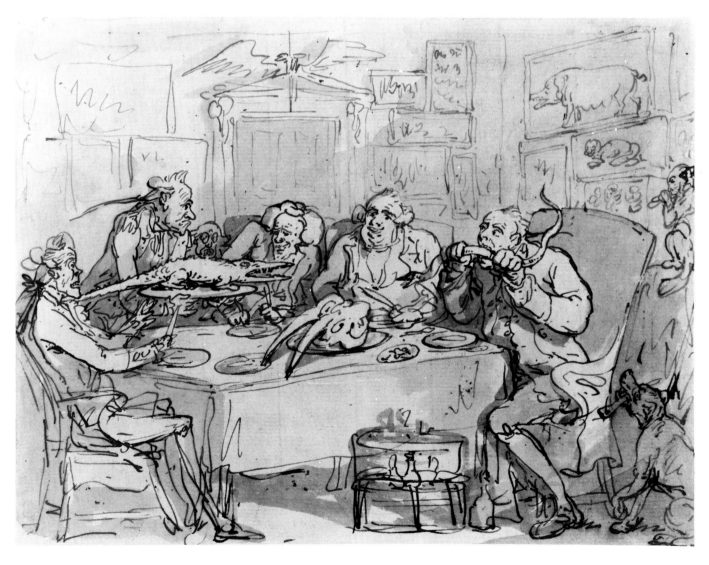

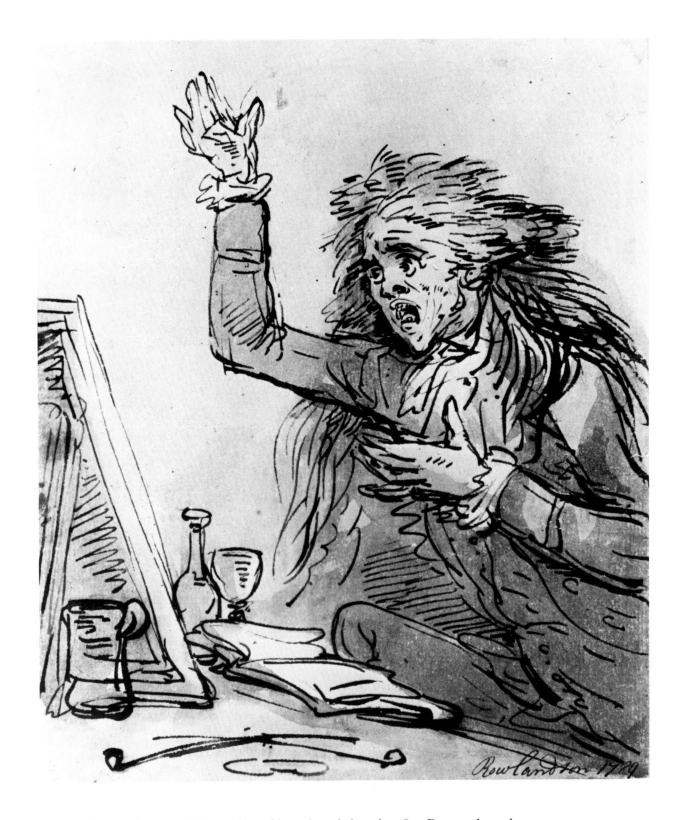

70. A Tragic Actor Rehearsing. Signed and dated 1789. Pen and wash.
Formerly Henry S. Reitlinger Collection

The tragic actor is seen here as a slim and rather highly-strung type. Rowlandson's
characterization of his passionate declamation in front of the mirror is enhanced
by the cascading penwork.

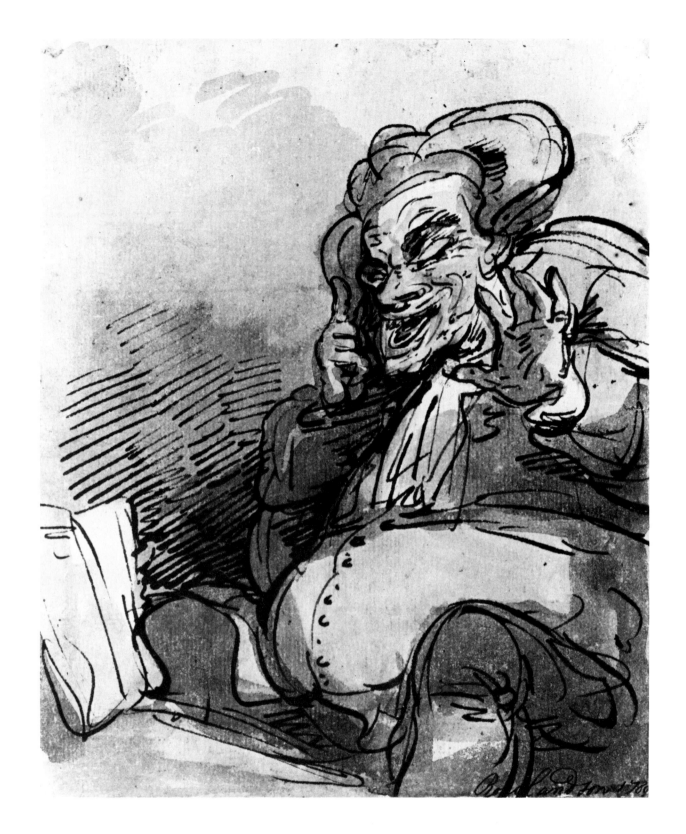

71. A Comic Actor Rehearsing. Signed and dated 1789. Pen and wash.
Formerly Henry S. Reitlinger Collection

The comic actor is interpreted as a pot-bellied old bon viveur. Neither of these sketches has quite the brilliance and total assurance throughout of *High Spirits* (Plate 62), but certain passages, notably the coarse, flexible penwork outlining the actor's left knee, have a tremendous vitality none the less.

72. Dressing for a Masquerade. Signed and dated 1790. Etched and published by S. W. Fores, 1 April 1790. Pen and watercolour over pencil, $12\frac{3}{4} \times 17\frac{1}{4}$ in. (324×438 mm.). *Birmingham, Barber Institute of Fine Arts*

Four attractive young damsels preparing for a masquerade which, according to the invitation in the hands of the girl on the right, is to take place at the Pantheon in Oxford Street (the magnificent assembly rooms designed by James Wyatt in 1772, totally destroyed by fire in 1792). One of the party, who is wearing an enormous tricorne, is going dressed in male attire. As in the drawing of a similar subject (Plate 60), the figures are grouped in the front planes of the composition, though in this case the design is pyramidal.

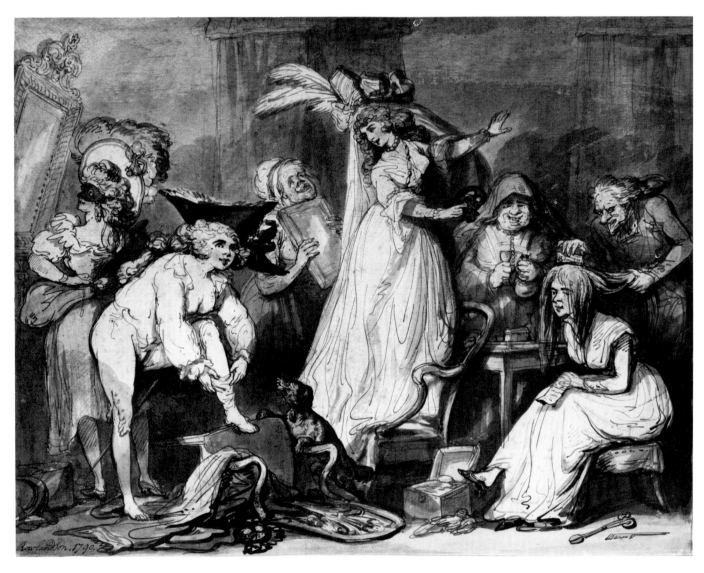

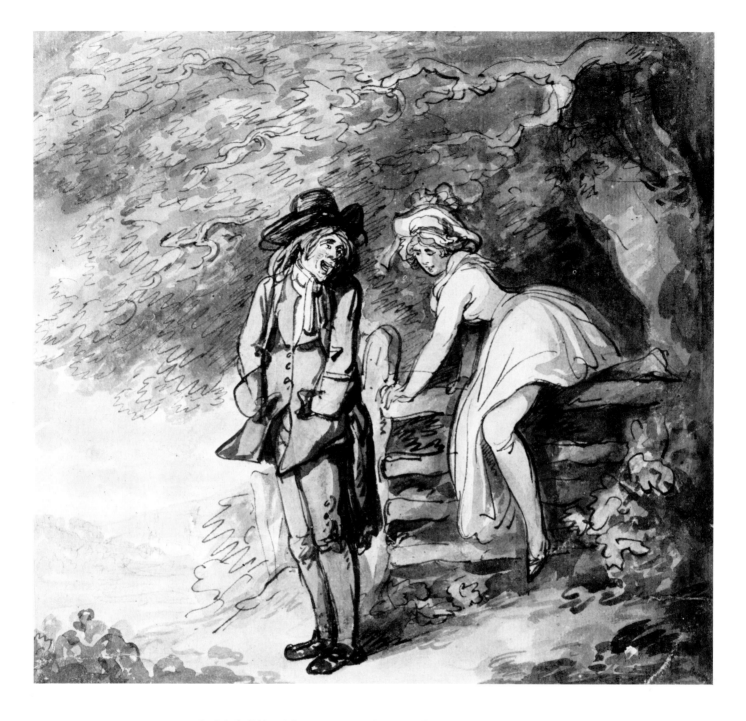

73. A Girl Climbing over a Gate. About 1790. Pen and watercolour over pencil, $9\frac{5}{8} \times 10\frac{3}{16}$ in. (244×259 mm.). *Boston, Public Library (Wiggin Collection)*

A sketchy and rustic variant on the theme of *Matrimony* (Plate 31). In this case Rowlandson is concerned less with expressing an idea than with the incidental result of the girl exposing a pretty leg.

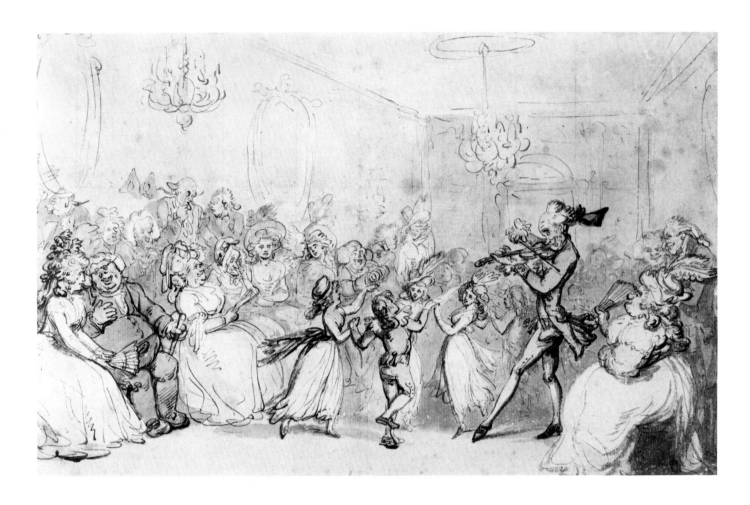

74. The Children's Dancing Lesson. About 1790. Pen and watercolour,
8 15/16 × 14 11/16 in. (227 × 373 mm.). *Boston, Public Library (Wiggin Collection)*

A rapid sketch executed in a thin, rather scratchy pen line, brilliantly evocative of
the different reactions of the assembled company. Rowlandson has indicated the
character of the salon in the simplest possible way, by means of a couple of
decorative mirrors and two chandeliers, and used no more than a few circular
lines and some supporting wash to suggest the crowd in the distance.

75. Portraits of the Duchess of Devonshire and Countess of Bessborough.
Signed and dated 1790. Pen and watercolour over pencil, 18½ × 16½ in.
(470 × 419 mm.). *From the collection of Mr and Mrs Paul Mellon*

Georgiana and Henrietta Spencer, sisters who became respectively the Duchess of
Devonshire (1757–1806) and Lady Bessborough (1761–1821), were two celebrated
beauties of the day, and Rowlandson included them as the most prominent
members of the company assembled in his famous *Vauxhall Gardens* (Plates 16 and
17). Rowlandson has drawn the heads with the delicacy of a Wheatley, but the
brilliant pen and brushwork suggesting the fall of the ladies' dresses has a vigour
and life of its own. There is another version of this double portrait, at three-
quarter length and omitting the musician.

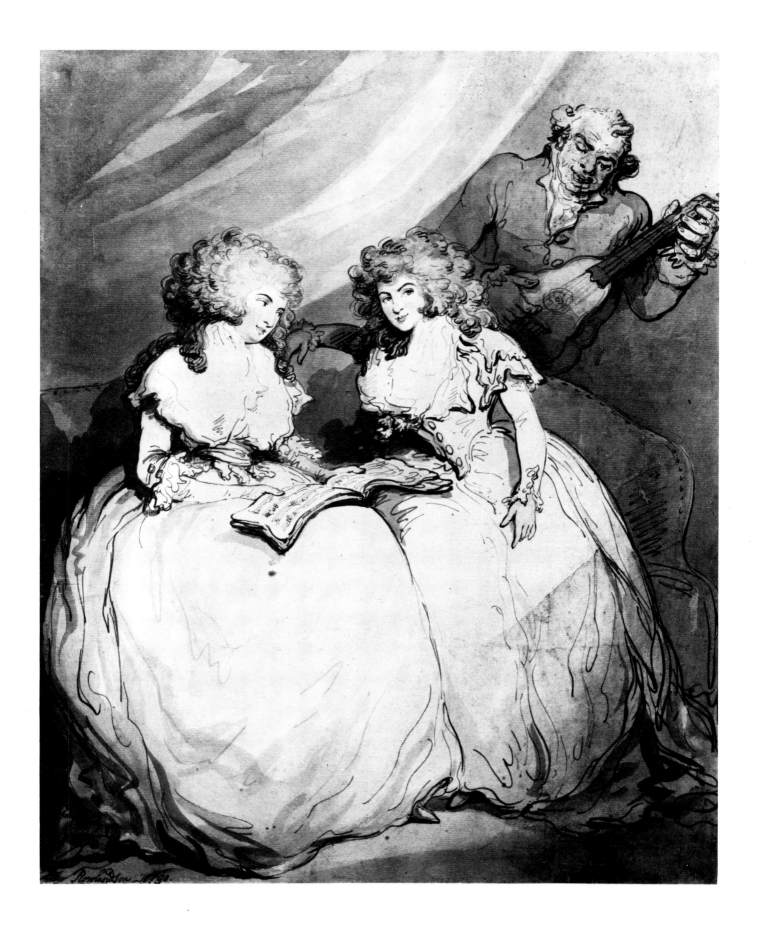

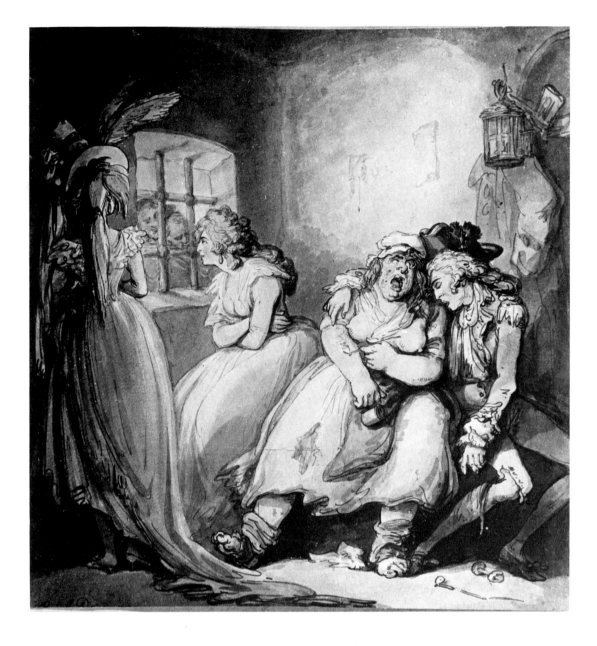

76. The Lock Up. Signed and dated 1790. Pen and watercolour over pencil, $12\frac{3}{4} \times 12\frac{1}{4}$ in. (324 × 311 mm.). *Formerly London, Walter T. Spencer*

A couple of attractive *demi-mondaines*—one dressed at the height of fashion and strongly reminiscent, in her exaggerated hair style and headgear, of Fuseli's predilections in his drawings of young women—have evidently been picked up on the streets. A drunken soldier and his whore have been imprisoned with them. The watchman's overcoat, lantern and rattle are hanging on a hook, and there is a *graffito* of an execution on the wall. Rowlandson's pen line is thin and spidery, a tendency which was to become more pronounced in later years.

77. Portraits of Jack Bannister and 'Miss Orser'. About 1790. Pen and watercolour over pencil, $13\frac{1}{2} \times 17\frac{1}{8}$ in. (343×435 mm.). *Boston, Public Library (Wiggin Collection)*

The portrait of Bannister (see also Plates 9 and 39) is highly wrought, and comparable to the full-length of George Morland (Plate 38). The contours of the young girl's features and arms are also carefully delineated. Nothing is known about the identity of Miss Orser, the name traditionally given to the young lady; she is clearly not Mary Ann Orger, the actress, who was not born until 1788. The figure under the table is presumably an elderly lover who has been disturbed by the arrival of Bannister; his tricorne is in full view in the foreground. The picture on the wall of a nude goddess with a cupid is typical of Rowlandson's uncomplicated symbolism.

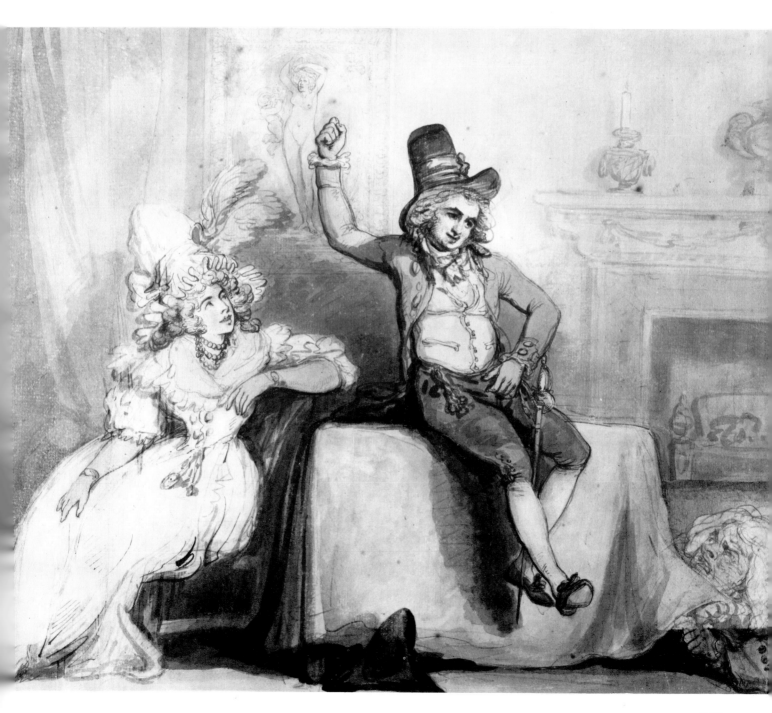

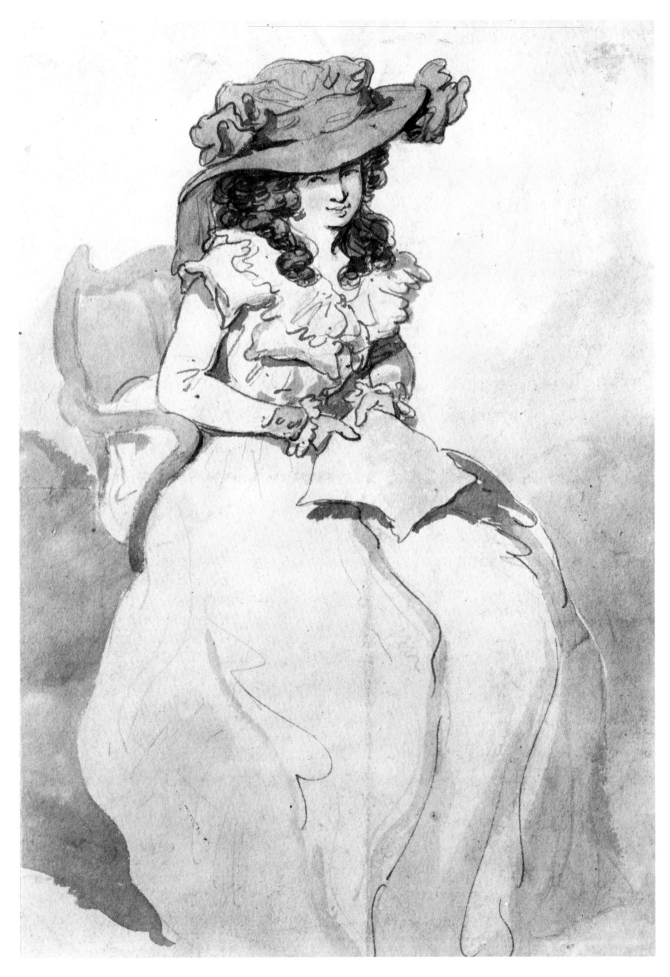

142

78. The Love Letter. About 1790. Unfinished. Pen and watercolour over pencil, 11 × 7½ in. (279 × 191 mm.). *From the collection of Mr and Mrs Paul Mellon*

A gentle, sentimental study in the manner of Wheatley. It is interesting to note that, in this drawing, Rowlandson has used watercolour over his pencil outline before employing the pen, a procedure that he seems to have adopted in a number of works, particularly in *A Tour in a Post Chaise*. The chair has been carefully outlined in pencil and filled in with watercolour but not given strengthening in pen, and it is likely that the area of wash suggesting the shadows on the left would have been hatched with the pen and that a good deal of penwork would also have been used to enliven the modelling of the girl's skirt (compare Plate 75).

79. A Review in the Market Place of a Country Town. About 1790. Pen and watercolour over pencil, 11⅜ × 17½ in. (289 × 445 mm.). *From the collection of Mr and Mrs Paul Mellon*

An attractive but diffuse composition with the figures isolated in separate clusters. Rowlandson has caricatured both the officer and his troop of soldiers, who are either ignored or regarded with amusement by the townsfolk. It has been suggested that the view is of Winchester, but this does not seem to be correct; no alternative identification has been proposed. The topographical detail, though circumstantial and carefully rendered, falls short, as always in Rowlandson, of the exactitude of a Malton, Hearne or Dayes: the architectural precision characteristic of these artists would have been unnecessary to his purpose.

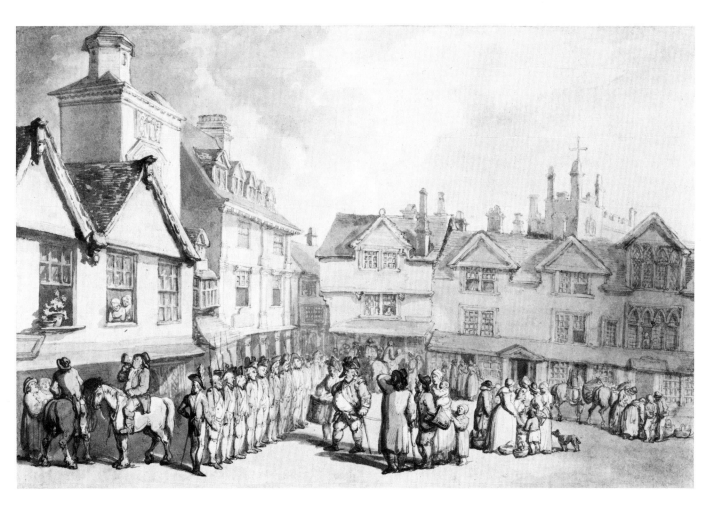

80. Cuckfield, Sussex, at Fair Time. Etched by Rowlandson and aquatinted by
Alken as Plate IV for *An Excursion to Brighthelmstone made in the year 1789*, 1 June
1790. Pen and watercolour over pencil, $9\frac{1}{16} \times 11\frac{13}{16}$ in. (230 × 300 mm.).
Liverpool, Walker Art Gallery (Beausire Collection)

One of the watercolours Rowlandson worked up from the sketches he made during
his trip to Brighton with Wigstead in 1789. The volume, published in 1790 and
dedicated to Rowlandson's patron the Prince of Wales, was provided with
eight aquatints after Rowlandson's drawings and a commentary by Wigstead.
The precise pen line which Rowlandson has used in this watercolour was evidently
employed with etching in mind. The view shows the main street of Cuckfield, with
Holy Trinity church in the background; the King's Head inn still exists.

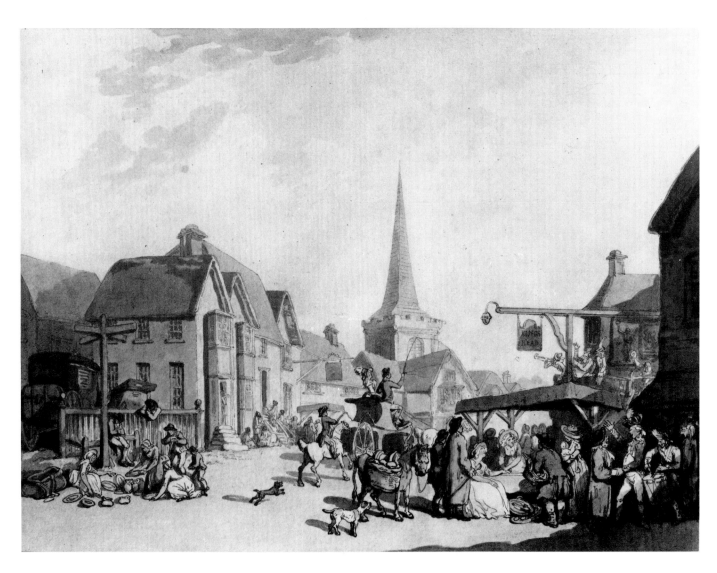

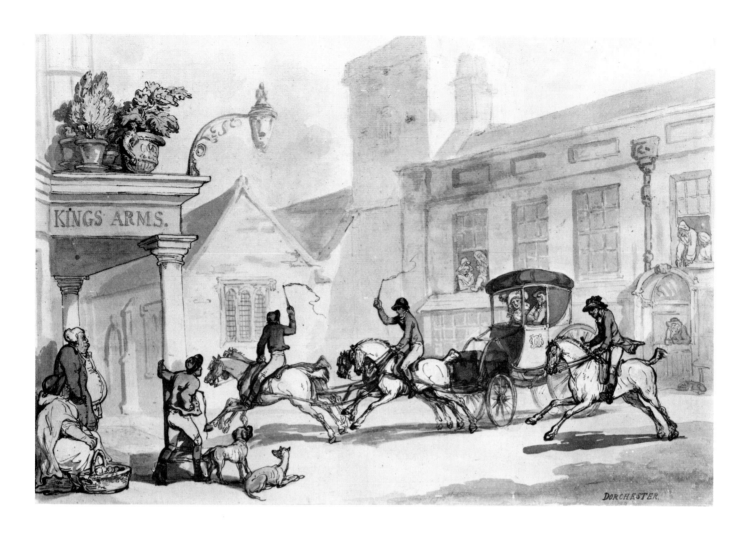

81. **The King's Arms, Dorchester, Dorset.** About 1790. Inscribed. Pen and
watercolour over pencil, 10¾ × 16⅛ in. (273 × 410 mm.). *Cambridge,
Fitzwilliam Museum*

A nobleman and his wife passing through Dorchester in a post-chaise; their
travelling trunk can be seen slung between the two front wheels. Rowlandson has
again used a thin and precise pen line, generally lacking in the rich flexibility
characteristic of his earlier work. This view of the High Street shows the King's
Arms, with its familiar bay window over the entrance porch, the church of All
Saints (rebuilt in 1843), and the old County Hall. The buildings on the far side
of the street have only been washed in, Rowlandson's normal procedure when
architecture was intended more as background than as part of a view.

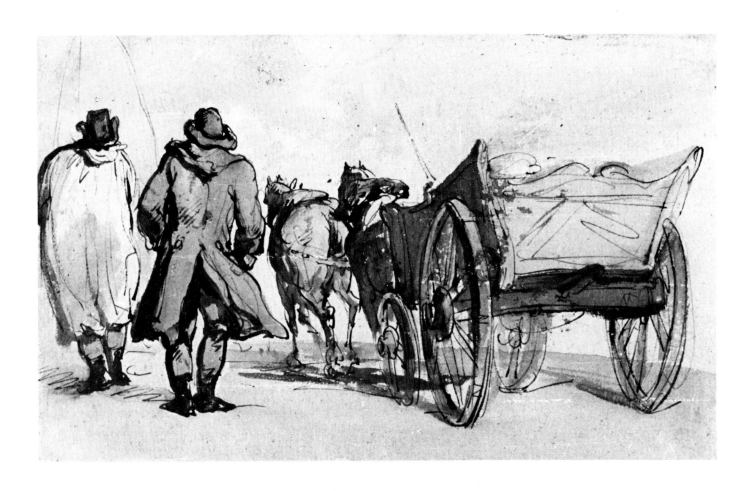

82. Two Drovers with a Waggon. About 1790. Pen and watercolour over pencil, $5\frac{3}{4} \times 9\frac{1}{4}$ in. (146×235 mm.). *Sir Hickman Bacon Collection, now at Raveningham Hall*

A study of a waggon and horses in foreshortening, brilliantly executed, though with one or two weaknesses in detail, such as the positioning of the smaller wheel on the far side. The weight of the nearer drover's hat, coat and boots is admirably suggested by the thick contour lines and rich shadows; looser, thinner lines are used for the lighter material of the white smock worn by the other drover.

83. Horses Grouped round an Oak Tree. About 1795–1800. Falsely signed. Pen and wash over pencil, $10\frac{1}{2} \times 14\frac{1}{2}$ in. (267×368 mm.). *Ottawa, National Gallery of Canada*

In common, perhaps, with most of his contemporaries, in an age when riding was the usual means of travelling any distance, Rowlandson possessed a considerable understanding of the psychology and movement of the horse. Horses offered him more opportunities for fine and spirited drawing than almost any other subject, the tailpiece to *A Tour in a Post Chaise* (see p. 214) being the prime example; he did sketches of stallions fighting, and lyrical compositions of the present description are more common in his *œuvre* than is usually allowed. Notice how he has conveyed all the nervous alertness of the animal on the left in a simple silhouette of even, unassisted wash.

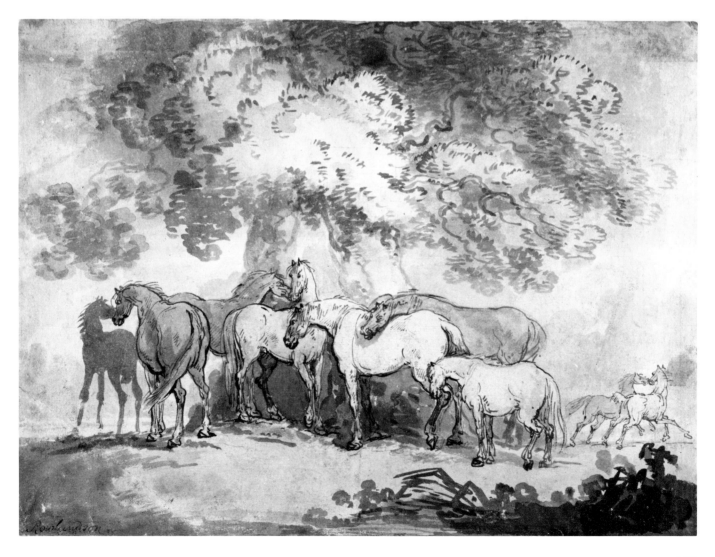

84. A Coffee House. Signed and dated 1790. Pen and watercolour over pencil, $5\frac{3}{4} \times 9\frac{1}{16}$ in. (146 × 230 mm.). *Poughkeepsie, New York, Vassar College*

Rowlandson has again employed a rich, thick and flowing contour line to give substance and vigour to the principal figures. With characteristic economy, he has made no attempt to suggest what happens behind the soldiers on the left. The serving girl who is preparing a syllabub was originally planned to be further to the left, as can be seen by the *pentimento* of a female head, outlined in pencil, visible next to the sheet on the wall entitled *List of the Army*.

85. The Long John, a Cannon at Gosport. About 1790. Pen and watercolour over pencil, $4\frac{1}{2} \times 7$ in. (114 × 178 mm.). Reproduced original size. *England, Private Collection*

A simple but striking little composition. The slightly sceptical artilleryman holding the ramrod provides an effective equipoise to the main diagonal thrust. Rowlandson has barely indicated the rampart and the castle behind in broad, loose washes.

86. The Horse Fair. About 1790. Pen and watercolour over pencil, $7\frac{5}{8} \times 16$ in. (194×406 mm.). *London, Victoria and Albert Museum*

A fine, loosely drawn, almost monochromatic sketch in which Rowlandson has suggested the taut, nervous energy of the nearer animals in crisp, firm penwork. The composition is based on two diagonals linked, more convincingly than in certain other works, by the group of onlookers in the foreground and the horseman in the distance.

87. A Gaming Table at Devonshire House. Signed and dated 1791. Pen and watercolour over pencil, 12⅛ × 17⅛ in. (308 × 435 mm.). *New York, Metropolitan Museum of Art*

A vortical composition, suggestive of the hazards of the evening, and based on the round shape of the gaming table; the stolid form of the old man in the right foreground serves as a stabilizing element in the design. The stakes are evidently high, as was customary in Rowlandson's day, since the figure '1000' is clearly marked on the pieces of paper underneath the piles of golden sovereigns. The girl on the left has run out of cash and is sorely tempted to accept the purse being offered to her by an ardent young officer, a motif that seems to be derived from Hogarth's late masterpiece, *The Lady's Last Stake* (see Figures 52 and 53), a picture which it is not clear that Rowlandson could have known. The close resemblance of the two ladies in the large hats to Rowlandson's portraits of the Duchess of Devonshire and Lady Bessborough (Plate 75) has prompted the suggestion that the scene is Devonshire House. Note the careful cross-hatching in the cheeks of the lady who may be intended as Lady Bessborough. The background is broadly washed in with tints of blue and grey. Bunbury's drawing of this subject is more likely to be a free version after Rowlandson than the original basis for the composition.

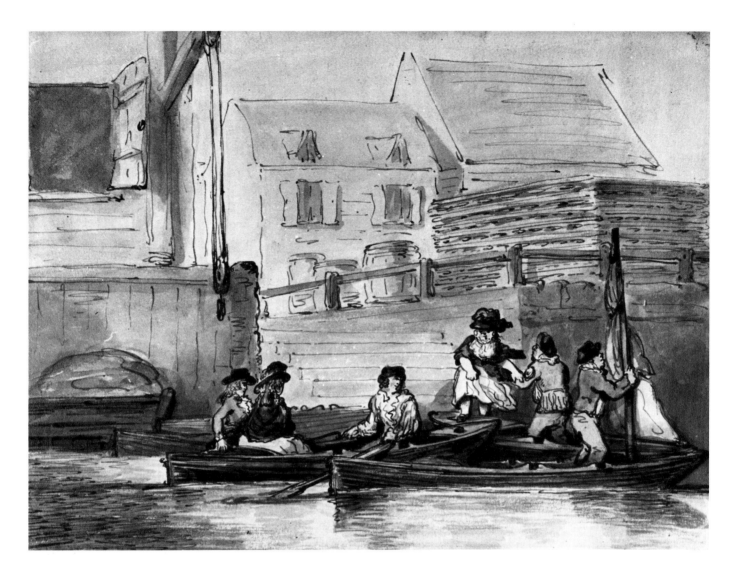

88. Wapping Stairs. About 1790–5. Pen and watercolour over pencil, $8\frac{7}{8} \times 12\frac{5}{16}$ in. (225×312 mm.). *London, Courtauld Institute of Art (Witt Collection)*

A lady being helped into a wherry by a Thames waterman. Rowlandson has caught to perfection her expression of apprehension in case she might slip. In the days when there were only a couple of bridges across the Thames in London, one London Bridge itself, the other at Westminster, there were innumerable stairs along the waterfront where watermen were ready to ferry passengers across to the other side.

89. The Pier at Amsterdam. Inscribed and signed, and inscribed and dated 1792 on the verso. Pen and watercolour over pencil, $7\frac{7}{8} \times 10\frac{1}{2}$ in. (200 \times 267 mm.). *Birmingham, City Museum and Art Gallery (J. Leslie Wright Collection)*

A lively sketch, inscribed as drawn on the spot, and evidence that Rowlandson was travelling in Holland in 1792. The composition is daring, but any effect of imbalance is offset by the dark mass of the rowing boat on the left and by the sail which keeps the spectator's eye firmly in the picture plane. The vessel in the foreground does not sit too well in the water. There is a sketch of Dutch fisherfolk on the verso.

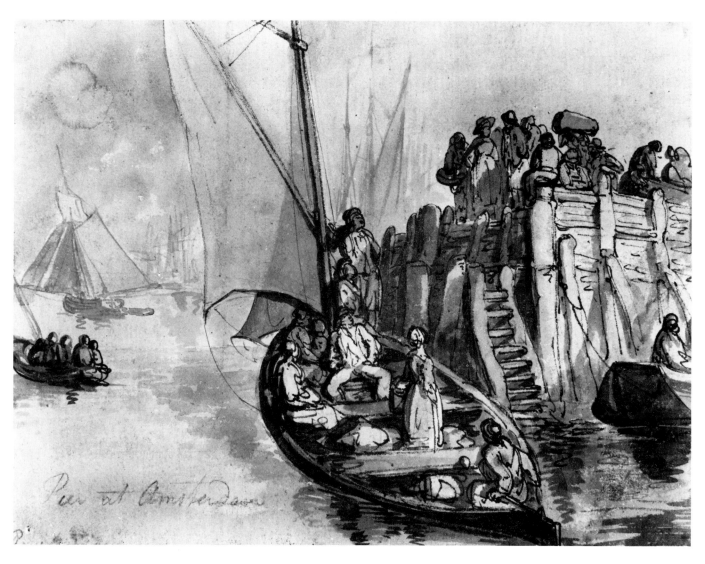

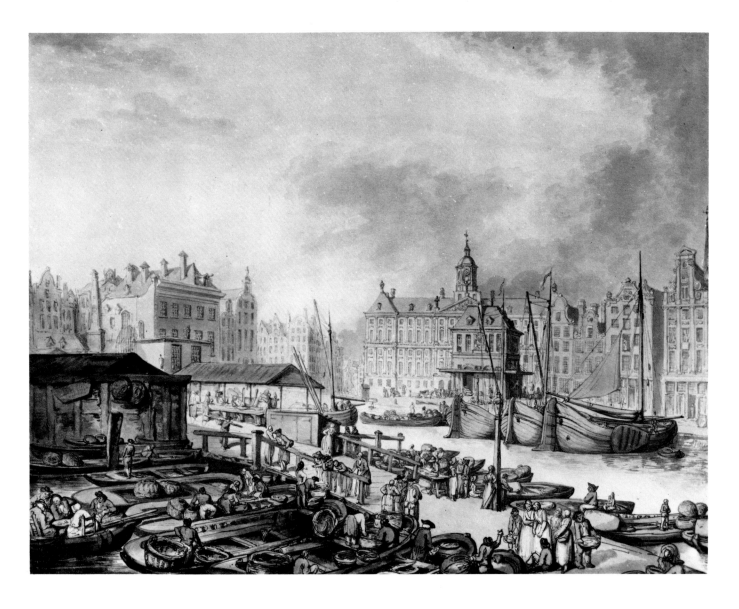

90. The Fish Market at Amsterdam. About 1794. Etched by Wright and
Schutz and published by R. Ackermann, 1 August 1797. Pen and watercolour
over pencil, 16½ × 21½ in. (419 × 546 mm.). *Bolton, Museum and Art Gallery*

One of Rowlandson's most elaborate and carefully delineated topographical views.
The Royal Palace and the Weigh House are seen in the background. Rowlandson
drew this subject, the companion of the Stadhuis, and the Place de Mer at
Antwerp (opposite), when he was on a tour of the Low Countries with Matthew
Michell, and either this drawing or the version of it which appeared at Sotheby's
in 1958 was probably the one owned by Michell.

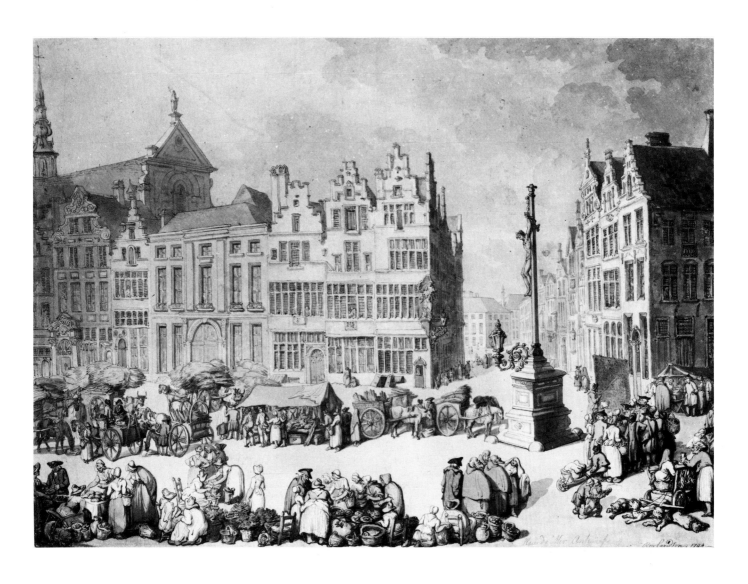

91. The Place de Mer, Antwerp. Signed and dated 1794, and incribed.
Etched by Wright and Schutz and published by R. Ackermann, 1 August
1797. Pen and pencil over watercolour, $16 \times 21\frac{3}{4}$ in. (406 × 552 mm.). *Formerly
London, Fine Art Society*

As in the case of its two companions, Rowlandson has taken exceptional care with
the topography and detail of this view. The Place de Mer became one of the most
important thoroughfares in Antwerp in the sixteenth century, owing to the
proximity of the Stock Exchange. Both the church of the Carmelites, seen on the
left, and the cross were demolished in 1797, during the French occupation of the
city. The street on the right is the Huidevettersstraat. The figure groups in this
drawing are animated enough, but Rowlandson's congenital inability to fuse his
sequences of figures into a completely plausible whole is demonstrated here by the
way in which they are strung out in two separate planes. This is probably the view
of the Place de Mer, owned by Matthew Michell, that fetched the top price of
nine pounds at the sale of his Rowlandsons at Sotheby's in 1818. An unsigned and
undated version is in the Victoria and Albert Museum.

92. The Elopement. Signed and dated 1792. Pen and watercolour over pencil, $10\frac{7}{8} \times 8$ in. (276×203 mm.). *From the collection of Mr and Mrs Paul Mellon*

A typically Rowlandsonian adventure in which an officer intent on speedy elopement helps his loved one to escape from the constrictions of boarding school; the sprightly young lady is giving ample demonstration of her charms in the course of her descent from the first floor balcony. The line is thin and tight, and the handling somewhat cursory for a Rowlandson of this date. A companion drawing is entitled *Smuggling In*.

93. The French Hunt. Signed and dated 1792. Pen and watercolour over pencil, $14\frac{3}{4} \times 20\frac{5}{8}$ in. (375×524 mm.). *London, British Museum*

Rowlandson's feelings about the French are apparent from this caricature of a French stag hunt. Nothing could be more ridiculous than the unseated sportsman with the hounds diving through his upturned legs or the miserable old fellow in his greatcoat who is bringing up the rear. The foppish figure with the absurd monkey-like expression is worthy of Gillray. The line is precise and the modelling of the horses' flanks reinforced with hatching; by contrast, the handling of the foliage is more generalized than is customary with Rowlandson, and closer to the style of contemporary landscape watercolourists such as Francis Nicholson.

94. Mountainous Landscape. About 1790–5. Inscribed. Pen and watercolour over pencil. *Formerly London, Frank T. Sabin*

Many of Rowlandson's pure landscapes were done in Cornwall and Devon on visits to his friend Matthew Michell, who lived near Bodmin; others were done on a tour of Wales. The hilly countryside of these parts of Britain suited his essentially rococo vision, and the present drawing, executed on two leaves of a sketchbook joined together, has a flowing, undulating, almost eruptive quality. It has not been possible to decipher the inscription, which is trimmed on the available photograph, so that the identity of the view must remain uncertain until the original drawing reappears.

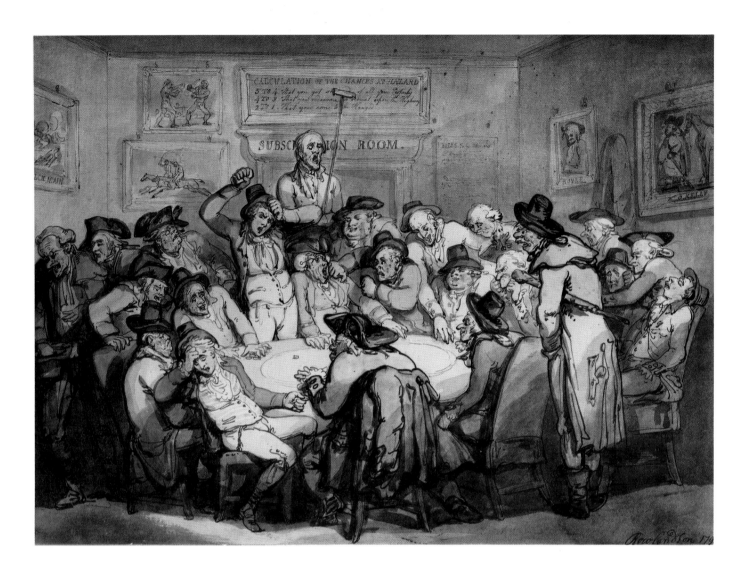

95. A Club Subscription Room. Signed and dated 1792. Pen and watercolour over pencil, 12¾ × 17⅝ in. (324 × 447 mm.). *London, Victoria and Albert Museum*

A group of sharpers round a gaming table. The ruffian on the right is armed with a club and pistol, and evidently prepared for the kind of fracas which occurs in Rowlandson's *A Kick-Up at Hazard*; the grasping individual in the foreground, wearing a tricorne, is reminiscent of the figure on the right in the scene at Devonshire House (Plate 87). The light is falling full across the table and has isolated the fateful dice whose last throw has evidently, to judge by the anguish of their reactions, irretrievably ruined the two young men present; this emphasis on the calamity of sudden ruin may have been influenced by Hogarth's gambling scene in *A Rake's Progress*. The inscription above the entrance to the room calculates the odds on disaster: '5 TO 4 That you get stripped of all your Property/ 4 TO 3 That you endeavour to recruit upon the Highway/2 TO 1 That you come to be Hanged.' Something of the poignancy of this composition derives from Rowlandson's own experience of coming close to ruin on similar occasions. There is a pencil sketch of figures and horses' heads on the verso. A version signed and dated 1791 is owned by Philip Pinsof.

96. The Runaway Horse. About 1790–5. Pen and grey wash, $6\frac{3}{8} \times 8\frac{3}{4}$ in. (162 × 222 mm.). *Boston, Public Library (Wiggin Collection)*

In this brilliant sketch Rowlandson has used a quite different kind of penwork from that in the *French Hunt* (Plate 93): here the line is rapid, broken, staccato and infinitely flexible, suggesting the frenzied gallop of the runaway horse and the inevitability of disaster to the terrified driver and his gig, both already perilously off balance. The composition is firmly based on the downward diagonal of the shaft and the outstretched form of the horse, but the power of the design, and the impression of continuity beyond the picture space, is enormously enhanced by the horseman furiously reining in behind and by the dog rushing in towards the vehicle as fast as its legs will carry it. The gibbet in the background has no obvious relationship to the subject-matter.

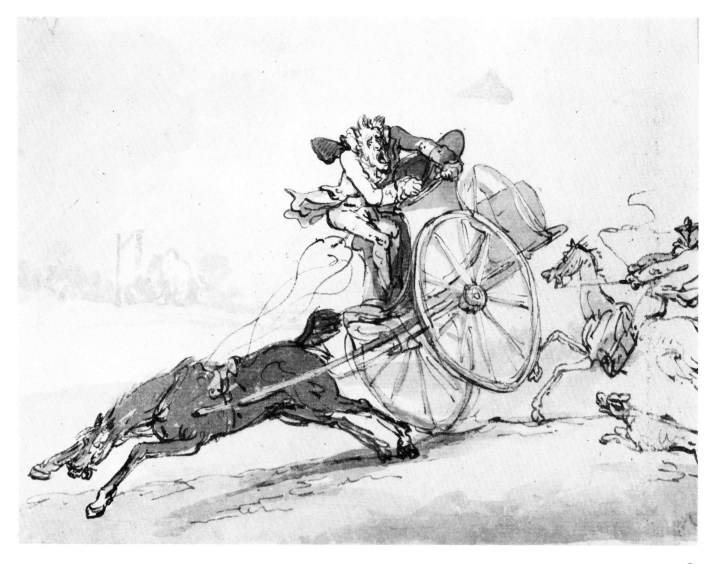

97. A Waggon Team. About 1790–5. Pen and watercolour over pencil,
 10 × 14 in. (254 × 356 mm.). *Private Collection*

The uphill sweat of the team of horses is counterbalanced by the clouds moving in
the opposite direction. An unusually atmospheric distance has been created on
the right by means of the sensitive and loosely brushed wash suggesting the shapes
of hedgerows and trees.

98. A Cascade. About 1790–5. Pen and watercolour over pencil, 17 × 11⅜ in.
 (432 × 289 mm.). *Formerly Dyson Perrins Collection*

Three travellers, dwarfed by the surrounding scenery, are seen admiring the
beauty, sublimity, or picturesqueness (according to taste) of a cascade. William
Gilpin, in his descriptive *Tours*, circulated in manuscript in the 1770s and
published in the 1780s and 1790s, had opened the eyes of a public too long
accustomed to a bias for Swiss and Italian scenery to the beauties of the English
countryside, and travel for the purpose of viewing and delineating scenery became
a popular pastime by the turn of the century. Rowlandson's soft treatment of the
distant foliage is extremely sensitive, and the tall foreground tree arches over the
scene like those in Wilson's classic *Vale of Narni*.

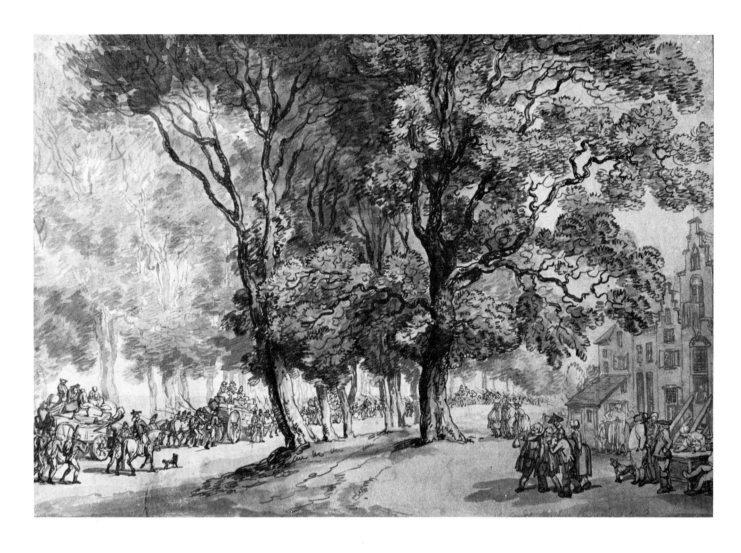

99. The Guards Marching through Holland. About 1790–5. Inscribed. Pen
and watercolour over pencil, $13\frac{1}{4} \times 19\frac{3}{4}$ in. (337×501 mm.). *London, Courtauld
Institute of Art (Spooner Bequest)*

The column of soldiers with their baggage waggons is dwarfed by the huge trees
which line the road and their luxuriant foliage. Rowlandson's highly rococo
treatment of the branches, which twist and turn in all directions, is fundamentally
no different from the style of his earliest drawings (compare Plate 2).

100. A Military Escapade. About 1795–1800. Pen and watercolour over pencil,
$15\frac{1}{4} \times 10\frac{7}{8}$ in. (387×276 mm.). *From the collection of Mr and Mrs Paul Mellon*

A superbly contrived spiral of figures, conveying to the full the physical tension of
the rescuers who are preparing to grip the legs of the gay young spark as he
descends with the aid of a sheet, as well as the movement and excitement of the
onlookers in the rowing boat. The moonlight effect adds additional romance to the
scene. There is no trace of vermilion ink in the *Club Subscription Room* (Plate 95) or
the *French Hunt* (Plate 93), both of which are signed and dated 1792, but at some
point in the mid-1790s Rowlandson began to use this medium to enrich his
penwork: it is chiefly evident here in the drawbridge on the right.

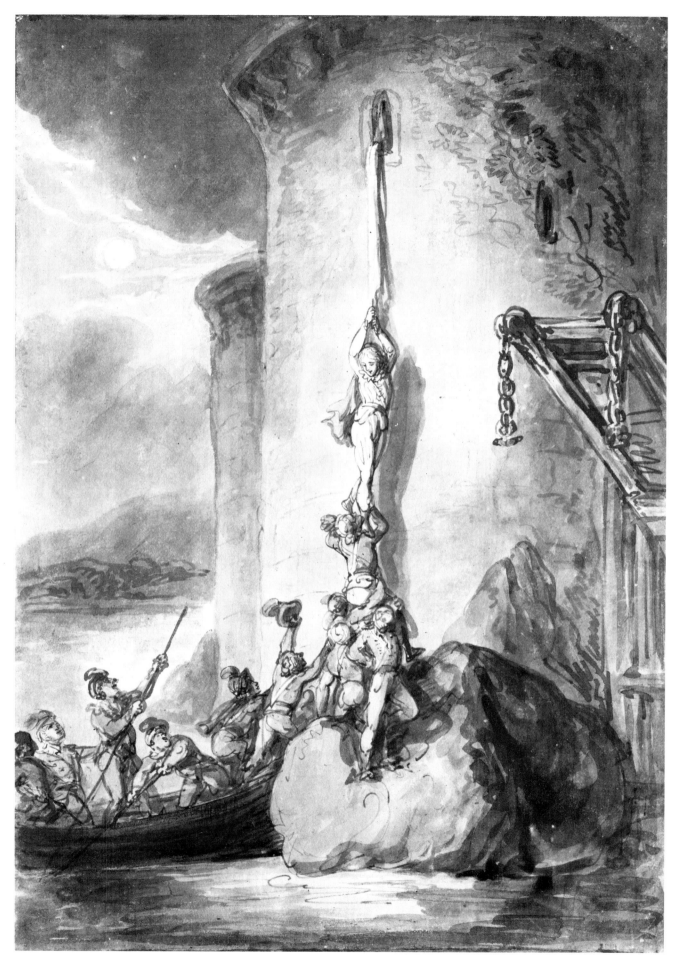

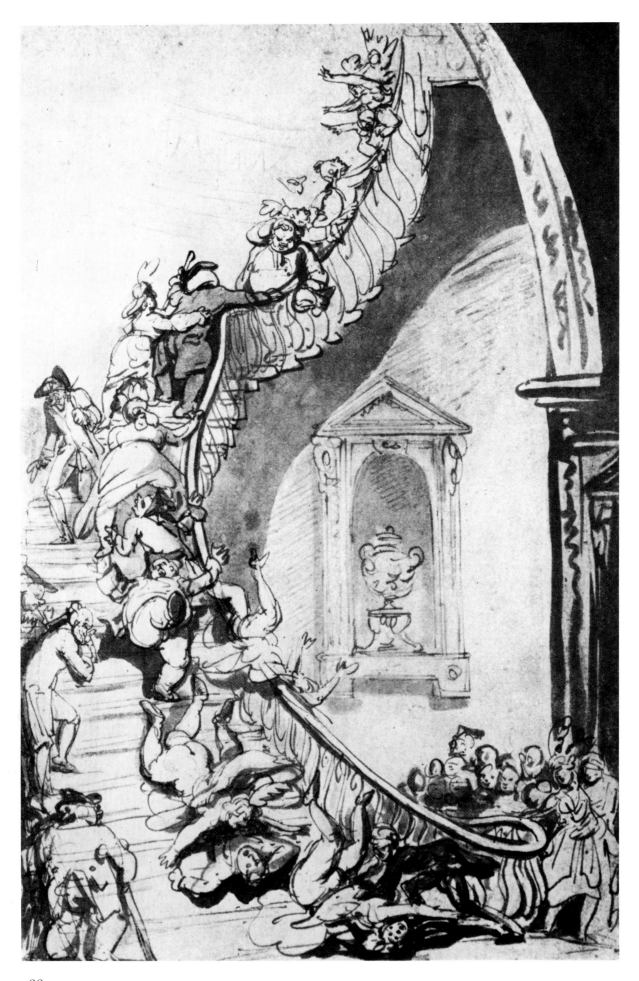

101. The Exhibition 'Stare-Case'. About 1800. Etched and published about 1811. Pen and wash, $15\frac{3}{4} \times 10\frac{5}{8}$ in. (400 × 270 mm.). *Formerly London, University College (destroyed in the Second World War)*

One of Rowlandson's most striking compositions, showing visitors going up the staircase to see the Royal Academy exhibition (then shown at Somerset House): as a result of people slipping on the stairs, both at the top and half-way up, a general tumble has ensued, and Rowlandson has portrayed a continuous and visually breathtaking spiral of interlocked figures, some mounting, some cascading violently downwards, the women indecorously displaying their backsides as their clothes fly over the tops of their heads. In the print, the display of nudity has been transferred from the figures to a statue—deliberately turned to show *its* backside—which replaces the urn in the niche.

102. A Timber Waggon. About 1795–1800. Falsely signed. Pen and watercolour, $4\frac{1}{2} \times 7\frac{1}{4}$ in. (114 × 184 mm.). Reproduced original size. *From the collection of Mr and Mrs Paul Mellon*

A scene clearly taken from the life which Rowlandson has composed into a delightful and unaffected, but gently rhythmical, design. The loose, naturalistic treatment of the foliage contrasts sharply with the rococo mannerisms or studied delicacy of previous drawings (Plates 99 and 98).

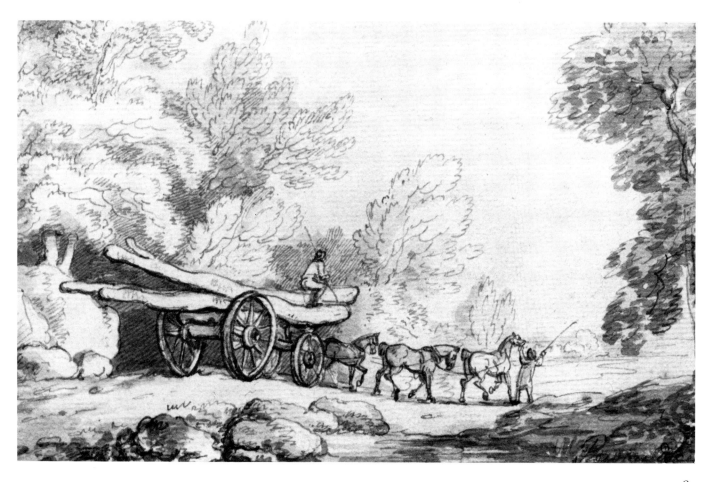

103. Fording a Stream. Signed and dated 1795. Pen and watercolour over pencil, $15\frac{7}{8} \times 20\frac{7}{8}$ in. (404 × 530 mm.). *England, Private Collection*

A Gainsboroughesque scene of rustics returning home from market. The thin, spidery penwork in the figures and horses has now become typical for Rowlandson's more lyrical or delicate subject-matter. The tortuous rococo treatment of the branches is even more mannered than in *The Guards Marching through Holland* (Plate 99), and the gnarled tree stump in the right foreground seems almost to be some living creature.

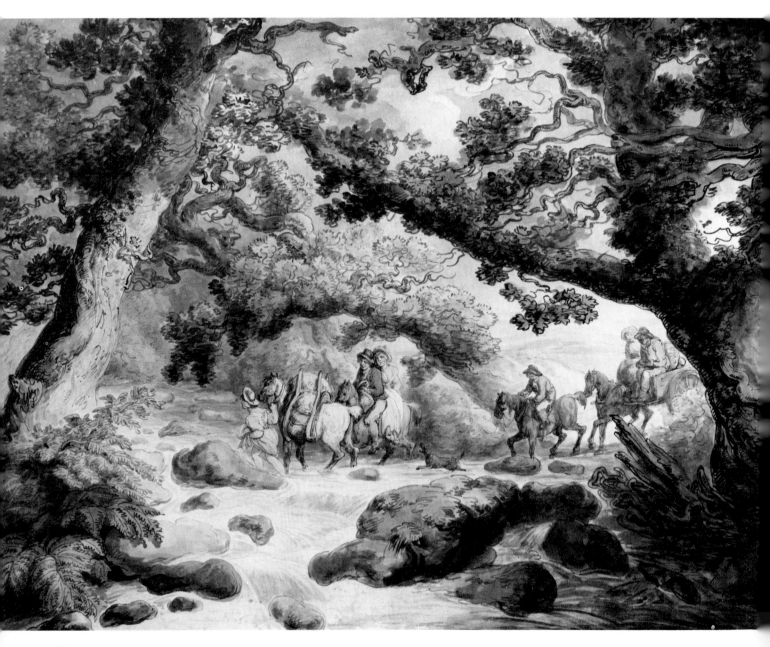

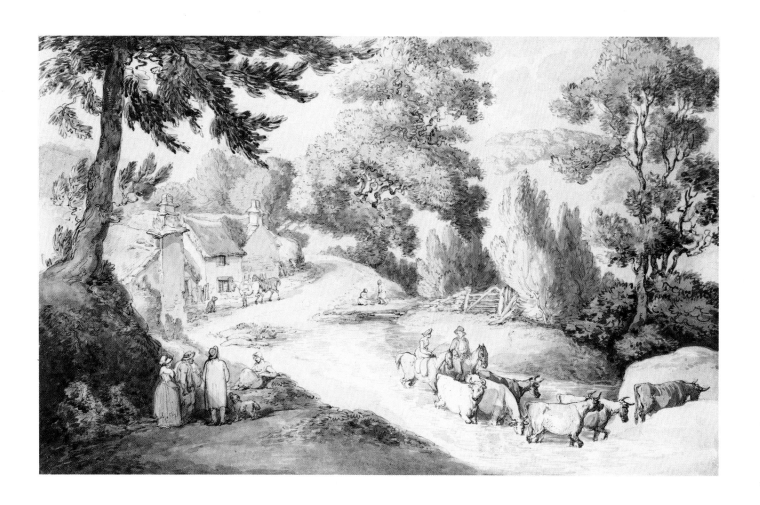

104. Landscape with Cows Being Driven through a Stream. About
1795–1800. Pen and watercolour over pencil, $9\frac{1}{2} \times 15$ in. (241 × 381 mm.).
Oxford, Ashmolean Museum

One of Rowlandson's most delightful rural scenes, with a typically rococo winding
composition and a *repoussoir* tree on the left reminiscent of classical landscape
design. The trees and foliage are almost wholly free of Rowlandson's usual
mannerisms, the colour is fresh and unfaded, and the drawing crisp and precise.

The Living obtained.

Rowlandson 1793

105. The Living Obtained. About 1795–1800. Inscribed. Pen and watercolour over pencil, $3\frac{7}{8} \times 6$ in. (98 × 152 mm.). *Cambridge, Fitzwilliam Museum*

The figure on the right, who seems to have had a glass too many, is abandoning all pretence of deference or decorum after the matter of his preferment to a living has been settled. The figure on the left, evidently the patron of the living, is clearly concerned as to whether he has made the right choice after all.

106. Sunday Morning. Signed and dated 1798. Pen and grey and pink wash, $3\frac{3}{4} \times 5\frac{3}{8}$ in. (95 × 137 mm.). Enlarged. *Windsor Castle (reproduced by gracious permission of Her Majesty The Queen)*

Another vignette, also sketched without background, making fun of familiar human relationships. In this case, the archetypal matriarch is shown setting forth, an invincible battleship ensconced in an enormous bonnet, fiercely alert to anything that may meet her gaze; her husband, doleful but resigned in expression, trudges a few paces behind.

107. A Carrier's Waggon Halting in a Village. About 1800. Pen and watercolour over pencil, 10 × 15 in. (254 × 381 mm.). *From the collection of Mr and Mrs Paul Mellon*

A lyrical drawing in which the colour, applied in a range of delicate, muted tones, is of greater importance than the line. The scene is a peaceful one, the horses resting, a girl descending from the back of a waggon at the end of her journey, and a woman drawing water from a well; the soft, luxuriant foliage enveloping the scene emphasizes the gentle, summertime mood of the composition.

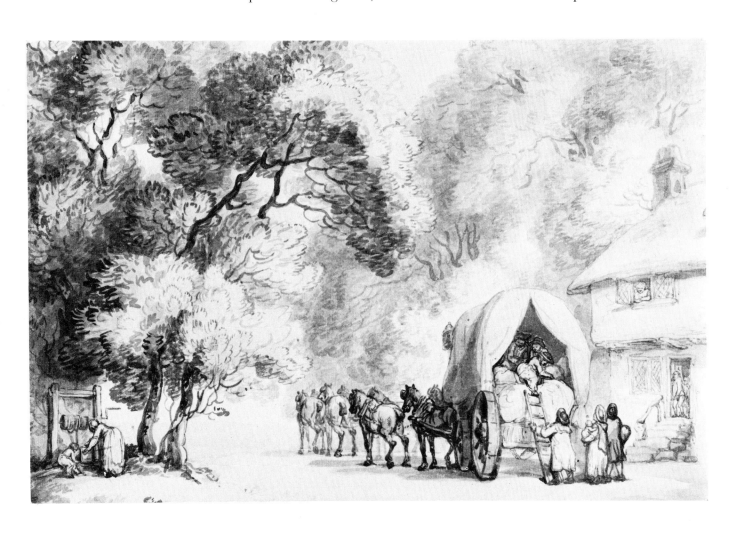

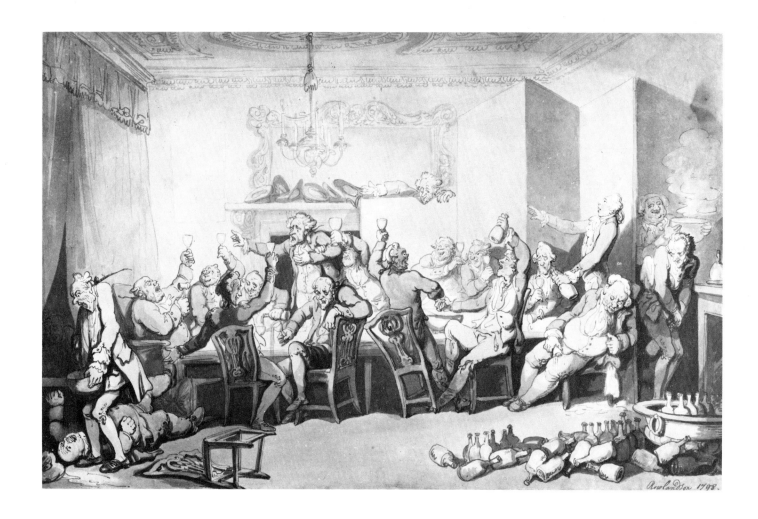

108. The Brilliants. Signed and dated 1798. Etched and published by R.
 Ackermann, 15 January 1801. Pen and watercolour over pencil, $11\frac{3}{4} \times 18\frac{1}{4}$ in.
 (298 × 464 mm.). *Formerly London, Frost and Reed*

A lively composition which would have gained from richer penwork, and based on
an interplay of swaying movement and counter-movement suitably suggestive
of the state of intoxication which everyone seems to have reached. The Brilliants
was a club composed chiefly of actors and journalists, who met after the play at
the Swan Inn, Chandos Street, Covent Garden, and often caroused until
4 or 5 o'clock in the morning. Excessive consumption of liquor was habitual in
Rowlandson's day, and to a certain extent it has become accepted as one of the
signs of a gentleman (or, at least, a 'real man') ever since. In the published print
the sheet of paper hanging on the wall to the left of the mirror is filled in with the
club's rules: '1st. That each member shall fill a half-pint bumper to the first toast.
2nd. That after twenty-four bumper toasts are gone round every member may fill
as he pleases. 3rd. That any member refusing to comply with the above regulations
to be fined, i.e. compelled to swallow a bumper of salt and water.'

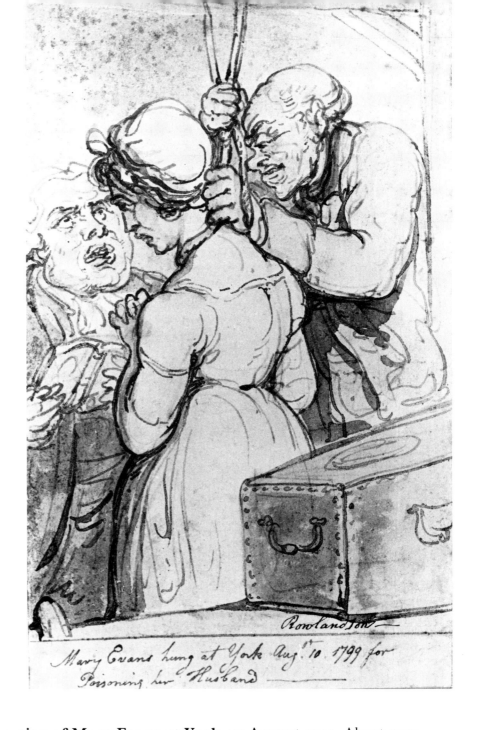

Mary Evans hung at York Aug.ᵗ 10. 1799 for
Poisoning her Husband

109. The Execution of Mary Evans at York, 10 August 1799. About 1799.
Inscribed, but falsely signed. Pen and wash over pencil, $8\frac{1}{2} \times 5\frac{1}{8}$ in.
(216 × 130 mm.). *York, City Art Gallery*

A coarse but vigorous drawing. Rowlandson has evidently gone over much of the
penwork twice: stronger ink has been used to reinforce contours, and darker lines
can be detected in a number of places side by side with lighter ones, notably in
the neck line of the woman's dress. This was the age of the criminal broadsheet—
sensational accounts of horrific crimes and of the victim's 'last dying speech'—
which were hawked in the streets hot from the press; and Rowlandson drew a
number of execution scenes and portraits of notorious criminals. It is not clear in
this instance whether he was present at York, which seems to be implied by the
specific nature of the inscription, or whether the whole scene, with its sadistic,
leering hangman, was drawn from his own imagination.

110. The Rivals. Signed and dated 1803. Pen and watercolour over pencil, $9\frac{1}{4} \times 12\frac{1}{8}$ in. (235 × 308 mm.). *Boston, Public Library (Wiggin Collection)*

A young lady at her work-basket is becoming increasingly infuriated at the attentions being paid to her sister, so much so that her scissors are beginning to look like a threatening weapon; their mother glares down at the offending officer from her portrait on the wall. Rowlandson's drawing is weak in places: the legs of the jealous sister are badly proportioned, and her right arm is anatomically incorrect. Much of the penwork is in vermilion ink.

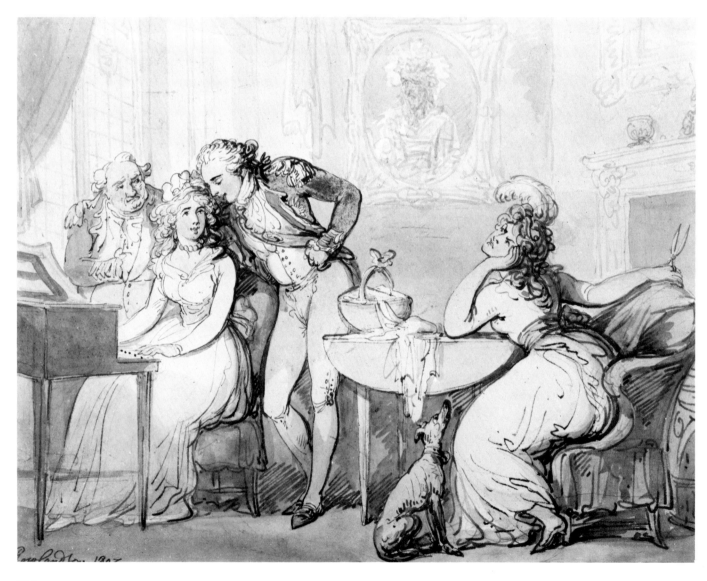

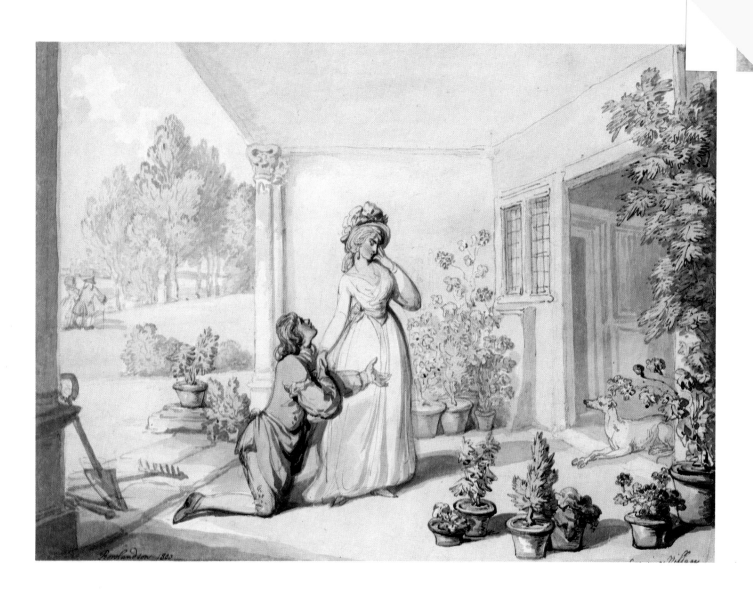

III. A Scene from 'Love in a Village'. Signed and dated 1800, and inscribed. Pen and watercolour over pencil, $7\frac{7}{8} \times 10\frac{11}{16}$ in. (200×271 mm.). *London, British Museum*

This drawing, which shows Young Meadows and Rosetta in a scene from Bickerstaff's popular comic opera *Love in a Village*, is one of the most delightful of Rowlandson's middle-period watercolours, and preserved in almost mint condition. The penwork, although supported by vermilion, is of less aesthetic significance than the colouring, which is in a range of delicate and subdued tints, mainly blues and greys; the cheeks of the lovers are gently hatched, a practice which Rowlandson had seemed to have abandoned, and the shadows in Young Meadows's blue apron are in a deeper tone of blue instead of the customary Indian ink. The couple walking across the lawn in the distance no doubt symbolize the married state some thirty years on from the ardours and doubts of courtship.

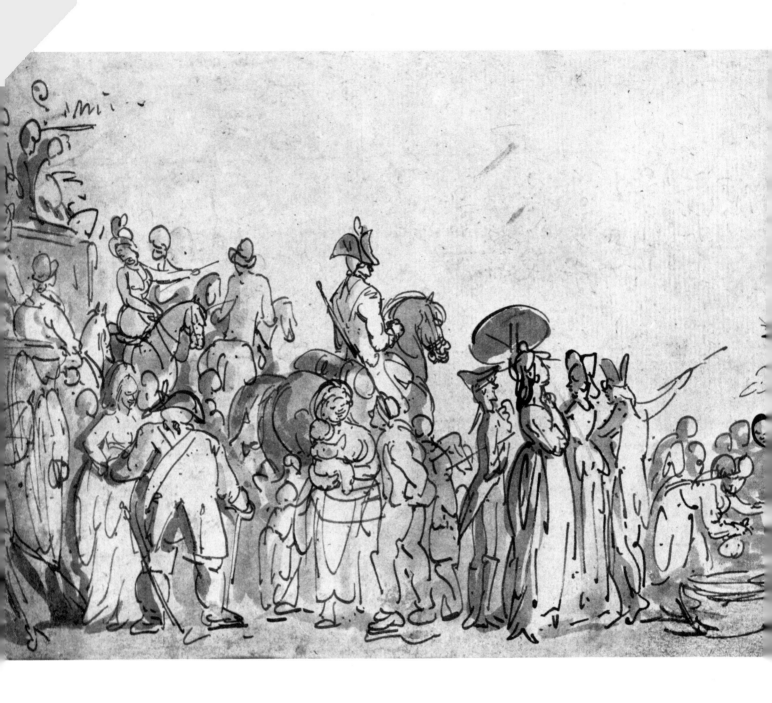

112. A Review in Hyde Park. About 1795–1800. Pen and grey wash with traces of pencil, 7 × 18 in. (178 × 457 mm.). *Felsted, Dr C. B. M. Warren*

A brilliant, almost shorthand, sketch (compare Figure 26) in which Rowlandson has arranged complex groups of figures in descending diagonals. The drawing is evidently preparatory to a composition, apparently not carried further, similar to the *Review of the Light Horse Volunteers on Wimbledon Common*, etched and published in 1798 (see Figure 27). The twirl of short, curving lines modelling the prancing horse and the lively vignette in the background, scarcely more than indicated yet full of vigour and movement, are passages one might expect from the pen of Picasso.

113. The Gardener's Offering. About 1800–5. Pen and watercolour over pencil, 11 × 16¾ in. (279 × 425 mm.). *London, Brinsley Ford*

Similar in concept to *Love in a Village* (Plate 111) except that, on this occasion, the young lady is more absorbed by her pet dog than by the ardour of her admirer; an element of comedy is added by the inclusion of a figure watching the scene from the top of a ladder on the far side of the wall. The lyrical quality of the drawing is emphasized by the trees, which are varied in tint and, though stylized and typically Rowlandsonian, far less mannered in treatment than in other work of this period (see opposite). The contours and proportion of the female figure are characteristic of Rowlandson's neo-classicism.

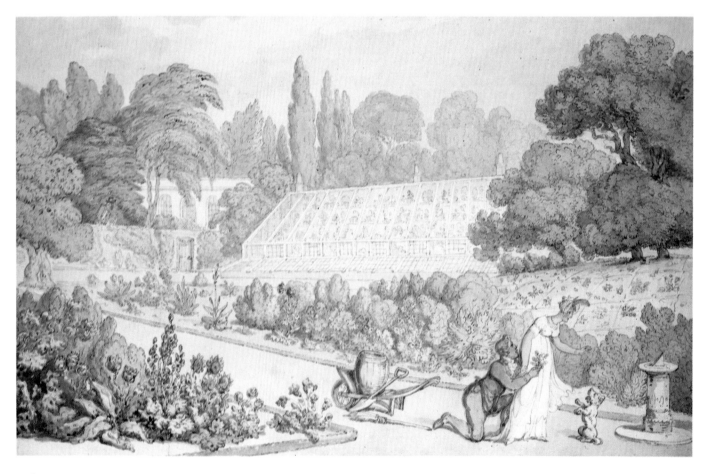

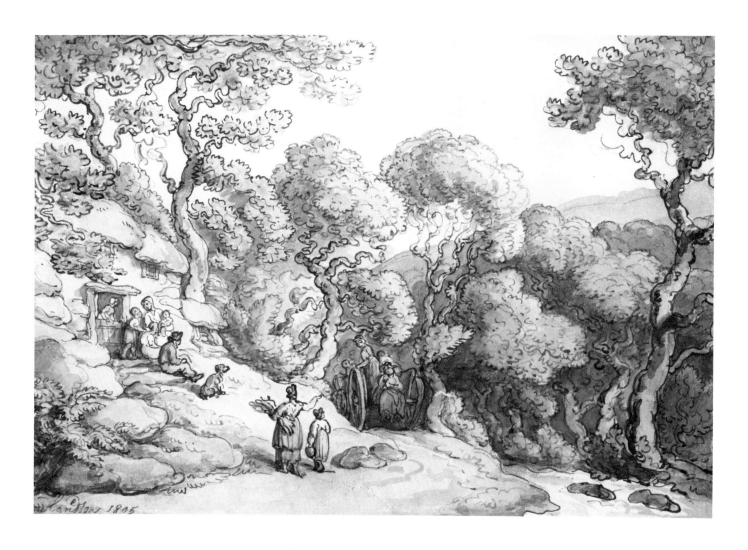

114. A Country Scene with Peasants at a Cottage Door. Signed and dated 1805. Pen and watercolour over pencil, $6\frac{7}{8} \times 10\frac{13}{16}$ in. (175×275 mm.). *Boston, Public Library (Wiggin Collection)*

The subject-matter of this watercolour is entirely Gainsboroughesque, with its peasant family grouped outside the door of a sequestered cottage, woodcutter, and passing cart. The tree trunks, outlined in short, curving strokes of the pen, resemble strange serpent-like monsters growing out of the ground, and are a striking example of Rowlandson's mannered rococo style at its most exaggerated. In contrast to this vigorous treatment, the rocks on the left are somewhat doughy in character. A version was recently sold at Sotheby's (19 March 1970 Lot 18).

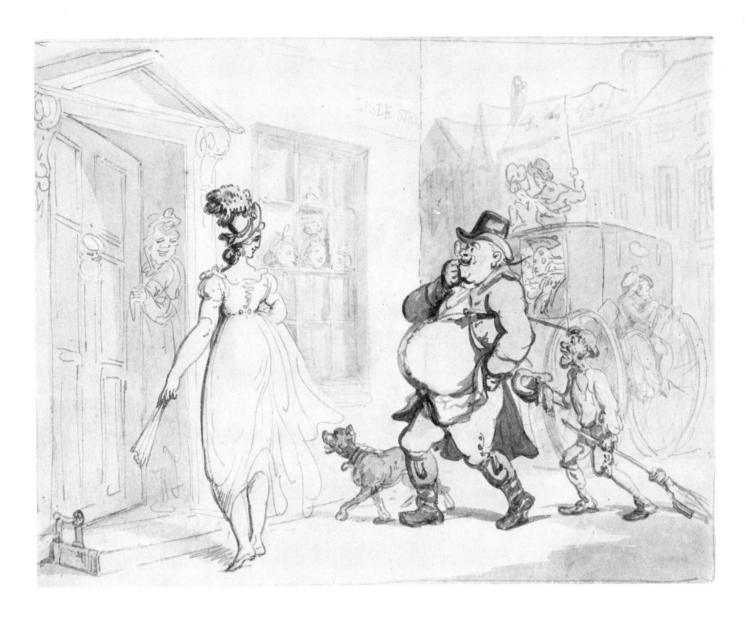

115. An Irish Member on His Way to the House of Commons. Etched
and published by R. Ackermann, September 1801 (as an 'old' rather than an
'Irish' member). Inscribed on the original mount. Pen and watercolour over
pencil, $6\frac{7}{8} \times 9\frac{1}{8}$ in. (175×232 mm.). *London, London Museum*

A distinctly pot-bellied but unashamedly amorous member of the legislature is
seen ogling a lady of the town, who is decoying him into a house of pleasure in
Lisle Street, Soho, the door of which is already being opened by an old bawd. The
theme of the drawing is underlined by the passing coach, which is replete with
loving couples, not only inside, but perched on the back and on the box as well.

116. Broad Grins. About 1800. Inscribed, but falsely signed. Pen and water-colour over pencil, $9 \times 11\frac{1}{2}$ in. (228×293 mm.). *London, Courtauld Institute of Art (Witt Collection)*

A different kind of catch from the previous drawing. Not only is this a good example of Rowlandson's rather obvious and simple-minded humour, but it shows his inability (or lack of desire) to be really horrific: the Negro fisherman's expression of fear seems real enough, but the crocodile is a cardboard, stagey kind of monster and the whole thing is meant to be taken as a joke, as the caption makes clear.

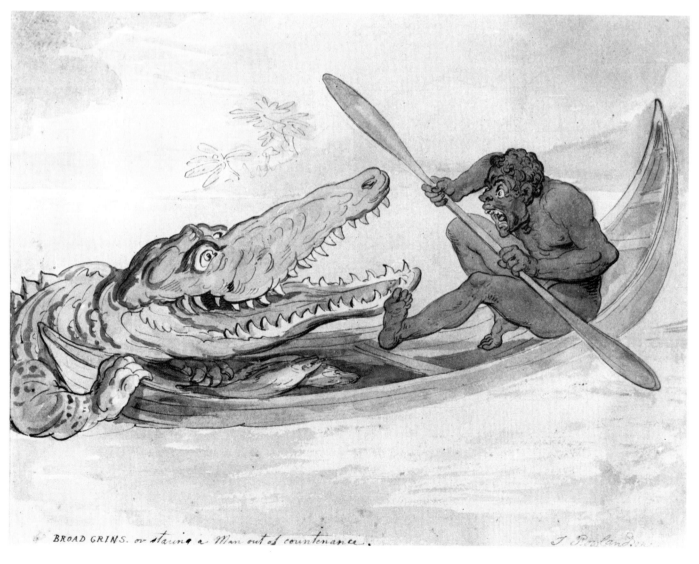

BROAD GRINS. or staring a Man out of countenance.

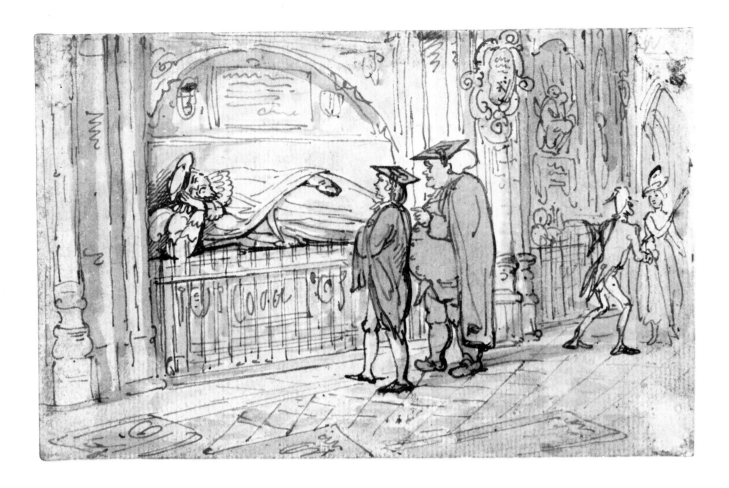

117. A Schoolmaster and His Pupil Admiring a Tomb in a Cathedral.
 About 1800–5. Pen and watercolour over pencil, $4\frac{7}{16} \times 7\frac{1}{8}$ in. ($113 \times$ 181 mm.). Reproduced original size. *London, Private Collection*

By the turn of the century it was as fashionable to admire things medieval as it
had been to study the antique a hundred years before; Gough had published his
Sepulchral Monuments of Great Britain, to which Blake had contributed drawings, and
serious antiquarian scholarship in this field was replacing the mood of rococo
Gothic fantasy associated with Horace Walpole. In this sketch the master seems to
be using the tomb of a Tudor worthy to elaborate some historical lesson.

118. Brazen Nose Chaple Broke Loose. About 1800–5. Etched and published by Thomas Tegg, 1811, with variations, as *Bacon Faced Fellows of Brazen Nose, Broke Loose.* Inscribed. Pen and watercolour over pencil, $5\frac{1}{2} \times 9\frac{1}{4}$ in. (140 × 235 mm.). *Oxford, Bodleian Library*

A procession of dons emerging from chapel. As in other drawings representing members of the learned professions, Rowlandson has seized on the pompous, complacent, and therefore ridiculous, aspects of their characters, and the result in this instance is a masterpiece of controlled caricature to which the caption adds extra spice. The crowd scene under the archway is especially well managed, and the flow of the gowns is skilfully suggested in rapidly brushed dabs of wash.

Dwelling House of Inigo Jones the celebrated Architect designed & built by him in Whitehall

119. Vanbrugh's House in Whitehall Court. About 1800–5. Inscribed. Pen and watercolour over pencil, $4\frac{1}{2} \times 7$ in. (114 × 178 mm.). Reproduced original size. *London, Private Collection*

Vanbrugh's house in Whitehall Court (Rowlandson has wrongly called it Inigo Jones's house) was built in 1700 and pulled down at the end of the nineteenth century when Horse Guards Avenue was planned. The description of the building is sketchy but accurate in general outline. Most of the penwork is in vermilion ink.

120. Dead Alive. About 1800–5. Inscribed. Pen and watercolour over pencil, $6\frac{1}{4} \times 5\frac{1}{4}$ in. (159 × 133 mm.). Enlarged. *Vancouver, N. M. Fleishman*

A young lady, apparently recently bereaved, is already in the arms of her new lover when her husband suddenly rises out of his coffin to confront them. The thick, chunky quality of Rowlandson's penwork in the smaller sketches of this period is particularly evident here in the husband's head; the background is also very broadly sketched, but in passages like the lady's costume, where the line is heavily reinforced with vermilion, his penwork is unusually fussy. Rowlandson developed the theme of this composition for *The English Dance of Death*, 1814–6.

Dead alive

Royal Exchange London.

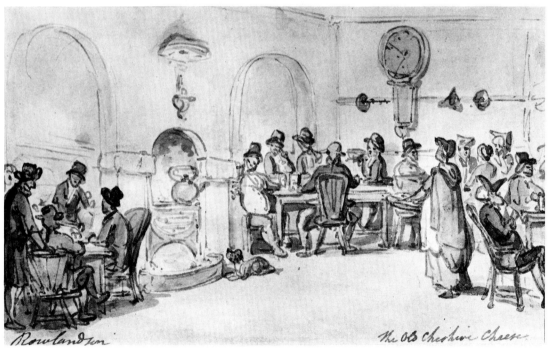

Rowlandson

The Old Cheshire Cheese.

121. The Courtyard of the Royal Exchange. About 1800–5. Inscribed. Pen and wash over pencil. *Formerly London, Frank T. Sabin*

The thick, rather staccato contour line, which is typical of Rowlandson's rough sketches of this period (see also Plate 122), is very marked in this drawing, and this kind of shorthand for modelling figures is an equivalent of Canaletto's method, though not technically similar. The view shows merchants meeting to transact business in the cloistered courtyard of the post-Fire Royal Exchange, which was burnt down in 1838.

122. The Old Cheshire Cheese. About 1800–5. Inscribed, but falsely signed. Pen and wash over pencil. *Formerly London, Frank T. Sabin*

A rough sketch of the interior of the famous tavern in Wine Office Court, off Fleet Street, one of the very few of such places to have survived, relatively intact, to the present day. In the eighteenth century it was reputedly the haunt of Dr Johnson, Goldsmith and the London literary world.

123. Early Morning. About 1800–5. Pen and watercolour over pencil, $5\frac{3}{16} \times 7\frac{3}{4}$ in. (132×197 mm.). *Boston, Public Library (Wiggin Collection)*

A coachman is asleep on his box, and three ladies of the town are sleeping on a nearby doorstep, while a watchman passes wearily by. The penwork is superficial and the building in the distance barely sketched, but Rowlandson still retains his ability to suggest expression, attitude and the weight of the body even when he seems to be betraying carelessness and inattention. Rowlandson at his most slovenly was still capable of being a fine draughtsman.

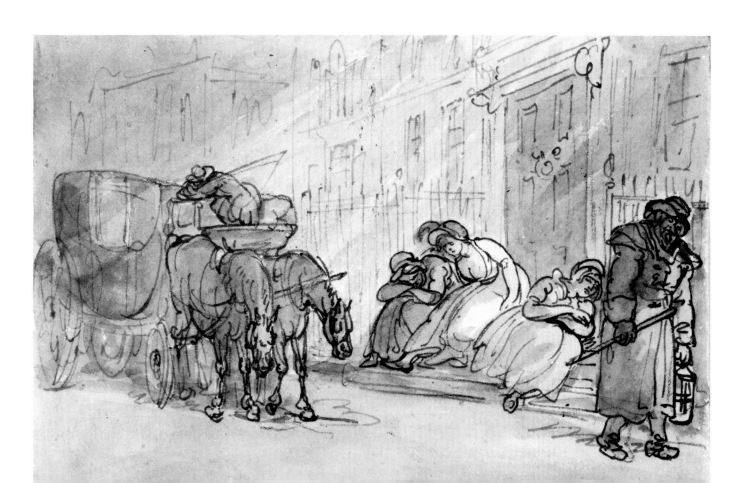

124. A Military Encampment on the Coast. About 1800–5. Pen and water-
colour over pencil. *Formerly London, Frank T. Sabin*

An attractive and loosely composed design in which the clump of trees serves as a
fulcrum for the main diagonals in the foreground, and helps to integrate the
distant groups through the long, overhanging branch. Though the branches are
again outlined in short, curving strokes, and the treatment is distinctly rococo in
character, the handling is freer and less stylized than in *Fording a Stream*, dated
1795 (Plate 103), or the *Country Scene with Peasants at a Cottage Door* of 1805 (Plate
114). The figures are suggested in thick, broken, almost undifferentiated penwork,
Rowlandson's shorthand technique characteristic of this period.

125. The Female Volunteer. About 1800–5. Falsely signed. Pen and watercolour
over pencil, 6¾ × 5½ in. (171 × 140 mm.). Enlarged. *Corsham Court, Lord Methuen*

A suitably bold and spirited sketch depicting a gay young damsel being helped into
a military uniform by her old serving maid, while an officer, in much the pose of
one of the Elders spying on Susanna at her bath, peeps round the door of the
dressing room. A bottle of cordial labelled 'Brittis Spirrits' is standing at the girl's
feet, and the inscription on the wall indicates that she is going to join Lady J's
'new raised Corps of Riflewomen'.

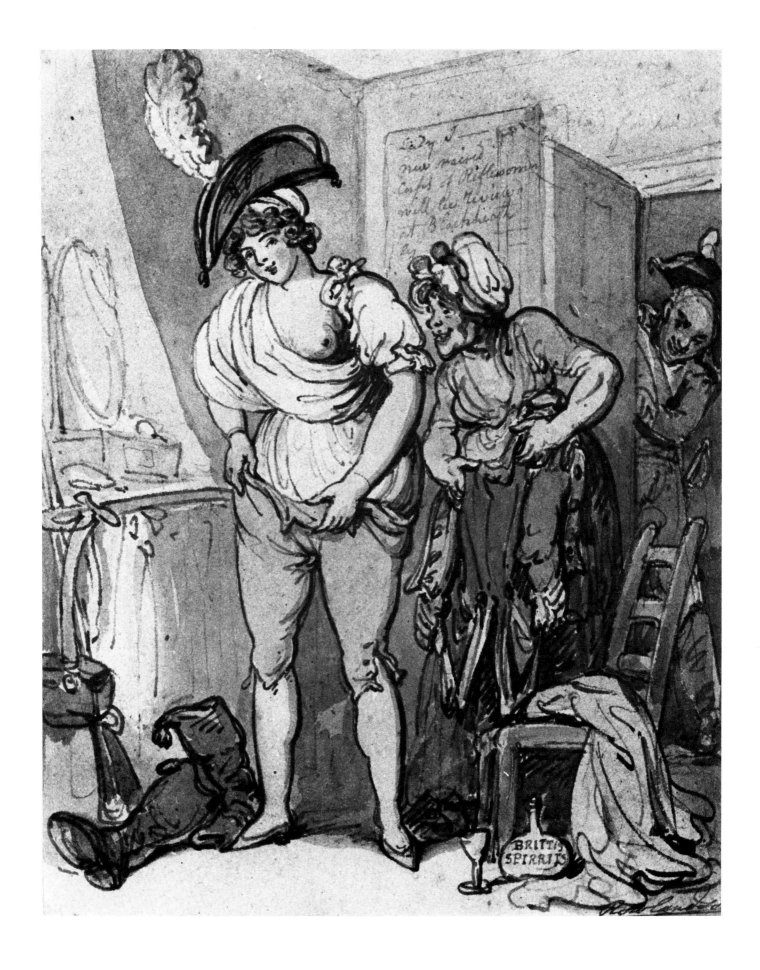

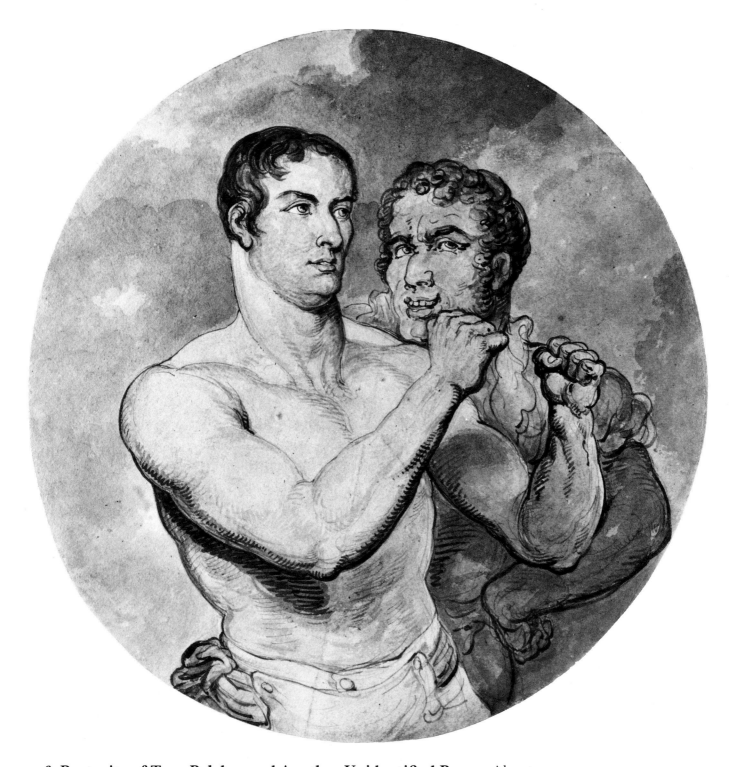

126. Portraits of Tom Belcher and Another Unidentified Boxer. About
1805–10. Pen and watercolour over pencil, 12½ in. diameter (318 mm.).
Brodick Castle, National Trust for Scotland

Tom Belcher (1783–1854), one of the most celebrated pugilists of his age, was
active between 1804 and 1813; he was noted for his gentlemanly manners and
mild deportment. Even in a subject of this sort, Rowlandson has used a fairly
precise and continuous contour line, characteristic of his neo-classical phase, with
hatching reinforcing the outline in place of wash. The roundel is about the same
size as *Showing Off in Rotten Row* (Plate 41) and other circular drawings of sports
and pastimes.

127. A Ballad Singer. About 1800–5. Pen and watercolour over pencil, $6\frac{1}{4} \times 8\frac{11}{16}$ in. (159×221 mm.). *Poughkeepsie, New York, Vassar College*

A crowd has gathered round a ballad singer at a street corner; a boy chimney-sweep and a brick-dust seller are among the characters represented. The drawing is again perfunctory, and this is particularly noticeable in the girl on the left responding to the officer quizzing her from the doorway opposite: her head is no more than blocked out in two or three evenly drawn contour lines, while some touches of hatching suffice for modelling.

128. The Englishman in Paris. Signed and dated 1807, and inscribed. Pen and watercolour over pencil, $6 \times 9\frac{1}{2}$ in. (152×241 mm.). *London, Duke of Wellington*

A portly English 'John Bull' has been enticed into a plush Parisian house of delight and is surrounded by a bevy of attractive young nymphs who are evidently anxious to please. The two groups of dancers are clearly intended to be a parody on the theme of the 'Judgment of Paris'. The strongly rhythmical character of the design, which is pointed by the draperies the girls are fluttering about, is also emphasized by the loops of the curtains.

129. The Afternoon Nap. About 1805–10. Unfinished. Pen and watercolour over pencil. *Formerly London, Frank T. Sabin*

The attenuated proportions of the young man asleep and the exaggerated length of the chaise-longue and lute exemplify Rowlandson's interpretation of the neo-classical aesthetic. The juxtaposition of figures in different planes was one of many mannerist devices to shock the spectator used to classical design, and the absorption of mannerist ideas by artists of the late eighteenth-century suggests that Rowlandson's unusual relegation of the girl playing the harpsichord to the background was deliberate. The flowing, rhythmical nature of the composition is emphasized by the round table placed in the centre and by the pronounced loops of the curtains. The rococo penwork has given a particularly woolly character to the little dog.

This is the Cat, engaged to squall, to the Poor in the Pigeon holes over the Boxes, tit to the Great, that visit the House that Jack built

130. The O.P. Riots at Covent Garden. Etched and published by T. Tegg,
27 September 1809. Pen with traces of pencil, $4\frac{1}{16} \times 4\frac{3}{8}$ in. (103 × 111 mm.).
Enlarged. *London, London Museum*

One of the sketches for the series of six cartoons concerned with the 'Old Prices'
riots of 1809, which resulted from J. P. (Jack) Kemble's opening of the new
Covent Garden Theatre with higher prices and less room for the ordinary public.
The disturbances lasted for 61 nights, after which Kemble gave in to popular
pressure. This brilliant sketch, scarcely more than notation, shows the Italian
singer Mme Catalani (coarsely and cruelly caricatured by Rowlandson as
Madame Catsqualani in another well-known drawing) being drowned by the din
of rattles and post-horns from the auditorium. The tiny size of the balconies over
the boxes, which led to their being characterized as 'Pigeon holes', is obvious from
the drawing. The tracing on the verso, which is not in Rowlandson's hand, seems
to have been made for the convenience of the engraver.

131. Mr Accum Lecturing at the Surrey Institution. Dated 1809, and inscribed; the signature cut. Etched and published by Rowlandson, about 1810. Pen and watercolour over pencil, 8¾ × 12¾ in. (222 × 324 mm.). *London, London Museum*

Friedrich Accum (1769–1838), the distinguished chemist and pioneer of gas lighting, is seen conducting an experiment in the lecture theatre of the Surrey Institution, Blackfriars Road, which was founded in 1808 as an educational centre for middle-class and professional people in South London. The composition is based on Rowlandson's familiar diagonals, and both the caricature types and the drawing are somewhat mechanical. Rowlandson used a more general view of the lecture theatre for his plate for the *Microcosm of London*, which was published the same year.

132. Apollo and the Muses. About 1810. Pen and watercolour over pencil, $8\frac{1}{4} \times 14$ in. (210×356 mm.). *San Marino, California, Henry E. Huntington Library and Art Gallery*

A loose, pyramidal composition in depth. Rowlandson's thin, spidery line is rounded and relaxed in quality, and the whole scene is conceived in gentle and lyrical terms rather than in the grand manner; the Muses do not give the impression of being particularly elevated personages.

133. The Chamber of Genius. About 1810. Etched and published by Rowlandson, 2 April 1812. Pen and watercolour over pencil, $8\frac{5}{8} \times 13$ in. (219 × 330 mm.). *Windsor Castle (reproduced by gracious permission of Her Majesty The Queen)*

Probably inspired by Hogarth's *The Distressed Poet*, and distinctly Hogarthian in the crowded nature of the composition and the accumulation of relevant detail. The painter is shown rapt in his work, a frenzied expression on his countenance, and clad only in his night-shirt and nightcap; he is surrounded by signs of his would-be genius, books, musical instruments and chemical apparatus. In his state of total concentration, he is oblivious of the dog pawing at his leg or of having upset the chamber pot; his wife is still asleep, and one of the children is pouring some cordial into a wine-glass while the other is playing with the fire. Purchased by the Prince Regent from Colnaghi's in 1811.

134. Logan Rock, Cornwall. About 1810. Watermarked 1808. Inscribed. Pen and watercolour over pencil, $5\frac{3}{4} \times 9\frac{1}{4}$ in. (146 × 235 mm.). *Leeds, City Art Gallery*

A couple of sightseers are admiring the Logan Rock, near Land's End, a massive rocking stone weighing 66 tons which, in Rowlandson's day, was so delicately balanced that it could be pushed over without much effort. Rowlandson's sophisticated and effortless line, short flowing strokes with a few dots and squiggles, lacks the versatility and richness essential for conveying mass and weight, and as a result the rocks are closer to resembling sponges than stones.

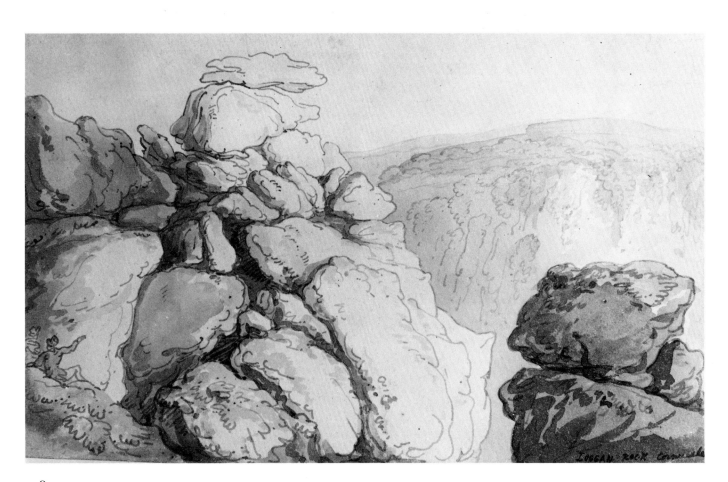

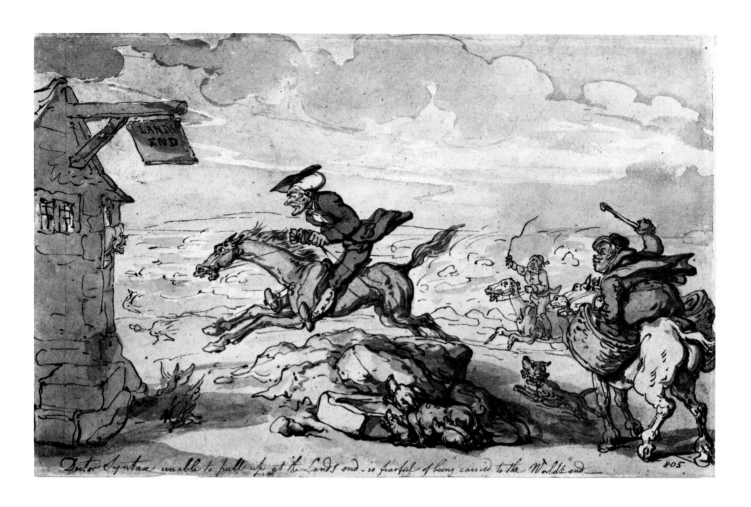

Doctor Syntax unable to pull up at the Lands end - is fearful of being carried to the Worlds end - 805

135. Doctor Syntax Unable to Pull Up at the Land's End. About 1810–12.
From *The Tour of Dr Syntax in Search of the Picturesque, 1812*, but unpublished.
Inscribed. Pen and watercolour over pencil, $5\frac{1}{4} \times 8\frac{1}{2}$ in. (133×216 mm.).
London, Victoria and Albert Museum

The production of *Doctor Syntax* was a co-operative venture between the publisher,
Rudolph Ackermann, the writer and versifier William Combe, and Rowlandson.
Combe has given us a detailed account of his working relationship with the artist:
'An Etching or a Drawing was . . . sent to me every month, and I composed a
certain proportion of pages in verse. . . . When the first print was sent to me, I did
not know what would be the subject of the second; and in this manner . . . the
Artist continued designing, and I continued writing, every month for two years,
'till a Work, containing near ten thousand Lines was produced: the Artist and the
Writer having no personal communication with, or knowledge of each other.' The
present drawing, which was not used in the book, shows the worthy Doctor unable
to pull up as he reaches Land's End, his nag Grizzle, frightened by the storm, still
going at full gallop.

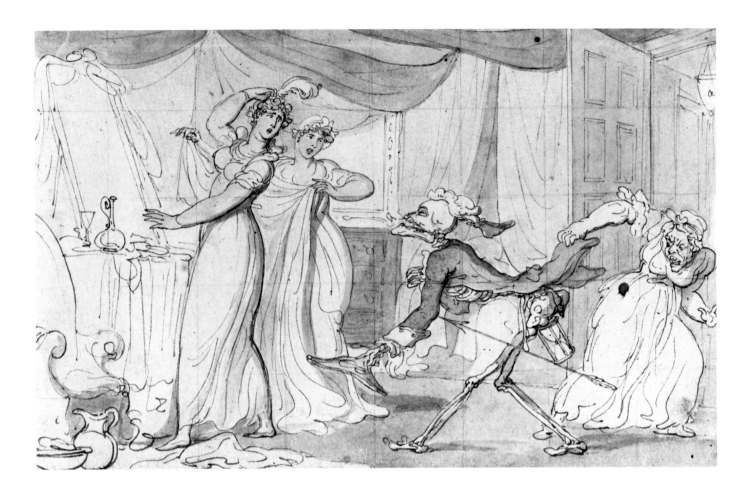

136. The Coquette. Etched and published by R. Ackermann, 1 October 1814,
for *The English Dance of Death*. Unfinished; squared up in pencil. Pen and
watercolour over pencil, $5\frac{3}{4} \times 9\frac{1}{4}$ in. (146×235 mm.). *San Marino, California,
Henry E. Huntington Library and Art Gallery*

The success of *Doctor Syntax* prompted Ackermann to embark on a fresh enterprise
with Combe and Rowlandson; the subject he proposed was *The English Dance of
Death*, which was issued in serial form between 1814 and 1816, three prints being
published every month, together with the accompanying verses. The same proce-
dure was adopted as in the case of *Doctor Syntax* (see note to the previous drawing),
Rowlandson producing the designs which, in the order they were delivered,
Combe accompanied with (not very apposite) verse. The present drawing is a
good illustration of Rowlandson's neo-classical line. It is squared up for engraving.
The unpublished handwritten caption reads: 'I'll lead you to the splendid
Croud:/But your next dress will be a shroud.'

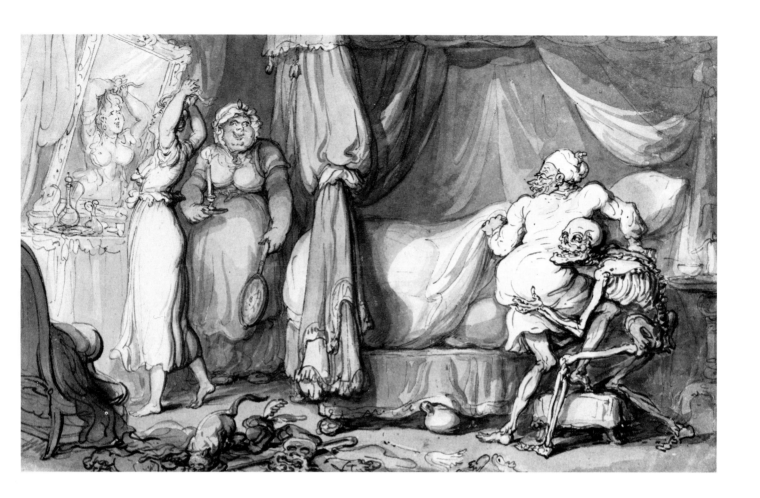

137. Death Helping an Old Lover into Bed. About 1814–16. From *The English Dance of Death*, 1814–16, but unpublished. Pen and watercolour over pencil, $5\frac{9}{16} \times 9\frac{3}{16}$ in. (141×233 mm.). *San Marino, California, Henry E. Huntington Library and Art Gallery*

The old man casts a covetous eye at his pretty young mistress doing her hair at the dressing table as he is hoisted into bed by the figure of Death. The line is much more vigorous and flexible than in many of Rowlandson's late drawings, notably in such details as the armchair in the corner, and the composition is enriched by an effective play of light and shadow.

138. The Winding Up of the Clock. Etched and published by R. Ackermann, 1 July 1815, for *The English Dance of Death*. Pen and watercolour over pencil, $4\frac{13}{16} \times 8\frac{3}{16}$ in. (122 × 208 mm.). *San Marino, California, Henry E. Huntington Library and Art Gallery*

A powerful design in falling diagonals, with the window serving as a stabilizing vertical. As the old man falls off the ladder, the figure of Death tips up his wife's armchair, thus precipitating the collapse of the tea-table. The caption reads: '"No one but me shall set my Clock." He set it & behold the Shock.'

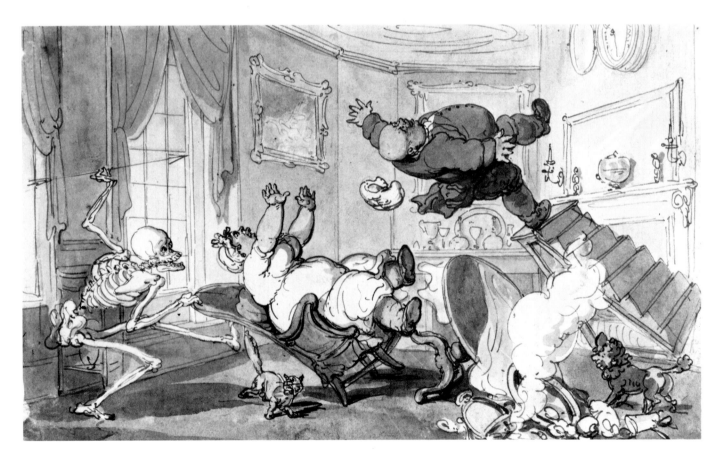

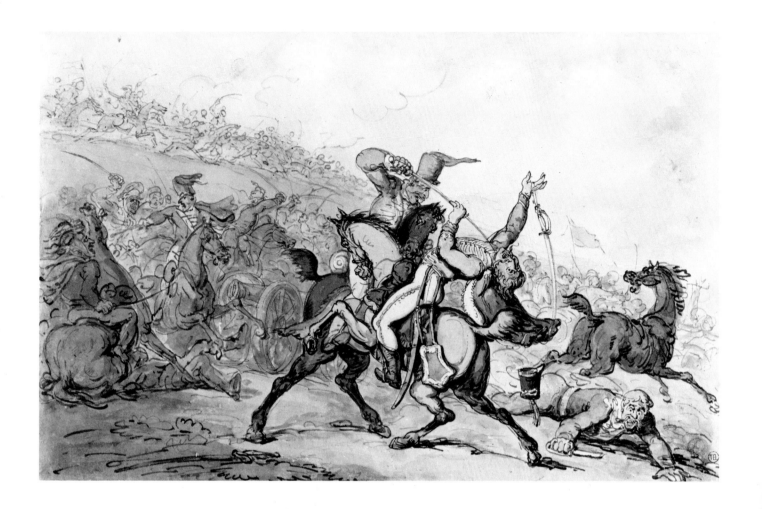

139. The Scots Greys at Waterloo. About 1815. Pen and watercolour over pencil, 9½ × 14¾ in. (241 × 375 mm.). *San Marino, California, Henry E. Huntington Library and Art Gallery*

A lively sketch, showing that Rowlandson had lost none of his ability to suggest rapid and violent movement. The mêlée on the left is superbly contrived, brilliantly suggestive of the cut and thrust of a fierce cavalry engagement. Notice, in the encounter in the foreground, the tension of the horses' legs and how the thrust of the victor's blade is powerfully increased by the way in which the cavalry rushing down the slope are absorbed into the same diagonal.

140. Robbing an Orchard. About 1815. Pen and watercolour over pencil, 6 × 9¾ in. (152 × 248 mm.). *London, Private Collection*

The exceptionally free drawing and loose handling of the foliage is typical of much of Rowlandson's late work. Rowlandson included a similar subject in the *English Dance of Death*, where one of the urchins is not only hit by the owner's blunderbuss but savaged by the dog into the bargain.

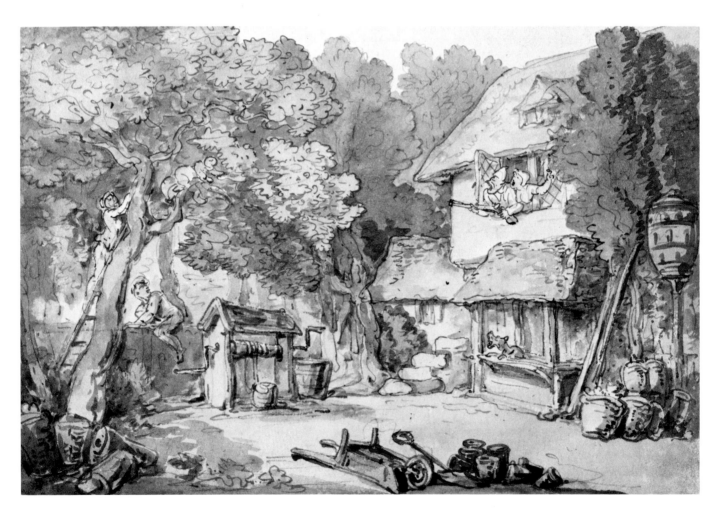

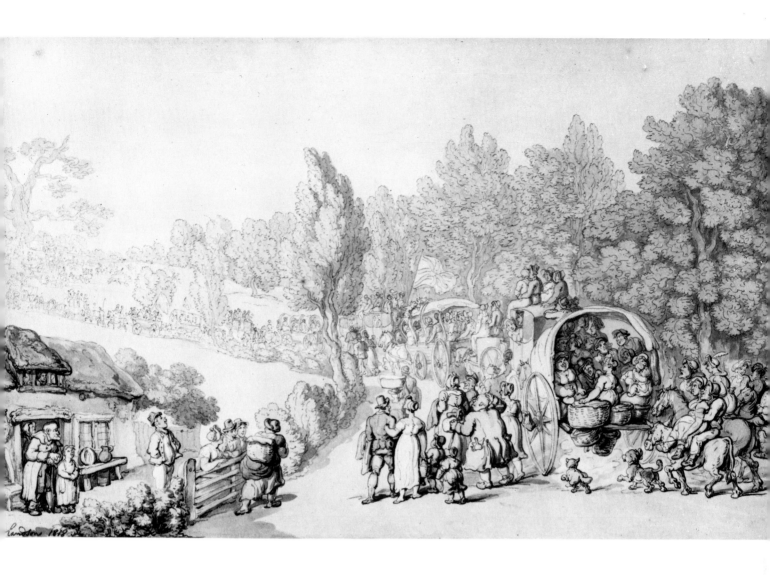

141. The Road to Fairlop Fair. Signed and dated 1818. Pen and watercolour over pencil, $10\frac{15}{16} \times 16\frac{9}{16}$ in. (262×421 mm.). *London, Victoria and Albert Museum*

Fairlop Fair was an annual event, celebrated on the first Friday in July in Hainault Forest, near Ilford, and though its heyday was in Rowlandson's time, it continued to be held there for some time after Hainault was disafforested in 1851. A long procession of figures, horses, carts and coaches is seen winding along a country road to the fair that is taking place in the distance in proximity to the famous Fairlop Oak, which was destroyed during a heavy gale in February 1820, soon after Rowlandson's drawing; the types are rather generalized and empty, as in so much of Rowlandson's late work. The foliage is shimmering with the tracery of Rowlandson's rococo penwork, and the tree in the centre seems to be shaking itself out of the very soil. Vermilion is freely used to reinforce the penwork in the foreground passages. The composition is based on a powerful receding diagonal, which is echoed by the trees. The sketch for this subject, in the Birmingham City Museum and Art Gallery, is inscribed 'Road to Fairlop Fair 7th July 1815' and there is a version of the finished drawing signed and dated 1816.

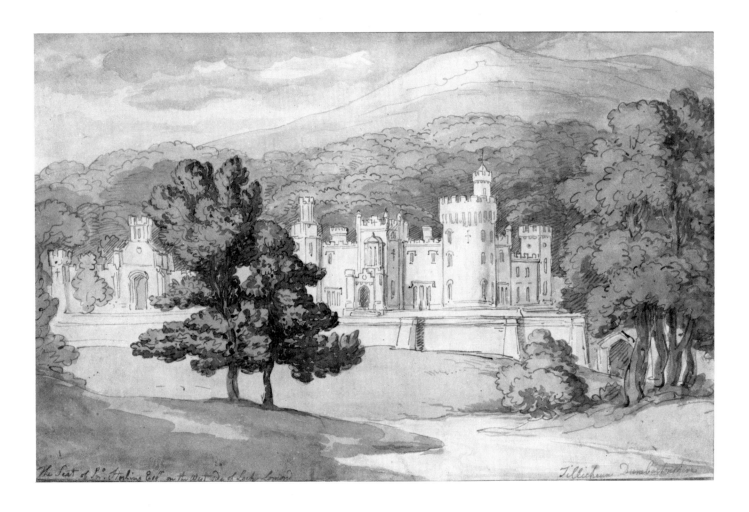

142. View of Tullichewan, Dunbartonshire. About 1815–20. Inscribed. Pen
and watercolour over pencil, 9½ × 15 in. (241 × 381 mm.). *Formerly London,
Fine Art Society*

Most of Rowlandson's contemporaries in the field of watercolour spent a good deal
of their energies on topographical work and the delineation of gentlemen's seats,
which were subjects much in demand; Rowlandson, however, seems to have done
very few such drawings, except of houses belonging to his friends, and the present
watercolour is exceptional in his *œuvre*. The view is of Jonathan Stirling's seat on
the west side of Loch Lomond, the first asymmetrical Gothic house in Scotland,
built in 1792 in the baronial style, to the designs of Robert Lugar, and
demolished about 1955.

143. The Gateway, Garden and Entrance to a Neo-Gothic House. About 1815–20. Pen and watercolour over pencil, $5\frac{9}{16} \times 8\frac{1}{2}$ in. (142×215 mm.). *London, Courtauld Institute of Art (Witt Collection)*

The owner of this imaginary house, who is sitting in the garden in a tall Gothic chair, has evidently been determined to cram as much medieval detail as possible into the design of his country seat: the gate-posts are derived from some cathedral façade, and the main entrance, surmounted by arched window, finials and crockets, looks like the doorway into a chapel. The foliage is in Rowlandson's loose, late style.

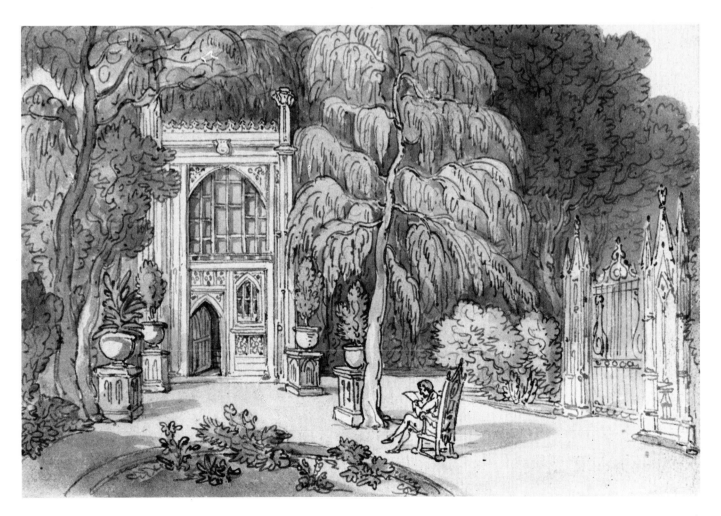

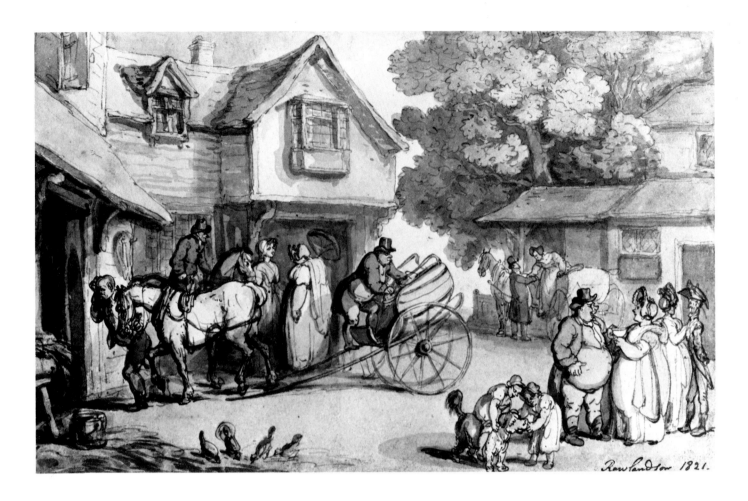

144. The Return Home. Signed and dated 1821. Pen and watercolour over pencil, $5\frac{7}{8} \times 9\frac{9}{16}$ in. (149×243 mm.). *London, British Museum*

A farmer has just returned home in his trap, and his horse is being led into the stable by a groom. The scene is made an excuse for various minor incidents: one of Rowlandson's familiar pot-bellied types is included in the conversation on the right, and a child is trying to get a ride on a dog. The penwork is more incisive than in many of Rowlandson's very late drawings, notably in the horses and figures on the left, where the outline has been gone over in vermilion. Though there are drawings extant on paper watermarked 1825 and 1826 (see Figure 13), Rowlandson evidently produced very little in the last two years of his life, when he was seriously ill and possibly incapacitated, and perhaps not a great deal after 1822: the last signed and dated work at present known dates from 1824.

BIBLIOGRAPHICAL NOTE

Apart from the prints, drawings and illustrated books themselves, there is extraordinarily little in the way of source material relating to Rowlandson. There are two surviving letters, one of which is reproduced here and the other in Falk's biography (see below), and a single page from one of his account books, again reproduced here. His will is in the Public Record Office (Prob.10/4946); and Sotheby's catalogue of the sale of his effects (23 June 1828 ff.: Lugt 11790) lists his enormous collection of old master and eighteenth-century prints. The obituary in the *Gentleman's Magazine*, June 1827, gives a brief biographical outline, and there are additional anecdotes in the memoirs of his friend Henry Angelo (*Reminiscences*, 1830 and *Angelo's Pic Nic*, 1834), W. H. Pyne's *Wine and Walnuts*, Vol. 2, 1824 and *Somerset House Gazette*, Vol. 2, 1824, J. Adolphus's *Memoirs of John Bannister*, 1839 and J. T. Smith's *A Book for a Rainy Day*, 1845. Two valuable articles, by W. P. (as yet unidentified) and William Bates, were contributed to *Notes and Queries* in 1869.

Joseph Grego's enormous two-volume work, *Rowlandson the Caricaturist*, 1880, which describes as many of the prints as he was aware of and illustrates a good many of them, is still indispensable, though a fresh, up-to-date catalogue is long overdue. The most penetrating critique of Rowlandson the draughtsman is A. P. Oppé's *Thomas Rowlandson: His Drawings and Water-Colours*, 1923; there is also a sensitive appraisal in Laurence Binyon's *English Water-colours*, 1946. The fullest biography—and the only useful and properly documented one—is Bernard Falk's *Thomas Rowlandson: His Life and Art*, 1949, an account which also contains a catalogue of the books illustrated by Rowlandson. An American scholar, Richard M. Baum, published the first serious art-historical study on Rowlandson, 'A Rowlandson Chronology', in the *Art Bulletin* for 1938; Robert R. Wark's *Rowlandson's Drawings for a Tour in a Post Chaise*, 1963, and *Rowlandson's Drawings for the English Dance of Death*, 1966, are far more than specialized studies and, taken together with his essay in *Ten British Pictures*, 1971, provide the best modern account of Rowlandson as artist and draughtsman. Ronald Paulson's review of Wark's second volume in *Eighteenth-Century Studies*, Vol. 3, No. 4, 1969, adumbrates a thesis of the meaning behind Rowlandson's work more fully stated in his *Rowlandson: A New Interpretation*, 1972. For Rowlandson's place in the history of English caricature, F. D. Klingender's *Hogarth and English Caricature*, 1944, and M. Dorothy George's *Hogarth to Cruikshank: Social Change in Graphic Satire*, 1967, should be consulted.

INDEX
of persons and places

Tailpiece from *A Tour in a Post Chaise*, 1784